LIVERPOOL JMU LIBRARY

3 1111 01528 6725

John Kane I

Laurence King Publishing

Published in 2011 by
Laurence King Publishing Ltd
361–373 City Road
London EC1V 1LR
United Kingdom
Tel: + 44 20 7841 6900
email: enquiries@laurenceking.com
www.laurenceking.com

Copyright © 2011, 2003 John Kane

All rights reserved. No part of this publication may be reproduced or transmitted in any form or by any means, electronic or mechanical, including photocopy, recording or any information storage and retrieval system, without prior permission in writing from the publisher.

A catalogue record for this book is available from the British Library

ISBN-13: 978-1-85669-644-9

Text and cover design: John Kane

Printed in the UK

Picture credits

All numbers refer to page numbers (t = top; b = bottom; c = center; r = right; l = left).

Courtesy of Apple 47: © James Austin, Cambridge, UK 19t; The Aviation Picture Library, London 45; reproduced with the kind permission of Transport for London 42; Bibliothèque Royale de Belgique 201: Bildarchiv Foto Marburg 20t: Courtesy of the Trustees of the Boston Public Library/Rare Books 19r, 20r, 21, 22, 23l, 23r, 24l, 24r, 32, 34, 38; © The British Library Board 26: © Trustees of the British Museum 16: The Museum and Study Collection at Central Saint Martins College of Art and Design 37b; Fototeca Unione, American Academy in Rome 17r; © Peter Kent, London, 43; A.F. Kersting, 27t; LKP Archive 31, 33, 39, 41/© Cameraphoto Arte, Venice 25t/Paul M.R. Maeyaert, Mont de l'Enclus (Orroir), Belgium 29t, 35/© Peter Ashworth 37t; Nina Pattek 40b; © Hattula Moholy-Nagy/DACS 2010 40t; RMN, Paris, 17l; © The Isamu Noguchi Foundation and Garden Museum/ARS, New York and DACS, London 2010 44; Shutterstock 88; E.M. Thompson, An Introduction to Greek and Latin Paleography, 1912, Clarendon Press 18I, 18c, 18r, 19I, 19c; D.B. Updike, Printing Types: Their History, Forms and Use, Volume II, 1922, by permission of Oxford University Press 28.

Acknowledgments

Author Grace Paley once pushed Hippocrates a bit to say that she wrote short stories because 'Art is too long, life is too short'. That sentiment nicely sums up what has kept this second edition off the shelves until now. The petty illnesses of middle age, combined with expanded professional responsibilities, didn't always allow me to stick as closely to this project as perhaps I should have. Apologies for the delay.

This edition grew out of the support and suggestions of valued colleagues. I am grateful to Nancy Skolos for inviting me to teach type at Rhode Island School of Design, and to Ernesto Aparacio, Jan Fairbairn, Lucinda Hitchcock, Matthew Monk, Bill Newkirk, Akefeh Nurosi, Douglass Scott, Hans van Dijk, Tom Wedell, Franz Werner, and - especially - Cyrus Highsmith and Krzysztof Lenk for their lessons in collegiality and professionalism. Students Mitchell Goldstein and Katherine Hughes at RISD offered invaluable teaching support.

At Northeastern, Ed Andrews, Isabel Meirelles, and Russell Pensyl kept me employed (no small thing); Cynthia Baron generously shared her expertise and advice; and Elizabeth Cromley actually read the first edition, which she proved by finding its one typo (minuscule!). I owe much to my students Dwight Roell, Kate Terrado, and Mitch Weiss for their assistance in wrestling various parts of this project to the ground. Fellow lecturers Sophia Ainslie, Julia Hechtman, and Karen Kurczynski make every day plain old fun, while colleague Mary Hughes gently punctures every pretension I throw her way. Department administrator Judy Ulman remains the heart and soul of all we do. But most of all, thanks with deep admiration and affection to Andrea Raynor and Matthew Rich, who school me daily in the ways of hard work, the Red Sox, handicapping throroughbreds, and All Important Things.

Thanks to the reviewers of the last edition: Andrea Marks (University of Oregon), Robert Newman (Savannah College of Art and Design), Liz Resnick (Massachusetts College of Art & Design), and David Smart (University of Plymouth, UK).

Generous students at RISD and Northeastern provided some of the examples that appear in this edition. I have credited them individually where their work appears, but I must thank them all, whether or not they're included in these pages, for giving me the best reason anyone could wish for to get out of bed each morning.

I have leaned too heavily on the goodwill and broad experience of my family and friends. In particular, I remain indebted to my mother, Carole Kane, for her unfailing encouragement and unflinching affection, even after all these years.

Finally...

Some things don't change. Just as with the first edition—in fact, just as with everything I do—the touchstones for this project remain Julie Curtis, David W. Dunlap, Nina Pattek, and my partner, Mark Laughlin. To them, once again, this book is dedicated.

JK

Contents

	٧	Acknowledgments
	viii	Introduction
Basics	1	
	2	Describing letterforms
	5	The font
	8	Describing typefaces
	10	Measuring type
	12	Comparing typefaces
	14	Display typefaces
Development	15	
Development	16	A timeline
	48	Text typeface classification
	40	TOXE TYPOTAGE GLASSIFICATION
Letters, words, sentences	51	
	52	Understanding letterforms
	56	Maintaining x-height
	57	Form/counterform
	62	Contrast
	64	Reinforcing meaning
	70	Making sentences, finding sense
	80	Type and color
	88	English is not Chinese
Text	89	
	90	Tracking: kerning and letterspacing
	94	Formatting text
	96	Texture
	99	Typing is not typesetting
	100	Leading and line length
	106	Kinds of proportion
	114	Components of the text page
	116	Placing text on a page
	122	Front matter, back matter
	124	Indicating paragraphs
	126	Highlighting text
	132	Headlines within text
	136	Widows and orphans

Vİ

Columnar organization	137 138 144 146 156 162	Columnar layouts Cross-alignment Expressing hierarchy Tabular matter Type as image and information
Grid systems	177 178 179 180 188 194 200 212	Introduction An example Components of the grid A simple grid Grids at large scale Creating a grid for text Creating a grid for text and images
	226	Next
	227 228	Selected bibliography Index

.,;;;

Design is solving problems. Graphic design is solving problems by making marks. Type is a uniquely rich set of marks because it makes language visible. Working successfully with type is essential for effective graphic design.

That said, I can tell you that

this is a practical book.

Over the last 20-odd years teaching typography, I have been unable to find a text that spoke clearly to beginning students about the complex meeting of message, image, and history that is typography. Some of the best history texts are weak in examples; some of the best theoretical texts speak more to the professional than the novice. And no text provides background information to the student in a sequence that supports the basic exercises in any introductory type course. My intention here is to present the basic principles and applications of typography in a way that mirrors what goes on in the classroom and to back up that information with a series of exercises that reinforce the acquired knowledge.

My intent here is to get you, the beginning student of graphic design, to the point where you can understand and demonstrate basic principles of typography. If instinct is the sum of knowledge and experience, this book is an attempt to broaden both in order to strengthen your own typographic instincts.

I should also point out that this is an autodidact's book. What I know about typography Hearned from reading, from practice, and from observation. I was lucky enough to read Emil Ruder first, And I was lucky to work in Boston at a time when dozens of gifted practitioners were trying to solve the same problems I was confronting daily, as we all moved from metal type through photoset type to digital type off our Macs. What Hearned from them was constant application of theory to practice, unflagging respect for the letterform, and a ceaseless search for that moment when the personal met, or at least approached, the platonic.

Paul Rand once wrote: 'Typography is an art. Good typography is Art, and therein lies the problem for both teacher and student. Craft can be taught. Art lies within the individual. Many beginning students are frustrated by the fact that there are no hard and fast rules in typography, no foolproof map to success. The pedagogic difficulty is that type has a system of principles, based on experience, and those principles keep evolving as language and media evolve. Countless times, students have asked, 'Is this right?' when in fact there is no such thing in typography as 'right.' The question they should be asking themselves is, 'Does this work? Is it useful?' Designers use type as a response to a message, to an audience, to a medium. The only way to recognize successful typography is through informed, direct observation. It takes time, trial, and error to know what works and to lose anxiety over what may or may not seem 'right.'

If you work through the examples in this book for yourself, you should have enough experience to test your own ideas in typographic applications. After all, it is what each designer brings to a project-the sum of what he or she knows and feels, his or her unique experience that guarantees that variety, excitement, and, occasionally, brilliance will continue to enliven typographic design. This book is not about style-a characteristic expression of attitude - so much as a clear-headed way of thinking and making. Style belongs to the individual; delight in thinking and making can be shared by everyone.

The guiding attitudes behind what follows are those that have vitalized most 20th-century art:

Content dictates form. Less is more. God is in the details.*

These three tenets neatly identify the typographer's job: appropriate, clear expression of the author's message, intelligent economy of means, and a deep understanding of craft.

^{*}The first idea is a variation of architect Louis Sullivan's famous dictate, "Form ever follows function." The second, although popularized by architect Ludwig Miles van der Rohe, was first articulated by Robert Browning in 'Andrea del Sarto,' 1855 (and, in fact, the idea has existed in literature since Hesiod's 'Works and Days' (700 B.C.E.) in which he writes 'They do not even know how much more is the half than the whole.') The third, although attributed to architect Louis Kahn, has no source that I have been able to uncover.

The basic thinking behind this book comes out of two simple observations. First.

type is physical.

Until quite recently, any study of type would necessarily begin by handsetting metal type. There is still no better way to understand the absolute physicality of the letterform-its 'thingness.' With each passing day, however, working with metal type becomes less and less possible. To approximate the experience of handling type, there are examples in this book that require careful hand-rendering of letterforms. (I've suggested these exercises primarilv for readers who don't have, as I did not, the benefit of a classroom experience. They are not intended to supplant working with a capable instructor, although I certainly hope that they can enhance that process.) These exercises not only help you hone your hand/eye coordination, but also help you develop a typographic sensibility. You cannot achieve this sensibility merely by looking and thinking. The only way to appreciate the reality of type is first to make your own.

The second observation, particularly in terms of text type, is that

type evolved from handwriting.

While there are any number of things you can do with text type (particularly on a computer), your work will have the most integrity when what you do reflects the same impulse that leads us all to put pen to paper—effective, direct, useful communication.

Particularly in later examples, I have assumed that people using this book have a working familiarity with Adobe Illustrator and Quark Xpress or Adobe InDesign. You should also have at least one font from each of the classifications described on pages 48–50; in fact, you could do a lot worse than to choose the ten typefaces highlighted on page 12. They provide a rock-solid foundation for any typographic design problems you may encounter in the future.

I've used numerous examples to demonstrate the points I raise because one of the joys of working with type is that you can see immediately what is successful and what isn't (for that same reason I've tried to keep text to a minimum). I have designed almost every example in this book to reflect what was, and still is, possible on a simple type press. I've kept these examples as simple as possible for two reasons: 'simple' is deceptively difficult (and, in typography, often desirable); and, as I said earlier, this book is about intent and content, not effect or style.

This second edition incorporates many additions and amendments to the first; perhaps the most significant is the companion website (www.atypeprimer.com). There you will find examples of student work, discussions of best typographic practice for the web, recommendations for a strong typeface library, links to typographic resources, and other timely topics. I consider the website a logical extension of the material in this book, and I encourage you to refer to it often. Perhaps the most surprising discovery I've made since the first edition is the direct correspondence between good print typography and good web typography. I hope that this book's website clearly demonstrates how the principles in print translate to the screen.

The sequence of examples in this book is built to demonstrate that the character and legibility of type only exist in the context of voids what type designer Cyrus Highsmith describes as 'where type isn't.' A serious typographer constantly monitors and manipulates the relationship of form (where type is) to counterform (where it isn't). To understand this relationship, it is essential to see type as a progression of spaces (right). Changing any one space immediately alters its relationship with all the other spaces. Those of you familiar with Gestalt Principles will doubtless find similarity to the concepts of contiguity, continuity, and closure. I conclude the introduction with this observation because it is central to all good typography and because it offers us an ideal point from which to start. As you go through this book, keep in mind how the spaces operate, both in the examples shown and in the pages themselves.

The space inside the form

The space between forms

er ox

The space between words

slip the

The space between lines

paused before a l door, from which see the whole of This room wa by Dantes' father

The space between paragraphs

der is already dows, over each icipal cities of d although the l with impatient onal friends of ler to do greater

end the nuptial ion could

The feast had familiar. The ap of which was wr France; beneath entertainment w and expectant go the bride-groon honor to the occurrence.

Various rumo feast; but all see

The space between columns of text

door, from which see the whole of

This room was or by Dantes' father

water was written in golden retters for some interpatation of inentertainment was fixed for twelve o'clock, an hour previor the bride-groom, the whole of whom had arrayed themselv Various rumors were affoat to the effect that the owners be intended.

Danelars, however, who now made his appearance, according

Danglars, however, who now made his appearance, according at La Reserve.

In fact, a moment later M. Morrel appeared and was sa

feast he thus delighted to honor would ere long be first in c choice of their superiors so exactly coincided with their own With the entrance of M. Morrel, Danglars and Caderous lively sensation, and to beseech him to make haste. Danglars and Caderousse set off mon their errand at full

Danglars and Caderousse set off upon their errand at full he bride, by whose side walked Dantes' father; the whole b Neither Mercedes nor Edmond observed the strange exp

The space between text and the edge of the page

Basics

Describing letterforms

As with any craft that has evolved over 500 years, typography employs a number of technical terms. These mostly describe specific parts of letterforms. It is a good idea to familiarize yourself with this lexicon. Knowing a letterform's component parts makes it much easier to identify specific typefaces.

(In the entries that follow, **boldface** texts denote terms described elsewhere in the list.)

ABC

Stroke

Any line that defines the basic letterform.

Apex/Vertex

The point created by joining two diagonal **stems** (apex above, **vertex** below).

Arm

Short **strokes** off the **stem** of the letterform, either horizontal (E, F, T) or inclined upward (K, Y).

bdhk

Ascender

The portion of the **stem** of a lowercase letterform that projects above the **median.**

Barb

The half-**serif** finish on some curved **strokes**.

Baseline

The imaginary line defining the visual base of letterforms (see the diagram below).

Median

The imaginary line defining the **x-height** of letterforms (see the diagram below).

X-height

The height in any typeface of the lowercase 'x' (see the diagram below).

ascender height cap height median

baseline

descender height

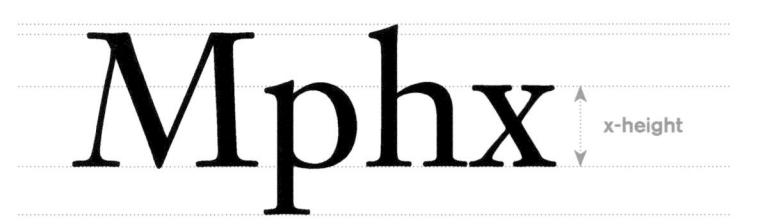

ETL

Beak

The half-**serif** finish on some horizontal **arms**.

bdpq

Bowl

The rounded form that describes a **counter.** The bowl may be either open or closed.

T1

Bracket

The transition between the **serif** and the **stem**.

adPC

Counter

The negative space within a letterform, either fully or partially enclosed.

AH

Cross Bar

The horizontal **stroke** in a letterform that joins two **stems** together.

ft

Cross Stroke

The horizontal **stroke** in a letterform that intersects the **stem.**

KV

Crotch

The interior space where two strokes meet.

рqу

Descender

That portion of the **stem** of a lowercase letterform that projects below the **baseline**.

gr

Ear

The **stroke** extending out from the main **stem** or body of the letterform.

Mdp

Em/en

Originally referring to the width of an uppercase M, an **em** is now the distance equal to the size of the typeface (an **em** in 48 pt. type is 48 points, for example). An **en** is half the size of an **em**. Most often used to describe em/en spaces and em/en dashes.

Finial

The rounded non-**serif terminal** to a **stroke**.

LKR

Leg

Short **strokes** off the **stem** of the letterform, either at the bottom of the stroke (L) or inclined downward (K, R).

fififlfl hn

The character formed by the combination of two or more letterforms.

Shoulder

The curved **stroke** that is not part of a bowl.

() e e

The orientation of the letterform, indicated by the thin stroke in round forms.

Swash

The flourish that extends the stroke of a letterform.

Tail

The curved or diagonal stroke at the finish of certain letterforms.

Terminal

The self-contained finish of a stroke without a serif. This is something of a catch-all term. Terminals may be flat ('T', above), flared, acute, ('t', above), grave, concave, convex, or rounded as a ball or a teardrop (see finial).

The stroke that connects the bowl and the loop of a lowercase G.

Spine

The curved **stem** of the S.

Spur

The extension that articulates the junction of a curved and rectilinear stroke.

In some typefaces, the bowl

created in the descender of the

Serif

lowercase G.

The right-angled or oblique foot at the end of the stroke.

Stem

The significant vertical or oblique stroke.

The full font of a typeface contains much more than 26 letters, 10 numerals, and a few punctuation marks. To work successfully with type, you should make sure that you are working with a full font and you should know how to use it.

Uppercase

Capital letters, including certain accented vowels, the c cedilla (ç) and n tilde (ñ), and the a/e and o/e ligatures (æ, œ).

Lowercase

Lowercase letters include the same characters as uppercase plus f/i, f/l, f/f, f/f/i, and f/f/l ligatures, and the 'esset' (German double s).

AÅÂÄÄÄÄÆBCÇDEÉ ÈÊËFGHIÌÍÎÏJKLMN OÓÒÔÖØŒPQRS TUÚÙÛÜVWXYZ

Small capitals

Uppercase letterforms, drawn to the x-height of the typeface. Small caps are primarily found in serif fonts. Most type software includes a style command that generates a small cap based upon uppercase forms. Do not confuse real small caps with those generated artificially.

Aa Baskerville small cap artificially generated

Aa Baskerville small cap from the font AÁÀÂÄÄÆBCÇDEÉÈÊË FGHIÍÌÎÏJKLMNÑ OØÓÒÔÖŒPQRSŠ TUÚÙÜVWXYÝZŽ

Typeface shown: Monotype Baskerville 6

Also called lining figures, these numerals are the same height as uppercase letters and are all set to the same kerning width. They are most successfully used with tabular material or in any situation that calls for uppercase letters.

1234567890

Lowercase numerals

Also called oldstyle figures or text figures, these numerals are set to x-height with ascenders and descenders. They are best used wherever you would use upper- and lowercase letterforms. Lowercase numerals are far less common in sans serif than in serif typefaces.

1234567890

Italic

Most fonts today are produced with a matching italic. Small caps, however, are almost always only roman. As with small caps, artificially generated italics are not the same as real italics.

Note the difference below between a 'true' italic and what is called an 'oblique.' The forms in a true italic refer back to 15th-century Italian cursive handwriting. Obliques are typically based on the roman form of the typeface. Contemporary typefaces often blur the distinction between italic and oblique, but you should be aware of the differences.

aa Baskerville roman with italic

Univers 55 (roman) with Univers 56 (oblique) AĂÂÄÂĂÂÆBCÇD EËÊÈÉFGHIÏÎÌÍJKLM NÑOØÖÔÒÓŒPQRST UÜÛÙÚVWXYZ 1234567890 aåâäàáãæbcçdeëêèéffiflff ffifflghiïîìíjklmnñoøöôòóœ pqrsβtuüûùúvwxyz 1234567890

Punctuation, miscellaneous characters

Although all fonts contain standard punctuation marks, miscellaneous characters can change from type-face to typeface. It's important to be acquainted with all the characters available in a typeface before you choose the appropriate type for a particular job.

!*---_() { } [] "", ', :,; ...
/ ?
$$\dot{c}$$
 † ‡ § \leftrightarrow «» ¶ & # \$ \dot{s} ¢ £ ¥

TM © ® @ \dot{a} o m < > + ± =

÷ • ° Ð ð Þ þ \dot{f} ° ¬ μ / ~ " 1
% % % 1/4 1/3 3/8 1/2 5/8 2/3 3/4 7/8

Dingbats

Various symbols and ornaments that are intended for use with type are called dingbats. The majority of dingbats are marketed as their own fonts and not in conjunction with any particular typeface.

Roman

Once you can recognize the parts of the letterform, you can apply what you know to identify different typefaces. Beyond the characteristic gestures of a typeface, however, there are also style applications that you should recognize. Keep in mind that some, all, or combinations of these styles may be found within one type family.

Roman The basic letterform style, so called because the uppercase forms are derived from inscriptions on Roman monuments. When used to describe a type style, the term 'roman' is always lowercase. In some typefaces, a slightly lighter stroke than roman is called 'book'.

Italic **Boldface**

Italic

Named for 15th-century Italian handwriting on which the forms were based. (See page 6 for a description of 'oblique.')

Boldface

Characterized by a thicker stroke than the roman form. Depending upon the relative stroke widths within the typeface, it can also be called 'semibold,' 'medium,' 'black,' 'extra bold,' or 'super.' In some typefaces (notably Bodoni), the boldest rendition of the typeface is referred to as 'poster.'

A lighter stroke than the roman form. Even lighter strokes are often

Light Condensed Extended

Condensed

called 'thin.'

Light

As the name suggests, a condensed version of the roman form. Extremely condensed styles are often called 'compressed'

Extended

Exactly what you would think. An extended variation on the roman forms.

The confusion of styles within families of typefaces may seem daunting to the novice; it certainly remains a small nuisance even to the experienced designer. The only way to deal with the profusion of names—like learning irregular verbs in French—is memorization. See page 44 for Adrian Frutiger's attempt to resolve the naming problem.

Adobe Caslon SemiBold
Akzidenz Grotesk Regular
Akzidenz Grotesk Medium
Bodoni Old Face Medium
Futura Book
Helvetica Compressed
Gill Sans Heavy
Gill Sans Extra Bold
Gill Sans Ultra Bold
Grotesque Black
Meta Normal

Univers Thin Ultra Condensed (Univers 39)

Along with its own lexicon, typography also has its own units of measurement. Originally, type size was determined by the height of actual pieces of lead type. Obviously, we no longer commonly use lead type in setting type; however, the concept of letterforms cast on small pieces of lead remains the most useful way of thinking of type size. Although type size originally referred to the body of the type (the metal slug on which the letterform was cast), today we typically measure it from the top of the ascender to the bottom of the descender.

Similarly, the space between lines of type is called 'leading' because it was originally strips of lead placed between lines of metal type.

We calculate the size of type with units called 'points.' A point as we use it now is 1/72 of an inch or .35mm. The 'pica,' also used extensively in printing, is made up of twelve points. There are six picas to an inch.

When writing out a dimension in picas and points, the standard abbreviation is **p.**

6 picas is written 6p or 6p0

6 picas, 7 points is written 6p7

7 points
is written
7 pts., 0p7, or p7

When specifying type size and leading, use a slash between the two numbers.

10 pt. Univers with 2 pt. leading is written 10/12 Univers

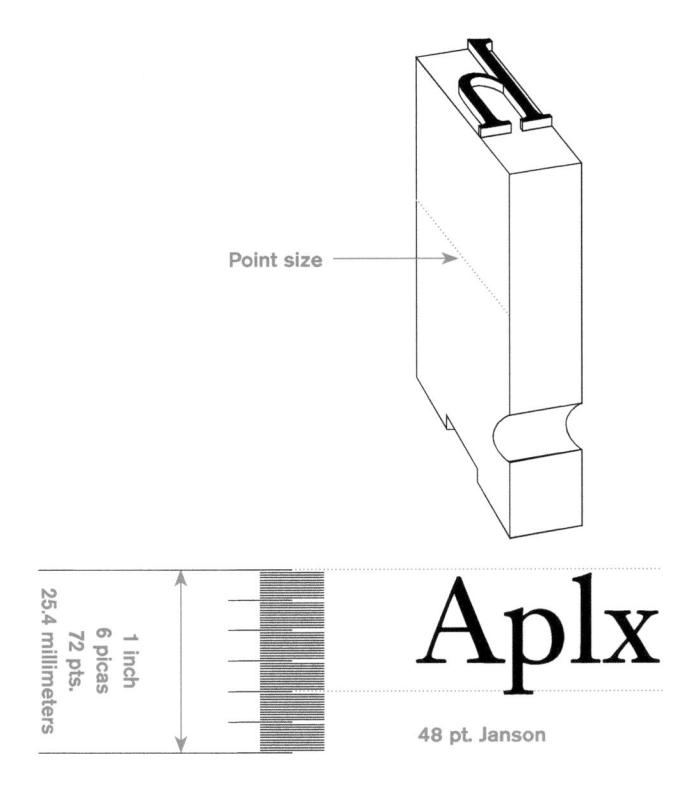

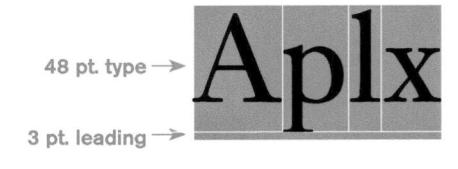

48 pt. Janson with 3 pt. leading – 48/51 Janson

Set width

All letterforms have set widths: the width of the form itself plus the space required on either side to prevent one letter from bumping into another. Set widths are described in **units**, an entirely arbitrary measure that changes from one system to another. In the example opposite, the uppercase M (typically the widest letterform) is 20 units wide and the lowercase a is 9 units wide; the measurements might just as easily be 40 units and 18 units.

When type was cast by hand, it was possible for every letter, upper- and lowercase, to have a unique set width. As mechanized typesetting evolved, type designers were forced to restrict the number of set widths in any typeface to accommodate the limitations of the system (metal or photo) that produced the type. An 'a' and an 'e', for instance, might be assigned the same set width in some systems because the technology wasn't able to express finer distinctions. Current digital technology has gone a long way toward restoring the variety of handcast type. Many softwares work at a scale of 200 units to the set width of an M

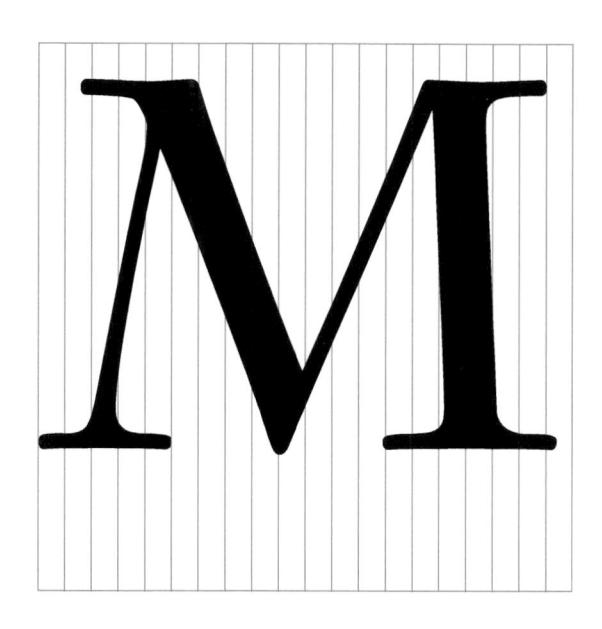

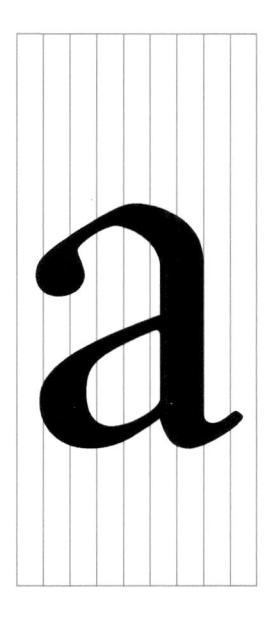

1,234,567.00 450,118.19

1,234,567.00 450,118.19

Traditionally, uppercase numerals had identical set widths so that they would align vertically (above). Lowercase numerals, designed with varying set widths, did not. For many typefaces, Open Type has removed these distinctions.

Comparing typefaces

Image, history, and meaning meet in every aspect of typography, even the simplest of letterforms.

The ten typefaces displayed opposite represent 500 years of type design. The men and women who rendered them all sought to achieve two goals: easy readability and an appropriate expression of contemporary esthetics. These typefaces (and there are others) have surpassed the latter goal. They have remained in use for decades—in some cases, centuries—after they were first designed, still considered successful expressions of how we think, how we read and write, and how we print.

As a beginning typographer, you should study these ten faces carefully. For any of the exercises in this book—and for almost any early projects—these are all you need to develop your skills. Once you understand how to use these faces appropriately and effectively, you'll be well prepared to understand and appreciate other typefaces as you encounter them.

Most of the typefaces shown here are fully displayed in the chapter on Development, pages 15-50.

Radiography

Garamond Radiography

Radiography

casion Radiography

Baskerville Radiography

Radiography

serifa Radiography

Radiography

Radiography

nivers Radiography

12

As you study other designers' work, you'll notice that many people who work seriously with type employ a limited palette of typefaces. Some, in fact, go through their entire careers using only one or two.

For our purposes, what is worth noting is not the similarities among these typefaces, but their differences—the accumulation of choices that renders each unique. Compare, for example, different forms of the lowercase 'a':

a a a a a a a a a

Beyond the gross differences in x-height, these forms display a wealth of variety in line weight, relative stroke width and other internal relationships, and in feeling. For any good typographer, each of these feelings connotes specific applications determined by use and expression. In other words, the type-faces suggest applications for which they are appropriate.

As Eric Gill said, letters are things, they are not pictures of things. While the generic letter 'A' may indicate a variety of sounds, the lowercase 'a' as rendered in Bembo is a specific character, different in form and sensibility from the lowercase 'a' rendered in Bauer Bodoni, Serifa 55, Helvetica, or Futura. All five convey the idea of 'A'; each presents a unique esthetic.

RRRRRRRR

The uppercase R (above) displays the range of attitude typefaces are capable of conveying. If you examine these forms long enough, you are bound to decide that some of the tails seem more whimsical, some more stately; some will appear more mechanical, some more calligraphic, some harmonious, some awkward. As much as anything, what this examination tells you is how you feel about type and specific typefaces. It tells you what you bring to the discussion of appropriateness in type choices.

14

For the bulk of this book, the type-faces that we're investigating have been designed as **text type**—that is, type intended primarily for presentation at between 6 pt. and 12 pt. Type presented at 18 pt. and above, for headlines or call-outs, is referred to as **display type**. Typefaces designed exclusively for use in display easily account for the majority of fonts produced today.

It's easy to understand the popularity of display typefaces. As these examples (right) demonstrate, they carry with them an endless variety of character, personality, history, and style. Experienced typographers use them to add spice to an already balanced composition. Neophytes, sadly, too often rely on them to give voice to what is otherwise irredeemably shapeless and bland.

The very characteristics that make display typefaces attractive at large scale—extreme compression or extension of form, unusually large or small counterforms, complex details, strong pictorial references—make them unsuitable at text sizes (bottom right). Keep in mind that display typefaces are meant to be 'seen' more than 'read'.

Top to bottom:
Bifur
Broadway
Brush Script
Cooper Black
Futura Black
Goudy Text
Haettenschweiler
Hobo
Kaufmann
Mistral
Onyx
Peignot
Playbill
Runic

HAMBURUS Hamburgs

Hamburgs
Hamburgs
Hamburgs

hamburgs
Hamburgs
Hamburgs

Hamburgs
Hamburgs
Hamburgs
Hamburgs
Hamburgs
Hamburgs

HAMBURGS Hamburgs Hamburgs Hamburgs

Namburgs Hamburgs Hamburgs

Hamburgs **Hamb**urgs Hamburgs

Hamburgs Hamburgs Hamburgs

Development

An alphabet is a series of culturally agreed upon marks-letters-that represent specific sounds. Before the Phœnicians (a seafaring mercantile group living in currentday Lebanon) developed an alphabet around 1500 B.C.E., written language had depicted entire words at a time. The picture of a bull meant a bull, independent of its pronunciation. Being able to write-to document speech-meant knowing the thousands of marks that represented all the things in the known world. By developing a system dependent upon sound ('ah') and not object (bull) or concept (love), the Phœnicians were able to capture language with 20 marks instead of hundreds or thousands. Writing cuneiforms, hieroglyphs-had been practiced for several millennia before the Phœnicians developed their set of marks, but, for our purpose-the study of letterforms - in the beginning was the alphabet.

The word 'alphabet' is a compression of the first two letters of the Greek alphabet: alpha and beta. By 800 B.C.E., the Greeks had adapted the 20 letters from the Phœnician alphabet, changing the shape and sound of some letters. (The Phœnician alphabet is also the forerunner of modernday Hebrew and Arabic, but our focus is on its European evolution.)

On the Italian peninsula, first the Etruscans and then the Romans appropriated the Greek alphabet for their own use. The Romans changed the forms of several Greek letters and, on their own, added the letters G, Y, and Z. As Rome's influence spread throughout Europe, Asia Minor, and northern Africa, so too did the Roman alphabet—and Roman letterforms.

Early letterform development: Phœnician to Roman

4th century B.C.E.
Phœnician votive stele
Carthage, Tunisia

The stele bears a four-line inscription to Tanit and Baal Hammon.

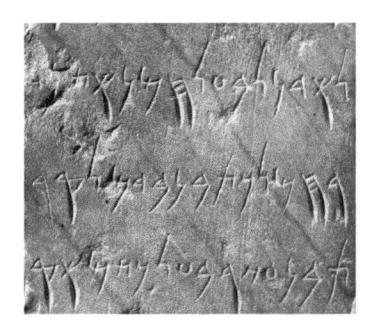

Initially, writing meant scratching into wet clay with a sharpened stick or carving into stone with a chisel. The forms of uppercase letterforms (for nearly 2,000 years the only letterforms) can be seen to have evolved out of these tools and materials. At their core, uppercase forms are a simple combination of straight lines and pieces of circles, as the materials and tools of early writing required. Each form stands on its own. This epigraphic (inscriptional) or lapidary (engraved in stone) quality differentiates upperfrom lowercase forms.

The evolution of the letterform 'A':

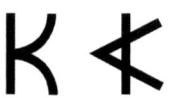

Phœnician 1000 B.C.E.

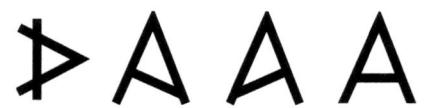

Greek 900 B.C.E.

Roman 100 B.C.E. The alphabet moved from Phœnicia through Greece to Rome, then throughout the Roman empire.

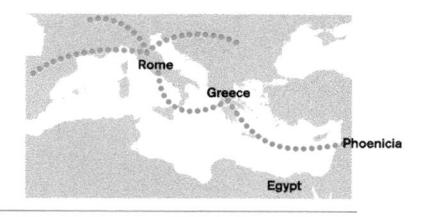

Date unknown
Greek fragment
Stone engraving

Late 1st century B.C.E. Augustan inscription in the Roman Forum Rome

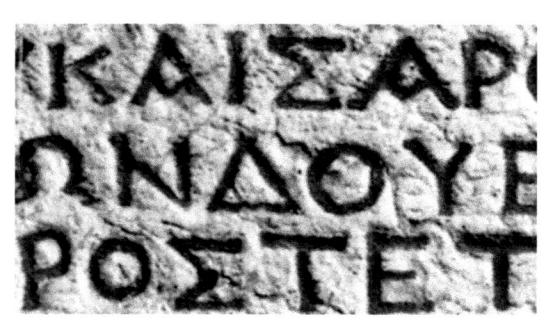

The Greeks changed the direction of writing. Phænicians, like other Semitic peoples, wrote from right to left. The Greeks developed a style of writing called *boustrophedon*, ('how the ox ploughs'), which meant that lines of text read alternately from right to left and left to right.

As they changed the direction of reading, the Greeks also changed the orientation of the letterforms, like this:

ASTHEYCHANGEDTHEDIRECTIO PARAHOOZJAYJAHTDRIDASTAOR EDTHEORIENTATIONOFTHELETTE

(Note: the Greeks, like the Phœnicians, did not use letterspaces or punctuation.) Subsequently, the Greeks moved to a strictly left-toright direction for writing.

Etruscan (and then Roman) carvers working in marble painted letter-forms before inscribing them. Certain qualities of their strokes—a change in weight from vertical to horizontal, a broadening of stroke at start and finish—carried over into the carved forms.

Not all early writing was scratched in clay or carved in stone. Business contracts, correspondence, even love songs required a medium that was less formal and less cumbersome than stone allowed for. From 2400 B.C.E., scribes throughout the eastern Mediterranean employed a wedge-shaped brush and papyrus for writing. Papyrus was made from a bamboo-like plant that grew in the Nile Valley. The plant's inner fibers were pulped, then flattened and dried under heavy weights.

Despite its relative ease of use, papyrus had several drawbacks. It could not be written on on both sides, and it was too brittle to be folded. Its main drawback, however, was its single source—Egypt. Availability was limited not only to the size of the papyrus crop from year to year, but also to the Pharaoh's willingness to trade.

Ephemeral communication—notes, calculations, simple transactions—were often scratched out on wax panels framed in wood. When the communication had served its purpose, the wax could be smoothed out for subsequent use. This practice continued into the Middle Ages.

4th or 5th century Square capitals Late 3rd to mid-4th century Rustic capitals

4th century Roman cursive

Square capitals were the written version of the lapidary capitals that can be found on Roman monuments. Like their epigraphic models, these letterforms have serifs added to the finish of the main strokes. The variety of stroke width was achieved by the use of a reed pen held at an angle of approximately 60° off the perpendicular.

A compressed version of square capitals, rustic capitals allowed for twice as many words on a sheet of parchment and took far less time to write. The pen or brush was held at an angle of 30° off the perpendicular. Although rustic capitals were faster and easier to write than their square counterparts, they were slightly harder to read because of the compressed nature of the forms.

Both square and rustic capitals were typically reserved for documents of some intended permanence. Everyday transactions, however, were typically written with a cursive hand, in which forms were simplified for speed. We can see here the beginning of what we now refer to as lowercase letterforms.

By 150 B.C.E., parchment had replaced papyrus as the writing surface of choice. Most famously manufactured in Pergamum (from which the word is derived), parchment was made from the treated skins of sheeps and goats (vellum—a particularly fine version of parchment—was made from the skins of newborn calves). Unlike papyrus, parchment could be written on on both sides and folded without cracking. Its harder surface also stood up to a hard-nibbed reed pen, which in turn allowed for smaller writing.

Paper was invented in China in 105 c.E. by Ts'ai Lun, a court eunuch, who made a pulp of various available fibers, which he then spread over a piece of cloth and allowed to dry. His contemporaries (and those who followed) used a brush to 'paint' characters on the resulting, rather rough, sheet. Over time, the drying cloth was replaced by a dense screen of thin strips of bamboo. The technique did not reach Europe for 900 years.

Papermaking spread to Japan in the 7th century, to Samarkand (now Uzbekhistan) in the 8th, and then, via the Moors, to Spain, where papermaking was practiced around 1000 C.E. A paper mill (or factory), using water-powered machines to pulp linen fiber and fine screens to produce smooth, flexible sheets, was operating in Fabriano, Italy by 1300. The process spread quickly through Europe. By 1600, more than 16,000 paper mills were in operation.

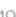

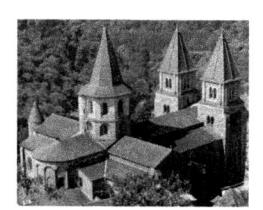

Abbey Church of Sainte-Fov Conques, France Late 10th-11th century

4th-5th century Uncials

c 500 Half-uncials 925 Caroline minuscule

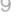

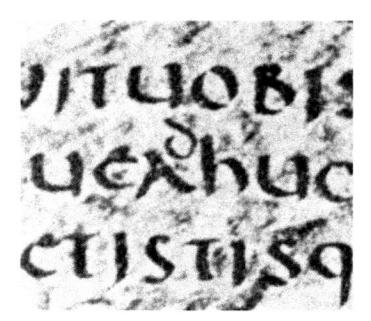

Uncials incorporated some aspects of the Roman cursive hand, especially in the shape of the A, D, E, H, M. U. and Q. 'Uncia' is Latin for a twelfth of anything; as a result, some scholars think that uncials refer to letters that are one inch (one twelfth of a foot) high. It might, however, be more accurate to think of uncials simply as small letters. The point for the scribe, after all, was to save expensive parchment, and the broad forms of uncials are more readable at small sizes than rustic capitals.

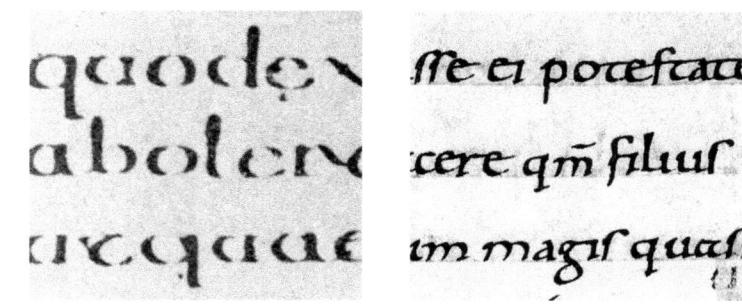

A further formalization of the cursive hand, half-uncials mark the formal beginning of lowercase letterforms. replete with ascenders and descenders. 2.000 years after the original Phœnician alphabet. Due to the political and social upheaval on the European continent at the time. the finest examples of half-uncials come from manuscripts produced in Ireland and England.

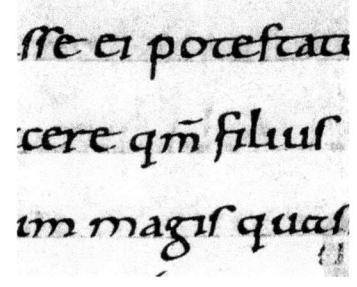

Charlemagne, the first unifier of Europe since the Romans, issued an edict in 789 to standardize all ecclesiastical texts. He entrusted this task to Alcuin of York, Abbot of St. Martin of Tours from 796 to 804, under whose supervision a large group of monks rewrote virtually all the ecclesiastical and, subsequently, secular texts then in existence. Their 'print'-including both majuscules (upper case) and minuscules (lower case) - set the standard for calligraphy for a century, including capitalization and punctuation.

Roman numerals, used in the 1st millennium throughout Europe, matched seven Roman letters.

XLCDM 50 100 500 1000

With the development of lowercase letterforms, the numerals came to be written in lowercase as well.

50 100 500 1000

What we call Arabic numerals originated in India between 1,500 and 2,000 years ago. Our first evidence of their use in Arabic is from an Indian astronomical table, translated in Baghdad around 800 c.E. Arab scribes referred to them as Hindu figures, and they looked like this (remember, Arabic reads from right to left):

987W457I

As with papermaking, use of Arabic numerals spread from Moorish Spain to Europe around 1000 C.E. The numerals were quickly adopted by merchants and scientists, not only because of their legibility but, significantly, because they brought with them the Hindu concept of zero, which allowed for decimals and place value. Compare:

1000 and

Blackletter to Gutenberg's type

c. 900 Blackletter (Textura) 1455
42-line bible
Johann Gutenberg
Mainz
(below [detail] and opposite)

yein consisti x muia peca ic? or in cath cie non sedit

With the dissolution of Charlemagne's empire came regional variations upon Alcuin's script. In northern Europe, a condensed, strongly vertical letterform known as black-letter or textura (for the woven effect it produced on a page of text) gained popularity. In the south, a rounder, more open hand, called 'rotunda,' prevailed. In northern France, England, and the Low Countries, a hybrid of the two, called batarde, was predominant. In the north, the blackletter style remained the standard for almost 500 years.

In the south, particularly in Italy, scholars were rediscovering, analyzing, and popularizing Roman and Greek texts. Their sources were written in Alcuin's Caroline minuscule, which they mistakenly believed to be that of the ancient authors. Scribes adapted the rotunda style to the Caroline as they copied the manuscripts, calling it 'scrittura humanistica'—humanist script.

We know that Johann Gutenberg did not singlehandedly invent type-casting or printing, but what little we know of him—mostly from court documents describing a lifetime of unpaid debts—is a good deal more than what we know of his few contemporaries. We do know that his achievement has endured, and so he is central to the development of type.

Born in Mainz in 1397, Gutenberg moved in 1428 to Strasbourg, where he worked as a goldsmith. Printing at that time-and it was a new idea in Europe - consisted of burnishing a piece of paper against a carved, inked block of wood. By 1436 he had begun experimenting with a new technology-an adjustable mold system for 'casting' movable, re-usable type from molten lead. In 1438 he designed his first press, based on the grape press used in winemaking. Along the way he developed an ink that had enough tack to stick to his metal type. By 1448 he had returned to Mainz and borrowed 150 gulden from a relative to set up shop.

By 1455, a subsequent mortgage from merchant Johann Fust had, with interest, reached 2,000 gulden. When Fust foreclosed, Gutenberg had to forfeit all his equipment—including his work in progress, the 42-line bible. Fust and his son-in-law Peter Schöffer finished production on the bible and sold it for a hand-some profit. Fust and Shöffer continued printing and publishing with great success. Fust died in 1466. Gutenberg died penniless two years later. At Schöffer's death in 1502, his son Johann took over the business.

puli iuxta id qd iuccūt. Dixitq; a relinquat ce i idiccūt cū: led d in: mane: ce fra

Gutenberg's skills included engineering, metalsmithing, and chemistry. He marshaled them all to build pages that accurately mimicked the work of the scribe's hand. For his letterforms, Gutenberg referred to what was known in his time and place-the blackletter of northern Europe. His type mold required a different brass matrix, or negative impression, for each letterform. Because he wanted his type to resemble handwriting as closely as possible, he eventually worked with 270 different matrices, including variants of individual letterforms and numerous ligatures.

20

vele lunt. Phi röftimit ei prepta atg; indicia: et ibi empranit eu dicens. Si audicia vocem dii dei mi-et qd redu elt coram eo feccio-et obdicio māta-ris et-cultodicilo; oniia prepta illi?: cundu langore que polmi egipto no inducă luper et. Ego eni lum domin? dus laluator. Cenerur aute in pelim filij ilrabel: ubi erant duoteim fonte aquarum e leptuaginta palme: et caltramerat lunt ineta aquas.

rofedige de helim venit omnie multitude filies ift'in detum Tyn-qd eft inter klim a finai:quintate = ama die menhe lecundi wikij egrelli lut de ita egipa. Et murmurauit ois rogregano filipe il cliona morten et naron in folicubine. Dixerunto: filij ilri ad eos. Unia moeni elimo per manu dii i ita egipti:quado feetam? Tup ollas carniū-a comertam9 panē i famricam. Eur induxillis nos in 🗱 lecci i Aud: ur occitereri e omnë miritu» dine fame! Dieit auten dus ad moylen. Ecce ego pluã vobie mues te edo. Egrediaf when colligar q lufticium pr lingulos dies: ur tempre eu-vrum ambuler in lege mea-an non. Die auran fero parer quod inferant: 4 lit dus plum quam colligere foletar p finqulos dies. Dixerunty moyles a aaron ad omes filios ilri. Velpere lcieris m doming eduxent voe de tra egipni:et mane videbicie gloria domini. Audini eni murmur veltru ontra dim. Mos vero go fund: quia inulitattis rotra nos frait mortes. Dabit nohis dis velver carnes edere-et mane panco i faturitate: eo co audiecit murmurationes veltras quibs murmuran eltie cona eu. Plos eni do lum? Mec contra nos est murmur vestru:

led coura domina. Dixit quon; morles ad aaron. Dit uniule cogregarionifiliou ilri. Acedin cora domino. Andinie eni murmur veltrū. Lūg: loqueret aaron-ad omné cerum filion ilri:respererut ad folitudinem. Er ecce gloria dai amaruit in nule. Locum elt auce doming ad morlen dices. Audiui murmuradones filiorū ilri. Loque ad eos. Beliere cometens carnes: 4 mane laturabimini paniba: literilg; m ego lum domin bue velter. Fadu elt ergo velvere a alrendés commix co opruit callra:mant quoq; ros iacuit pr circuită caltrou. Luq: opruillet luperficiem terre: amaruit in folitudine minuti-et quali pilo tulum in librudinem pruine finer tetrā. Quod tū vidillent filii ilrahel: direcunt ad inuice. Manhus Quod fignificar. Quid elf hor Agnoralant eni go ellet. Quibs ait moyles. The elt panis que dos des die vobie ad velembu. Die elt lermo que prepir vobie die. Colligar unulquilq: er eo quara lufficit-ad velcedu: gomor p lingla rapita. Juxta numerum animar veltrar q habitar in tabemado: fic collens. Feering ita filij ilit: et collegeut-alius plus alius minue: 4 menti lüt ab menlurā gomo: Mec que collegerar habuit ampliup:uec q min9 paraueat-reprit min9: led linguli ineta id ad edere poterant rögregauerüt. Dixing moyles ad eos. Aullus reinquater co i mane. Du non audierüt eü: fed dimiferüt quida tr eie ulg; mane: et leaere cepit umibsang compunuit. Et irat? i waa cos morles. Collinebant aute mane-inquli:quātū lufficere poterat ad velcendum. Lugi incaluillet fol: liquetietat. In die autem lerta-rollegerunt abos

Humanist script to roman type

European cities with printing offices, 1455–1500

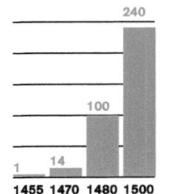

By 1500 there were 1,000 printing offices in 240 cities in Europe. 12,000,000 printed copies of 35,000 books were in distribution, more than all the books hand-copied in the previous one and a half millennia.

c. 1460
Lucius Lactantius
De Divinis Institutionibus
Venice

In 1462, the city of Mainz was ransacked by troops of the Archbishop of Nassau. Printers — many of whom had come from other countries to learn the new technology—spread back out across Europe in search of safer havens for the practice of their craft.

In 1465, two German printers—Conrad Sweynheym, who had clerked for Schöffer in Mainz, and Arnold Pannartz—established a press at the Benedictine monastery in Subiaco, some 31 miles (50 km) east of Rome. After printing just four books, they moved their press to the Palazzo de' Massimi in Rome, where they worked until 1473. Just as Gutenberg cast his type to mimic the prevailing writing style in the north, Sweynheym and Pannartz cast their type to match the Italian calligraphic hand—humanist script.

In 1469, German Johannes da Spira set up the first press in Venice. His type, too, reflected humanist script, but it displayed a regularity of tone that far exceeded the work of Sweynheym and Pannartz. Da Spira died in 1470, and his press was taken over by Nicholas Jenson, a Frenchman who had gone to Mainz in 1458 to learn type-casting and printing and who is believed to have cast da Spira's original type. Whether he did or not, in his own work until his death in 1480 Jenson effectively codified the esthetics of type for those who followed.

murture angeli aut porellate celetti fed infi quia hominis & condicione mortali & cima gulteno functus fiullet tradereur imanusim pionim mortema; susaperer ut ea quoq: piur mtem domita refurgiret & bomin quent duerat quem o trebat a spem umcende mor offerret & ad premia imortalitans admit teret hanc ergo dispositi ne quis ignoret do cebimus predicta elle omnia que in xpo uide mus effe completa Nemo affeuerationi noffre fidem comoder nifi oftendero propbetas an re multam remporum seriem predicaste fore ut alion films da nafcereau fleut homo &m rabilia faceret & cultum dei protam terram Commarce & politemo patibulo figeretur & terna die refurgerer que omma cu probauero comm uplomm luteres qui dei fun mortali cor pore utentem molanerant-quid aluid obita bit quo minul sapientiam ueram clarumsie inbac fold religione nerfari Nunca primapio totuif Acramenti origo narranda est Maiores mi qui erant principes hebreorum cum fte relitate atq: mopia laboratent transferintin egypum in fiumentarie gracu ibiq diumif commorantes intollerabili ferminist inco pre mebanuir Tum miserius coru deus edivet cos ac liberanit demanii reois epypuorii post

These three pages (above and opposite, with details below), produced within around ten years of each other, demonstrate the transition from humanist script to roman type in Italy. Nicholas Jenson's accomplishment—in terms of both craft and form—is all the more vivid when compared to the contemporary work of Sweynheym and Pannartz.

Some early printing offices, by date 1461 Bamberg1462 Strasbourg1465 Subiaco1466 Cologne1468 Augsburg

1469 Venice

1470 Paris Toulouse 1473 Lyons Utrecht Ulm 1474 Valencia1475 Bruges1476 London1477 Delft

1472
Cardinal Johannes Bessarion
Adversus Calumniatorem Platonis
Conrad Sweynheim and
Arnold Pannartz,
Subiaco Press, Rome

1471 Quintilian Institutiones Oratoriae Nicholas Jenson Venice

231

ung traxent per aduerlarid Nunc etul argumenta aggredior: et quonta nephandi amorti erime in primit Platoni obutet: gbul id rationibul oltedere conetur: polt uidebimul. Nunc de amore aliquid disteramus. Equidem non if sum qui nemine ung incidise in amore illicicos ac per libidinem scelus cómisse existime. Nequ ent negari pocelt plurel ex omni natióe extitille:natura puerla & deprauacif moribufiqui non animol fed corpora mariu amare initar corú qui ut Plato inquit fructuí appetut. Quippe & apo/ stolus Paulus epistola qua ad romaos scribicieos nefadi amoris arguit. & Plato non fine causa idipsú & reprebendit & lege uetat, Sed illud animaduercendú est non omnem amorem uitiosum es ac turpé: sed quéadmodú pleraq: alsa có muns no mine appellata: duerfam babere rationem : & partim boneftum: partim turpem confituu: quod non modo ex bif que geneilefauctoref fenplere: sed etta ex sacri nostre religionis litteris ostendi potest. Gentiles enim amorem sine cupidinem: si cui ita nocare magis placet inn non apre boc omnibul locif dici potest: duplicem esse uoluerunt ne eadem usa eodem ue afflatu animof bominum incendere: fed alterum ut nimil pueriliter fentientem nulla ratione regi ac infi/ pienum folummodo animifinfidere: libidinif arq luxurie comire: impudencem: scelestum: ad id quod male appetit temere ruetem. Alterum bonestum: modestum: uerecundu: constantem: sanctus beatu: casticatif: continentieq custodem: benigne animis afflanté & amanté observantemq ur cutifitaq cum unu amorif sit nomé non easidem ex utrog produce actiones quemadmodum pudoris quoq & cócencionif eodem permanente nomine diuerie actióel für. Nempe bomini cultul profuit.nocuit q pudorif:ut Hefiodul inquit. Cocentionil item genul non limplex led duplex est. ut.nidem poeta inquit. Hec puersa nimisidigna est laudarier illa. Ad/ uerforq animof longe propellere tendunt. Quid igitur mirum fi benuoletia bonesta & fancta idem nomen babet: cum turpi fe/ dog affectu! Honestum boc genus amoris quem Plato celestem etiam:ac diuinú appellat.in litterif quoq facrif celebrari uidemus. quemadmodum Salomon specie quadam elegie facra cătica mo/ dulatuf est: que nuli quisq pro sua & scribécis untute tudicet: male de uro illo diumo sentiat necesse est. precto ita natura coparatú é ut q castitate ac moderatióe as mi pstatiquectiq: buius mói uer ba in melioré parté accipiat. quero ppriss sceleribus coingnatus

MARCI FABII QVINTILIANI LIBER TERTIVS INCIPIT FOELICITER.

DE Scriptonbus artis rhetorica.

VONIAM IN LIBRO SECVNDO QVAESITü eft quid esse vite qui desse vite qui desse vite qui se sui sarré quo que esse ce se consideration de la companio del la companio de la companio de la companio de la companio de la companio del la compa

exequar. Intra quem modum pleriqi feriptotes artiü colliteriti adeo ut Appollodotus cotentus folis iudicialibus fuetit. Net fum ignarus hoc ame pracipue; quod hic liber incobatopus fludiosos eius defideraffei ut iquifitione opinionti qua diuertifilma fueruntilonge difficillimă ita nefcio; an minime legentibus furus uoluptati; quippe quod prope mudam praceptorum traditionem defideret. În exteris eni admifere tempratuimus aliquid nitoris; non iactandi ingeni grata manqi in ideligi materia poterat uberior. Sed ut hoc ipfo alliceremus magis iuuo tutem ad cognitionem eose qua neoeffaria fludiis arbitrabamur: fi ducht iucunditate aliqua lectionis libentius diferente ca quoru ne ietuna atq arida tradirio auerteret animos & aures; præfertim tam delicatas raderecuerebamur. Qua ione fe Lucretius dicit pracepta philosophia carmine esse copientem en libentius diferente conanturprius oras pocula circum: Afpirant mellis dulci flauoqu'iquore. Et qua fequunf. Sed nos nunc ueremur: ne parum hic liber melliss & abfinchi imultum habere uideaturifit; gialubrior fludia gi dulcior quinetiam hoc timeo ne ex co minorem gratiam ineat: quod pleraq; non inuéta per me: sed ab aliis tradita continebit. habeat etiam quos quo non inuéta per me: sed ab aliis tradita continebit. habeat etiam quos qui printima tupa fua fentamen uias inuenerun ratq; in suam quos qui induxit sequentes. Illi atti probant qualecunqi ingressi funcisem audicos qui contar sentian frones mutaureris squi a mem on so didiciss manus quos qui requi atqui mutantibus. Na primus post eos quos poete tradidei emous quod inuensifet; servicone mone sua primus post eos quos poete tradidei remous fe aliqua circa rhector cen Empedocles dicitur. Artium autem scriptores atiquissimi Corax & Thystas situationes me a companio de la corgias Leontimus

of nefádi a dit & lege orem uitio od hic liber nionű:qua ne legentik

1590 Japan

1499 Colona Hypnerotomachia Poliphili type by Francesco Griffo

1515 Lucretius De Rerum Natura type by Francesco Griffo

tamente, quella alquato temperai. Et reflexi gli risonati sospiri. & cu adulatrice [perácia (O cibo amoro so degli amanti, & souente sate cú lachry-moso poto cóuncto) per altro morsicante sreno gyrai gli cócitati pésieri cú tanto pensiculato & fabricato piacere, mirando cú extremo dilecto in quel corpo gratissimo & geniale, in quel erose gene, in qual mébri nitidi & luculei folaciantisi. Per leq le singulare cose gli mei fremédi desireosor tantime benignaméte mitigai, dallerabiose ire datropo ardore redempti, & dal foco amorofo cufi ppinquo che dispositamete se accendeuano.

LA NYMPHA PER ALTRI BELLI LOCHI, LO AMO-ROSO POLIPHILO CONDVCE. OVE VIDE INNVME RE NYMPHE SOLENNIGIANTE ET CVM IL TRIVM-PHO DI VERTVNO ET DI POMONA DINTORNO VNA SACRA ARA ALACREMENTE FESTIGIANTI. DA POSCIA PER VENER ON AD VNO MIR A VEGLIO SO TEMPLO. ILOVALE ELLO IN PARTE DESCRI-VE, ET LARTE AEDIFICATORIA. ET COME NEL DI-CTO TEMPLO, PER ADMONITO DELLA ANTISTITE, LA NYMPHA CVM MOLTA CERIMONIA LA SVA FACOLA EXTINSE, MANIFESTANTISE ESSER E L'A SVA POLIA A POLIPHILO, ET POSCIA CVM LA SA-CRIFICABONDA ANTISTETE, NEL SANCTO SACEL LO INTRATA, DINANTI LA DIVINA ARA INVOCO LE TRE GRATIE.

PONTRASTARE GIA NON VALEVA IO allecaleste & uiolentearmature, & dicio hauendo la ele-gantissima Nymphaamorofaméteadepto, de me misel lo amante irreuocabile dominio, Seco piu oltra (imitan teio gli moderati uestigii) abactrice pare allei uerso ad uno spatioso littore mecoduceua, Ilquale era cotermine della florigera & collinea coualle, Oue terminavano a questo littore le or nate montagniole, & uitiferi colli, cum præclusi aditi, questa aurea patria, iena di incredibile oblectamento circumelaustrando. Legnale erano di piena di increatorie obiectamento circumetaturanto, requaretamente filuofi nemori di cofipicua denfitate, quanto fi fufferon flati gli arbufeuli ordinatamtéte locatiamente, Qualeil Taxo cyrneo, & lo Arcado, Il pina ftro infructuo fo & refinaceo, alti Pini, driti Abieti negligenti al pandare, & contumaci al pondo, Arfibile Picce, il fungo fo Larice, Tedeaerce, & gli colli amanti, Celebrati & cultiuati da festigiante oreade, Quiui ambidui

T.VFR.

o bruerent terras:nisi inædificata superne M ulta forent multis exemptonubila sole. N ec tanto possent terras opprimere imbri: F lumina abundare ut facerent: camposq; natare; S inon extructis foret alte nubibus æther. H is igitur uentis, atq; ignibus omnia plena s unt:ideo paffim fremitus, o fulgura fiunt. Quippe etenim supra docui permulta uaporis s emina habere auas nubers: & multa necesse est C onapere ex folts radis, ardoreq; eorum. H oc, ubi uentus eas idem qui cogit in unum F orte locum quemuis, expressit multa naporis S emina: seq; simul cum eo commiscuit i gni: I nsinuatus ibi uortex uersaturin alto: E t calides acuit fulmen fornacibus intus. N am dupliciratione accenditur: ipfe sua cum M obilitate calefat: er è contaqubus ignis. I nde ubi perceluit uis uenti: uel graus ignis I mpetus incessit:maturum tum quasi fulmen P erfandit subito nubem: fertura; corusais o mnia luminibus lustrans loca percitus ardor. Quem graus insequitur sonicus: desplosarepente O pprimere ut cœli uideantur templa superne. I nde tremor terras grauiter pertentat: @ altum M urmura percurrunt coelum nam tota fere tum T empestas concussa eremit: fremitusq; mouentur. Quo de concussus fequitur grans imber, or uber: O mnis uti uideatur in imbrem uertier æther: A touta praapitans ad diluniem renocare: T antus diffidio nubis uentiq; procella,

Venetian publisher Aldus Manutius (1450-1515) was the first of the great European printer-scholars, his books valued for their accuracy and scholarship. Their beauty owed much to Francesco Griffo da Bologna, a type-caster working for Manutius. By making the uppercase letters shorter than the ascenders in the lower case, Griffo was able to create a more even texture on the page than Jenson had achieved.

Manutius's achievements include the first pocket-sized books, whose low cost and easy portability helped foster the spread of knowledge among Renaissance scholars. In 1501, editions of Virgil and Juvenal featured Griffo's first italic typeface, based on the chancery script favored by Italian papal scribes. The immediate value of the italic was its narrower letterforms, which allowed for more words on a page, thereby reducing paper costs. Griffo's italics were produced only in lower case.

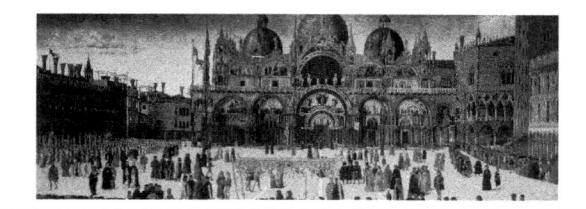

Gentile Bellini
Procession of the Reliquary of the
Cross in Piazza San Marco (detail)
1496
Galleria dell'Accademia, Venice

ABCDEFGHIJKLMN OPQRSTUVWXYZ 1234567890

ABCDEFGHIJKLMN OPQRSTUVWXYZ abcdefghijklmn opqrstuvwxyz 1234567890

ABCDEFGHIJKLM
NOPQRSTUVWXYZ
1234567890
abcdefghijklmn
opqrstuvwxyz
1234567890

Bembo (shown here) is based on type cut by Francesco Griffo in 1495 for an edition of *De Aetna* by Pietro Bembo. This revival of Griffo's typeface was first produced by the Monotype Corporation in 1929, under the direction of Stanley Morison. The italic is based not on Griffo's type, but on the calligraphy of early 16th-century scribes Ludovico degli Arrighi and Giovantonio Tagliente.

The Golden Age of French printing

1531
Terentiani Mauri Niliacae Syenes
Praesidis
Printed by Simon de Colines
Paris
Type-cast by Claude Garamond

The earliest printers in France brought with them the blackletter they had learned to cast in Mainz. By 1525, however, a group of French printers—among them Henri and Robert Estiennes, Simon de Colines, Geofroy Tory, and Jean de Tournes—had made the Venetian model their own, mirroring contemporary French interest in Italian Renaissance culture.

Of particular importance to the history of type is Parisian Claude Garamond (1480–1561), the first independent typefounder. Beyond establishing type-casting as a profession distinct from printing, Garamond created letterforms more expressive of the steel in which he worked than of the strokes made by a calligrapher's pen. A comparison of a Venetian 'a' (Monotype Dante, below left) with Garamond's (Adobe Garamond, below right) clearly demonstrates the difference:

a a

Around 1540, Garamond and his collaborator Robert Granjon developed the first italic forms that were intended for use with roman forms, including an italic upper case. Granjon's work in italic continued until 1577, when he designed a typeface called Civilité that reverted back to the elaborate French *batarde* handwriting of the day. Although it did not supplant italic, it did spur a line of script typefaces that continues to the present day.

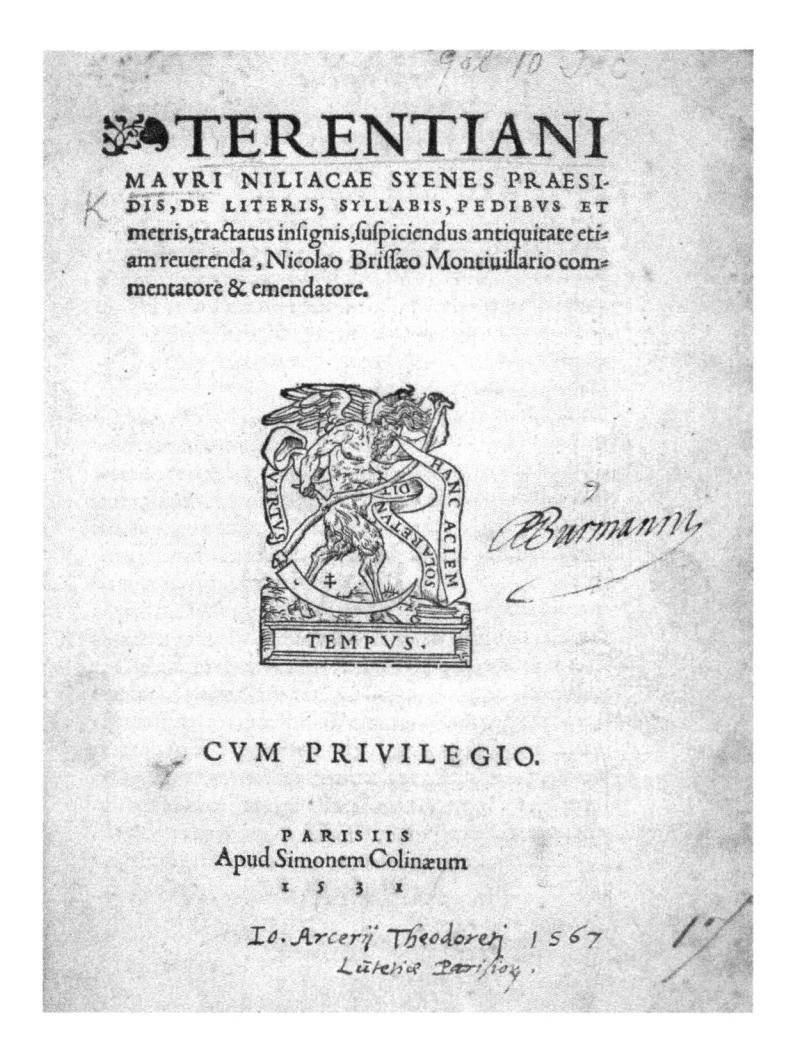

26
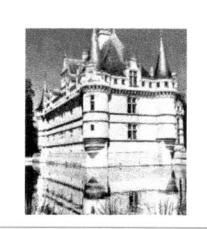

Château Azay-le-Rideau France 1518-1527

ABCDEFGHIJKLMN OPQRSTUVWXYZ 1234567890

ABCDEFGHIJKLMN OPQRSTUVWXYZ abcdefghijklmn opqrstuvwxyz 1234567890

ABCDEFGHIJKLMN
OPQRSTUVWXYZ
1234567890
abcdefghijklmn
opqrstuvwxyz
1234567890

For years, most typefaces called Garamond were derived from cuttings produced in 1615 by Jean Jannon, based on Garamond's work. Robert Slimbach produced Adobe Garamond (shown here) in 1989, working directly from specimens of Garamond's roman and Granjon's italic.

The spread of printing in the 17th century

1602 Philippines 1610 Lebanon Bolivia 1639 America

1640 Iran

1642 Finland 1643 Norway 1644 China

Dutch printing c. 1600

1572 Polyglot Bible (Preface) Printed by Christophe Plantin Antwerp

By the end of the 16th century, Dutch publishing houses, particularly the Plantin-Moretus and Elzevir family enterprises, were among the most successful in Europe. At first, these publishers and printers bought much of their type from French foundries. By the 17th century, however, they were buying from typefounders closer at hand.

Dutch type was widely recognized not so much for its intrinsic beauty as for its clarity and sturdiness. Compare, for example, (French) Adobe Garamond (left) and (Dutch) Linotype Janson (right):

Virtually all English type of the period was purchased in Holland. The Oxford University Press, founded in 1667, purchased its first type from Christoffel van Dijck of Amsterdam. In 1672, Bishop John Fell brought over punches and matrices cut by Dirk and Bartholomew Voskens for the press.

REGNI NEAPOLITANI PRIVILEGIVM.

PHILIPPUS DEI GRATIA REX CASTELLÆ, ARAGONVM, VTRIVSQYE SICILIA, HIBRYSALEM, VNGARIA, DALMATIA, ET CROATIA, &c.

NTONIVS Perrenotus, S.R.C. Tit. Sancti Petri ad Vincula Presbyter, Cardinalis de Granuela, prefatæ Regiæ & Catholicæ Maiestatis à confiliis starus, & in hoc Regno locum tenens, & Capitaneus generalis, &c. Mageo viro Christophoro Plantino, ciui Antuerpiensi, & præfatæ Catholicæ Maiestatis Prototypographo sideli Regio, dilecto, gratiam Regiam & bonam voluntatem. Cum ex præ-

clarorum virorum literis certiores facti simus, opus Bibliorum quinque linguarum, cum tribus Apparatuum tomis, celeberrimum, reique publice Christiana vtilissimu, eiusdem serenissimæ Maiestatis iussu, ope atque auspiciis, ad publicam totius Christiani orbis commoditatem & ornamentum, typis longè elegantissimis, & præstantissimi viri Benedicti Ariæ Montani præctpua cura & studio . quam emendatissimè à te excusum esse, eiusdemq; exemplar sanctissimo Domino nostro PP. Gregorio xivi. oblatum, ita placuisse, vt præfatæ Maiestatis sanctos conatus, & Regi Catholico in primis conuenientes, summopere laudarit, & amplissima tibi priuilegia ad hoc opus tuendum Motu proprio concesserit; Nos quoque cum naturali genio impellimurad fouendum przelara quzque ingenia, quz infigni quopiam conatu ad publica commoda promouenda arque augenda aspirant, primum quidem longè præclarissimum. hoc suz Maiestatis studium, yt vere Heroicum & Prolomes, Eumenis, aliorumque olim conatibusin Bibliothecis instruendis eò præstantus, quòd non vanz stimulo gloriæ, vt illi, sed rechæ Religionis conservandæ & propagandæ zelo susceptum, meritò suspicientes; deinde eximiam operam doctissimi B. Ariæ Montani, ac immortali laude dignam admirantes, rebusque tuis, quemadmodú tuo nomine expetitur, prospicere cupientes, ne meritis frauderis fructibus tanta opera, & impensa, qua summa folicitudine & industria in opus ad finem feliciter perducendum à teetiam insumpta esseaccepimus; cumque certo constet, opus hoc nunquam hactenus hoc in Regno excusum esse, dignumque ipso S. sedis Apostolicæ suffragio sit iudicatum vt diuulgetur ac privilegiis ornetur. Tuis igitur iustissimis votis, vt deliberato consilio, ita alacri & exporrecta fronte lubenter annuentes, tenore præsentium ex graria speciali, præsatæ Maiestatis nomine, cum deliberatione & assistentia Regij collateralis consilijistatuimus & decreuimus, ne quis intra viginti annos proximos, a die dat præfentium deinceps numerandos, in hoc Regno dictum Bibliorum opus, cum Apparatuum tomis coniunctis, vel Apparatus ipsos, aut eoru partem aliquam seorsum, citra ipsius Christophori, aut causam & iusab ipso habentis, licentiam imprimere, autab aliis impressa vendere, aur in suis officinis vel aliàs tenere possit. Volentes & decernêtes expresse,

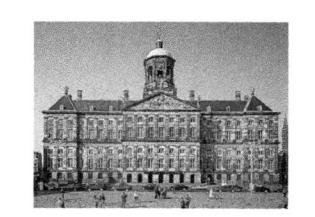

Jacob van Campen Royal Palace (formerly Amsterdam Town Hall) Dam Square 1647-1655

ABCDEFGHIJKLM NOPQRSTUVWXYZ 1234567890

ABCDEFGHIJKLMN
OPQRSTUVWXYZ
abcdefghijklmn
opqrstuvwxyz
1234567890

ABCDEFGHIJKLM NOPQRSTUVWXYZ 1234567890 abcdefghijklmn opqrstuvwxyz 1234567890 Although Janson was named for Dutch punch-cutter Anton Janson, we now know that it was cut by Hungarian Nicholas Kis in 1690. This version from Linotype is based on Stempel Foundry castings made in 1919 from Kis's original matrices.

1734 William Caslon Type specimen sheet London

SPECIME

By W. CASLON, Letter-Founder, in Ironmonger-Row, Old-Street, LONDON.

ABCDEFGHIJK ABCDEFGHIJKL ABCDEFGHIKLMN

Quoulque tanabutere, Catilina, pati-

abuttere Catilina At nos vigitimum i jan dien patimut bebefere selem horum

Double Pica Roman.

GREAT PRIMER ROMAN.

Quousque tandem abutère, Catilina, patientia nostra? quamdiu nos etiam futentia nostra? quamdiu nos etiam futentia nostra? quem ad finem e- ror iste tuus eludet? quem ad pieme fe- ror iste tuus eludet? quem ad pieme fe- ror iste tuus eludet quem ad finem fel est establication. nocturnum præfidium palatii, nihil ur-bis vigiliæ, nihil timor populi, nihil con-ABCDEFGHIJKLMNOPQRS

ENGLISH ROMAN. Quoufque ENGLIS ROSME, Quoufque tandem abutre, Catilina, patientia noftra' quamdiu nos etiam fuuro ille tuus eludet; quem ad finem fele efficanta jofabit sudacia? nihilne te nocumum prefidium palatii, nihil utbis vigilia, nihil timor populi, nihil confen-fus bosocum omnium, nihil hic munitdifimus ABCDEFGHIJKLMNOPQRSTYUW

PICA ROMAN. Catilina, pati
Quoufque tandem

Plea Roman.

Melium, novis rebus Modentene, manu fias occidit.

Melium, no

Double Pica Italick.

Quousque tandem abutere, Cati- Quousque tandem abutere, Catililina, patientia nostra? quamdiu na, patientia nostra? quamdiu nos etiam furor iste tuus eludet? nos etiam furor iste tuus eludet? quem ad finem sese effrenata jacquem ad finem sese effrenata jac-ABCDEFGHJIKLMNOP ABCDEFGHJIKLMNO

nocturnum præfidium palatii, nibil ur-bis vigiliæ, nibil timor populi, nibil con-ABCDEFGHIJKLMNOPQR

Rysulpue tandem angiere, Carlina, patientia nof-tral quamdin us ctiam furor ife tuus eludell quem ad finem spie diferenta justobie audacial rabibne te nathraum profilim palati, ubil-nible te nathraum profili, natil conferio lo-marum omnium, nitul bie munisfimus laboral ABCDEFGHIJKLMNOPQRSTVU

Pica Italick. Pita Italick.
Melium, woti rebus flueduetes, manu fua-ocidit.
Puis, fui ifia quandem in bas repub, virtis, a tris
fute activitus (pipplicii icomo princission, quam acritifiumus befun coircevet. Habemus cins fenatelcapillum in te, ceditina, vobennes, et grave: moti confillum in, coccidina, vobennes, et grave: moti die aperie, englied definum. Decrevit quandum fusi ABCDE FG HIGKLEND P. QRSTPUWXTZ

Benglith Arabick. No t. Englith Arabick. At mys ydeglinum jam diem patimum rhehjere aciem berum مدورة و ولا خليل كل منا الله الك الكرائية
And be it further enabled by the Authority aforeast, That all and every of the fail Ex-chequer Isilis to be made forth by birtue of this Aid. of many of them as thall from A TO C.D. Of Sid I R. O. 1921 BO R.

Brevier Black

ATTA nisak yn în himinam yeihiai nama yein ciimai yinainassis yeins yaikyai yiaga yeins sye în himina

-ил жен эфт бель фф нхраго неф ACTO OR POOP TANGLED OR OE OF OF OF OR δονο πλουφ μέσε κχράν εκές τροστάς -o - temmu uskis konubru tota yuuro

المحمر المادة الأمادة المادة
ለድመረያ መቀመነመ meinemel asiq ለድመረያ መቀመነመ መዋያመ መመመ ተጋርናል መጀመር የድሞ መያመ መመመ መመመመ የደረ ይላዶሙ እንደመደ የድሞ መያש ይመያመድ አረ ጋረ

English Arabick.

William Caslon (1692-1766) was the first notable English type designer. He introduced his sturdy, albeit idiosyncratic, typeface in 1734. It gained widespread acceptance almost immediately and, except between 1800 and 1850, has been a standard ever since. The influence of Dutch models is clear if you compare Janson (left) with Caslon (right):

Caslon's type was distributed throughout England's American colonies, and was the typeface used in the first printed copies of the U.S. Declaration of Independence and Constitution. Through his sons, the foundry was to continue well into the second half of the 19th century.

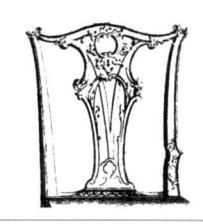

Thomas Chippendale Chair back (detail) from *The Gentleman and Cabinet-Maker's Director* London

ABCDEFGHIJKLM NOPQRSTUVWXYZ 1234567890

ABCDEFGHIJKLMN OPQRSTUVWXYZ abcdefghijklmn opqrstuvwxyz 1234567890

ABCDEFGHIJKLMN
OPQRSTUVWXYZ
1234567890
abcdefghijklmn
opqrstuvwxyz
1234567890

Adobe Caslon, introduced in 1990, was designed by Carol Twombly from Caslon specimen sheets of 1738 and 1786.

1761
William Congreve
The Works of William Congreve
typeset and printed by John Baskerville
Birmingham

At the turn of the 18th century, Philippe Grandjean was almost a decade into production of a *romain du roi* for Louis XIV's royal press—a project that would carry on 30 years past his death in 1714. Characterized by thin, unbracketed serifs, extreme contrast between thick and thin strokes, and a perpendicular stress, the typeface marked a clear departure from the types of Griffo and Garamond, and met with immediate acclaim. However, as the personal property of the king, it could not be used by commercial printers.

Enterprising typefounders in France began copying Grandjean's work almost immediately, but the most successful application of his ideas came from John Baskerville (1706–1775), a self-taught type-founder, papermaker, and printer in Birmingham. Baskerville's type featured pronounced contrast between thick and thin strokes and a clear vertical stress. Compare Bembo (left) and Baskerville (right):

To maintain the delicacy of his type on the page, Baskerville had to develop several ancillary technologies. To prevent his shiny ink from spreading beyond the actual imprint of the page, he crafted his own very smooth paper (now called a 'wove' finish; earlier, ribbed sheets are called 'laid'). He also pressed his sheets between heated copper plates after printing to hasten drying.

The Life of CONGREVE. xix natural, that, if we were not apprifed of it, we should never have suspected they were Translations. But there is one Piece of his which ought to be particularly distinguished, as being so truly an Original, that though it seems to be written with the utmost Facility, yet we may despair of ever seeing it copied: This is his Doris, so highly and so justly commended by Sir Richard Steele, as the sharpest and most delicate Satire he had ever met with.

His two Pieces of the Dramatic Kind, do him equal Honor as a Poet and as a Lover of Music, viz. The Judgment of Paris, a Masque, and The Opera of Semele. Of these, the former was acted with great Applause, and the latter finely set to Music by Mr. Eccles. In Respect to both, it is but Justice to say, that they have the same Stamp of Excellency with the Rest of his Writings, were considered as Master-pieces when published, and may serve as Models to Posterity.

His Essay upon Humor in English Comedy, is, without Doubt, as instructive, as entertaining,

George Hepplewhite Window stool from *The Cabinet-Maker and Upholsterer's Guide* London 1790

ABCDEFGHIJKLMN OPQRSTUVWXYZ 1234567890

ABCDEFGHIJKLMN
OPQRSTUVWXYZ
abcdefghijklmn
opqrstuvwxyz
1234567890

ABCDEFGHIJKLMN
OPQRSTUVWXYZ
1234567890
abcdefghijklmn
opqrstuvwxyz
1234567890

Monotype Baskerville was produced in 1929 under Stanley Morison's direction.

1818 Giambattista Bodoni *Manuale Tipografico* Parma (published posthumously)

Baskerville's innovations exerted a notable influence on European typefounders, particularly the Didot and Fournier families in France and Giambattista Bodoni (1740–1813) in Italy.

Serving as the subsidized private printer to the Duke of Parma, Bodoni produced over 100 type-faces. His early typefaces retain some elements we associate with Baskerville, primarily in the gentle slope of the upper serifs of the 'i,' 'j,' and 'l.' Firmin Didot, by contrast, produced type with unbracketed, purely horizontal serifs. Compare Bauer Bodoni (left) and Linotype Didot (right):

 $egin{cases} \dot{1} & \dot{1} \\ 1 & 1 \end{bmatrix}$

Bodoni carried forward the technological advances begun by Baskerville, improving both ink and paper surface to show off his delicate type to best advantage. I

GIAMBATTISTA BODONI

A CHI LEGGE.

Eccovi i saggi dell'industria e delle fatiche mie di molti anni consecrati con veramente geniale impegno ad un'arte, che è compimento della più bella, ingegnosa, e giovevole invenzione degli uomini, voglio dire dello scrivere, di cui è la stampa la miglior maniera, ogni qual volta sia pregio dell'opera far a molti copia delle stesse parole, e maggiormente quando importi aver certezza che

Alexandre-Pierre Vignon Church of Mary Magdalene ('La Madeleine') Paris 1807–1842

ABCDEFGHIJKLMN OPQRSTUVWXYZ 1234567890

ABCDEFGHIJKLMN
OPQRSTUVWXYZ
abcdefghijklmn
opqrstuvwxyz
1234567890

ABCDEFGHIJKLMN
OPQRSTUVWXYZ
1234567890
abcdefghijklmn
opqrstuvwxyz
1234567890

Bauer Bodoni, produced by Louis Höll of the Bauer type foundry in 1926, is based on Bodoni's cuts of 1789. It shows clearly the differences between what Bodoni actually produced and what people often think of as 'Bodoni'.

ABC

W CASLON JUNR

Boldface

The Industrial Revolution of the early 19th century, triggered by the invention of the steam engine, changed printing, typesetting, and type-casting from the product of the human hand to the product of power-driven machinery. The sheer speed of mechanized presses meant that thousands of copies could be printed in the time it formerly took to print dozens. The sudden, wide dissemination of printed matter contributed to the rise of literacy as dramatically as the invention of printing itself had three and a half centuries earlier. It also created a new market of consumers for manufacturers. Products (and services. for that matter) could be advertised to broad masses at relatively low cost. Printers began to distinguish between book printing and jobbing, or commercial printing. This new printing required a new esthetic.

Typefaces from the previous centuries, designed for text settings, seemed inadequate for the new medium of advertising. Bigger, bolder, louder type was required to make messages stand out in the otherwise gray printed environment. One of the first typefounders to experiment with a 'fat face' was Robert Thorne who, in 1803, cast the face that would bear his name (above left). Hundreds of boldfaces followed.

For several decades, boldfaces existed in a class distinct from text type. However, by the time typefaces from the 16th, 17th, and 18th centuries were revived in the early 20th century, typefounders (notably Morris Benton of American Type Founders) were so accustomed to working with boldface that they chose to retrofit bold forms into each typeface 'family', along with existing italics, small caps, etc.

Sans serif

One variation of the boldface idea involved losing serifs altogether. First introduced by William Caslon IV in 1816 (above right), sans serif type, featuring no change in stroke weight, was reserved almost exclusively for headlines, although there are occasional examples of sans serif captions.

Caslon named his type 'Egyptian,' probably because the art and architecture of ancient Egypt had colored European imagination since Napoleon's campaign and the discovery of the Rosetta stone in 1799. But the label didn't stick. Opponents of the form quickly called it 'grotesque,' others termed it 'gothic' (a style that was also enjoying a revival in the early 19th century). English typefounder Vincent Figgins was the first to call it 'sans syrruph,' in 1832.

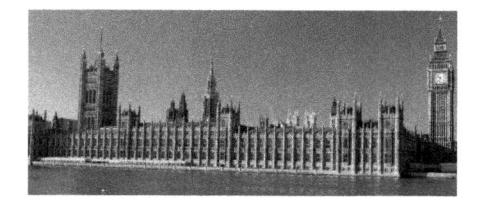

Charles Barry and A.W.N. Pugin Houses of Parliament London 1840–1860

1831 Poster

Display faces

Since medieval copyists had illuminated initial letters in manuscripts, typographers had often produced oversized, intricately detailed letterforms to provide color and contrast on the text page. In the 19th century, at the same time as the development of boldface and for much the same reason, typefounders began casting entire typefaces - upper- and lowercase - decorated (illuminated) to suggest various architectural and natural motifs. Typically, these typefaces were intended for use as headlines or display material; hence, the term 'display face.' In most cases the vogue for any particular display face lasted only as long as the trend in fashion it mimicked.

The subsequent evolution of type technology (first phototypesetting, then digital rendering), combined with the desire of some designers to introduce novelty for its own sake, has given rise to the use of these display faces (and their 20th-century offspring) in all kinds of settings, from 100-pt. display material in advertising to 7-pt, phone numbers on business cards. As it happens, we all know our alphabet well enough that we can usually read the letters and numbers in display faces despite the tortuous machinations they have endured.

1817 Vincent Figgins Specimens of Printing Types London

Two Lines Great Primer, in Shade.

ABCDEFGHIJKLMNO PORSTUVWXYZ&33.°

Two Lines Brevier, in Shade.

ABCDEFGHIJKIMNOPORSTUVWXYZ&,38%

Two Lines Nonpareil, in Shade.

ABCDERCHIJKLNINOPORSTUVWXYZƌ&»33°-,

FOUR LINES PICA, ANTIQUE.

MANKIND

Two Lines Small Pica, Antique.

ABCDEFGHIJKLMNOPQRSTUVW

v. FIGGINS.

A fourth 19th-century development in typography—the square serif—first appeared in England in 1817. Just as William Caslon IV was eliminating serifs altogether, other typefounders were fattening them up to have the same weight as the strokes of the letterform itself. First called 'Antique' by Vincent Figgins (above), the type eventually became known as 'Egyptian,' perhaps because its strong serifs mirrored the base and capital of an Egyptian column.

Although some 19th-century square serifs (such as Clarendon) drew upon traditional letterforms (and, like Clarendon, had bracketed serifs), many 20th-century typefaces referred to geometric models.

The mechanization of printing, and the allied rise of advertising, contributed to a general degradation of both the printer's and the typographer's craft. By the end of the 19th century, however, movements were afoot in both the U.S. and the UK to revive the handicraft and the care of previous centuries' printing. Central to this revival was William Morris's Kelmscott Press, founded in 1891.

Front of Crystal Palace Hyde Park, London from *The Illustrated London News* May, 1851

ABCDEFGHIJKLM NOPQRSTUVWXYZ 1234567890 abcdefghijklmn opgrstuvwxyz

ABCDEFGHIJKLMN OPQRSTUVWXYZ 1234567890 abcdefghijklmn opqrstuvwxyz

Adrian Frutiger designed Glypha for Linotype in 1977. Compare Frutiger's forms with earlier, more geometric slab serifs like Memphis (below), designed by Rudolf Wolf for the Stempel foundry in 1929.

ABCDEFGHIJ KLMNOPQRST UVWXYZ 1234567890 abcdefghijkl mnopqrstuvw xyz

1923 (top) Prospectus for the Bauhaus László Moholy-Nagy

1959 (bottom) New Graphic Design Josef Müller-Brockmann, Richard Lohse, Hans Neuberg and Carlo Vivarelli, eds.

The movement to revive older type models, led by T. J. Cobden-Sanderson, Stanley Morison, and Beatrice Warde in the UK and Daniel Berkeley Updike, Frederick W. Goudy, W. A. Dwiggins, and Bruce Rogers in the U.S., flourished in the early 20th century. Their scholarly work showed typography, for the first time, to be a subject worthy of study even as they demonstrated the value of earlier forms.

At the same time, the astonishing and often bewildering technological developments of the new century, combined with widespread social upheaval in Europe and America, caused many to seek new forms of graphic expression. Sans serif typeuntil then reserved for headlines and captions - was seen by many as most appropriate for asymmetric page composition that broke with traditional models. It is worth noting that the idea of graphic design as a profession distinct from printing, type-casting, or 'fine' art, began at the same time.

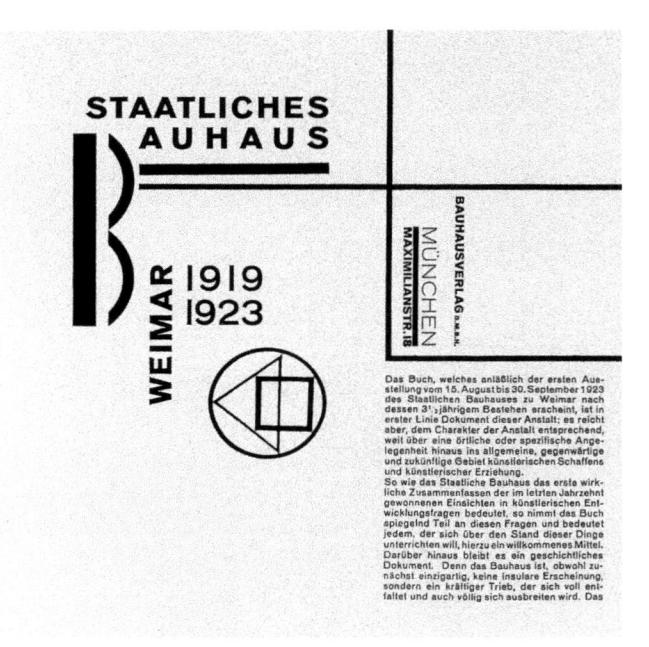

Neue Grafik New Graphic Design Graphisme actuel

International Review of graphic design and related subjects Issued in German, English and French Pervision an langue after continues at financial and continues at financial and continues at financial and continues at fin

Druck Verlag Printing Publishing Imprimeria Edition

Verlag Otto Walter A.G. Olten Schweiz Switzerland Suisse

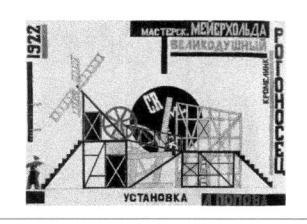

Lyubov Popova set design of Fernand Crommelynk, *Le Cocu magnifique* State Institute of Theatrical Art Moscow

ABCDEFGHIJKLMN OPQRSTUVWXYZ 1234567890 abcdefghijklmn opqrstuvwxyz

1234567890

ABCDEFGHIJKLM NOPQRSTUVWXYZ 1234567890 abcdefghijklmn opgrstuvwxyz

The first widely used sans serif typeface, Akzidenz Grotesk was developed by the Berthold type foundry in 1896. ('Akzidenz' is German for the 'schrift' or type used by commercial—as opposed to book—printers, and 'grotesk' is the German word for sans serif. In the U.S., the typeface was known simply as Standard.) The light weight includes a set of lowercase numerals (shown in red) designed by Erik Spiekermann in 1990.

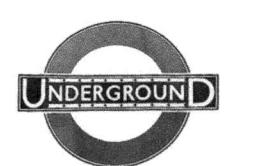

Edward Johnston London Underground logo London 1916

ABCDEFGHIJKLMN OPQRSTUV WX YZ 1234567890

abcdefghijklmn opqrstuvwxyz

ABCDEFGHIJKLMN
OPQRSTUVWXYZ
1234567890
abcdef ghijklmn
opqrstuvwxyz

Designed by Eric Gill in 1928, Gill Sans is based on the typeface his teacher, Edward Johnston, created in 1916 for the signage of the London Underground. Gill also designed several serif typefaces (Perpetua, Joanna, Aries) which share many of the proportions and characteristic counters of Gill Sans. Although strictly contemporary in effect, Gill's type, like Johnston's before him, owes much to the proportions and forms of the Renaissance letter.

Pierre Jeanneret (Le Corbusier) Villa Savoie Poissy, France 1928–1929

ABCDEFGHIJKLMN OPQRSTUVWXYZ 1234567890 abcdefghijklmn opqrstuvwxyz

ABCDEFGHIJKLMN OPQRSTUVWXYZ 1234567890 abcdefghijklmn opqrstuvwxyz

Designed by Paul Renner in 1927, Futura is the first geometric sans serif typeface designed for text applications. Although Futura seems to use basic geometric proportions, it is in fact a complex combination of stressed strokes and complex curves, with stronger connections to preceding serif forms than its spare effect would at first suggest.

Renner designed a number of lowercase forms and numerals for Futura (shown in red), which the Bauer foundry abandoned, but which were revived by The Foundry (London) as Architype Renner in 1994.

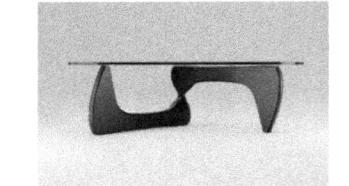

Univers **Univers** Univers Univers 73 83 53 63 Univers Univers Univers Univers 54 64 74 84 Univers Univers Univers Univers Univers 55 45 65 75 25 Univers **Univers** Univers Univers Univers 46 76 86 56 66 Univers Univers Univers 47 57 67 Univers Univers Univers 48 58 68 Univers Univers 59 49

By mid-century, phototypesetting had replaced metal type for most commercial work, further freeing both typesetting and layouts from the technical restrictions of older traditions. Phototypesetting had its own drawbacks, however, which were finally resolved with the introduction of desktop publishing in the 1980s.

Univers

39

Although Adrian Frutiger is well respected for a number of widely used typefaces, his masterwork is Univers, released in 1957 by the Deberny & Peignot foundry in Paris for both metal and phototype. In an effort to eliminate the growing confusion in typeface terminology (thin/light, regular/medium, bold/black) Frutiger used numbers rather than names to describe the palette of weights and widths in Univers. (Opposite: Univers 55)

In any two-digit descriptor, the first number designates line weight (3- is the thinnest, 8- the heaviest) and the second designates character width (-3 is the most extended, -9 the most condensed). Even numbers indicate italic, odd numbers roman. Frutiger has subsequently used this system on other typefaces he has designed (Serifa, Glypha, Frutiger, Avenir, etc.), and other type manufacturers have adapted his system for some of their typefaces (Helvetica Neue, etc.).

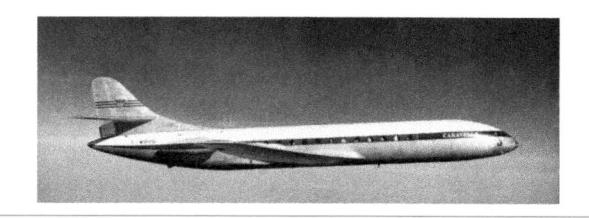

The 'Caravelle'
French jet transport plane
1956

ABCDEFGHIJKLMN OPQRSTUVWXYZ 1234567890 abcdefghijklmn opgrstuvwxyz

ABCDEFGHIJKLMN OPQRSTUVWXYZ 1234567890 abcdefghijklmn opqrstuvwxyz

Digital type

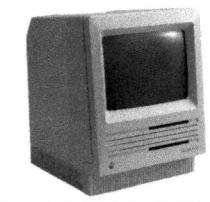

As the personal computing industry blossomed in the 1980s, so too did the concept of desktop publishing, whereby a designer had at his or her fingertips all the tools necessary to design, typeset, and illustrate a project, without having to resort to outside vendors. In many ways, the work method was a return to medieval scriptoriums. Bitstream, Inc. began offering digital typefaces in 1981; Adobe Systems, Inc. followed shortly thereafter. By 1990, virtually every type foundry in the world offered digital versions of their typefaces, and numerous type shops had opened up offering exclusively digital fonts. By 2000, 500-year-old methods of producing type had been relegated to the province of purists and hobbyists. An entire professional class-the typesetter-was extinct.

However, thanks to the early contributions and high standards of type designers Matthew Carter, Sumner Stone, and many others, this change in production did not necessarily mean a lessening of quality. The field of type design has continued to thrive, coupled with welcome advances in digital technology. Designers have never before had so much type—and so much good type—at their disposal.

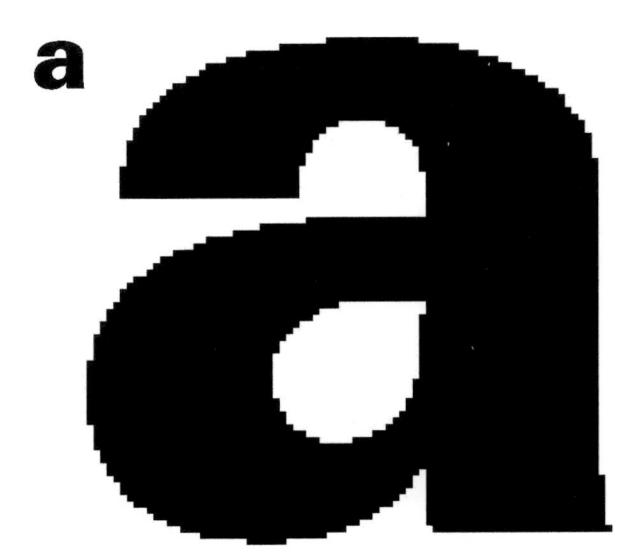

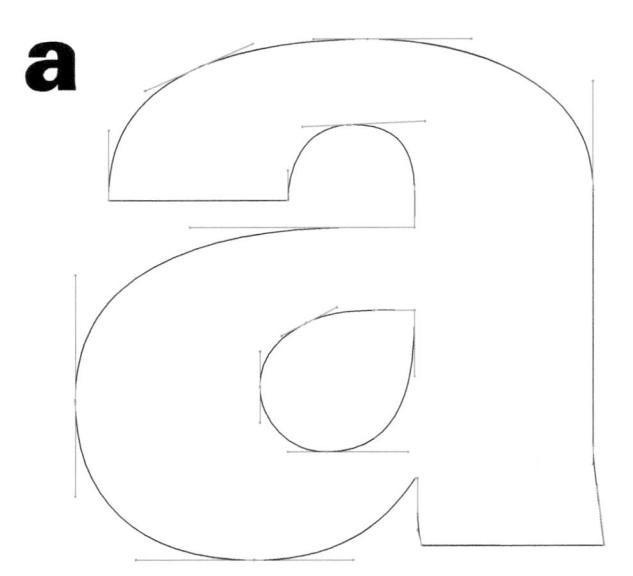

Top: 36 pt. Univers 75 bitmapped for screen presentation

Bottom: 36 pt. Univers 75 vectored for printing

46

An expanded type 'family'

In the last two decades, some typographers—notably Otl Aicher, Martin Majoor, Erik Spiekermann, and Sumner Stone—have developed families of typefaces that not only include a range of color (light/regular/bold/black), but also incorporate serif and sans serif versions. Shown here are samples from Aicher's Rotis family, drawn in 1989.

Rotis

Light

Rotis

Light

SemiSans

Sans Serif

Rotis

Rotis

SemiSans

Light Italic

Sans Serif

Light Italic

Regular Regular Regular Regular

Rotis

Rotis

Serif

Regular Italic Bold **Rotis** Rotis SemiSerif SemiSerif Regular Bold Rotis Rotis Rotis Rotis SemiSans SemiSans SemiSans SemiSans Italic Bold Regular Extra Bold Rotis Rotis Rotis Rotis Sans Serif Sans Serif Sans Serif Sans Serif Regular Italic Bold Extra Bold

Rotis

Serif

Rotis

Serif

47

Text typeface classification

Dates of origin approximated to the nearest quarter century

As you have seen, type forms have developed in response to prevailing technology, commercial needs, and esthetic trends. Certain models have endured well past the cultures that spawned them. Recognizing the need to identify the stages of typeform development, typographers have come up with a number of systems to classify typefaces, some of them dizzying in their specificity.

The classification here, based on one devised by Alexander Lawson, covers only the main forms of text type. Decorative styles have been omitted, and sans serif forms have been grouped together without differentiation between humanist and geometric forms.

This system offers a useful, if simplified, description of the kinds of type you will most often encounter working with text. As your experience with type develops, you should definitely familiarize yourself with other, more specific, systems. Keep in mind that the best system is the one that most helps you recognize kinds of typefaces and their historical origins.

1450

Blackletter

The earliest printing types, these forms were based upon the hand-copying styles then used for books in northern Europe.

Examples:

Cloister Black Goudy Text

1475

Oldstyle

Based upon the lowercase forms used by Italian humanist scholars for book copying (themselves based upon the 9th-century Caroline minuscule) and the uppercase letterforms found inscribed on Roman ruins. The forms evolved away from their calligraphic origins over 200 years as they migrated across Europe, from Italy to England.

Examples:

Bembo Caslon Dante Garamond Janson Jenson Palatino

1500

Italic

Echoing contemporary Italian handwriting, the first italics were condensed and close-set, allowing more words per page. Although originally considered their own class of type, italics were soon cast to complement roman forms. Since the 16th century, virtually all text typefaces have been designed with accompanying italic (or oblique) forms.

Script

Originally an attempt to replicate engraved calligraphic forms, this class of type is not entirely appropriate in lengthy text settings. In shorter applications, however, it has always enjoyed wide acceptance. Forms now range from the formal and traditional to the casual and contemporary.

Examples:

Kuenstler Script Mistral Snell Roundhand

1750

Transitional

A refinement of Oldstyle forms, this style was achieved in part because of advances in casting and printing. Thick-to-thin relationships were exaggerated and brackets were lightened.

Examples:

Baskerville Bulmer Century Times Roman

1775

Modern

This style represents a further rationalization of Oldstyle letter-forms. Serifs were unbracketed, and the contrast between thick and thin strokes was extreme. English versions (like Bell) are also known as Scotch Roman and more closely resemble transitional forms.

Examples:

Bell Bodoni Caledonia Didot Walbaum

1825

Square serif

Originally heavily bracketed serifs, with little variation between thick and thin strokes, these faces responded to the newly developed needs of advertising for heavy type in commercial printing. As they evolved, the brackets were dropped. This class is also known as slab serif.

Examples:

Clarendon Memphis Rockwell Serifa

Sans serif

As its name implies, these type-faces eliminated serifs altogether. Although the form was first introduced by William Caslon IV in 1816, its use did not become widespread until the beginning of the 20th century. Variations tended toward either humanist forms (Gill Sans) or the rigidly geometric (Futura). Occasionally, strokes were flared to suggest the epigraphic origins of the form (Optima). Sans serif is also referred to as grotesque (from the German 'grotesk') and gothic.

Examples:

Akzidenz Grotesk Grotesque Gill Sans Franklin Gothic Frutiger Futura Helvetica Meta News Gothic Optima Syntax Trade Gothic Univers

1990

Serif/sans serif

A recent development, this style enlarges the notion of a family of typefaces to include both serif and sans serif alphabets (and, often, stages between the two).

Examples:

Rotis Scala Stone

Letters, words, sentences

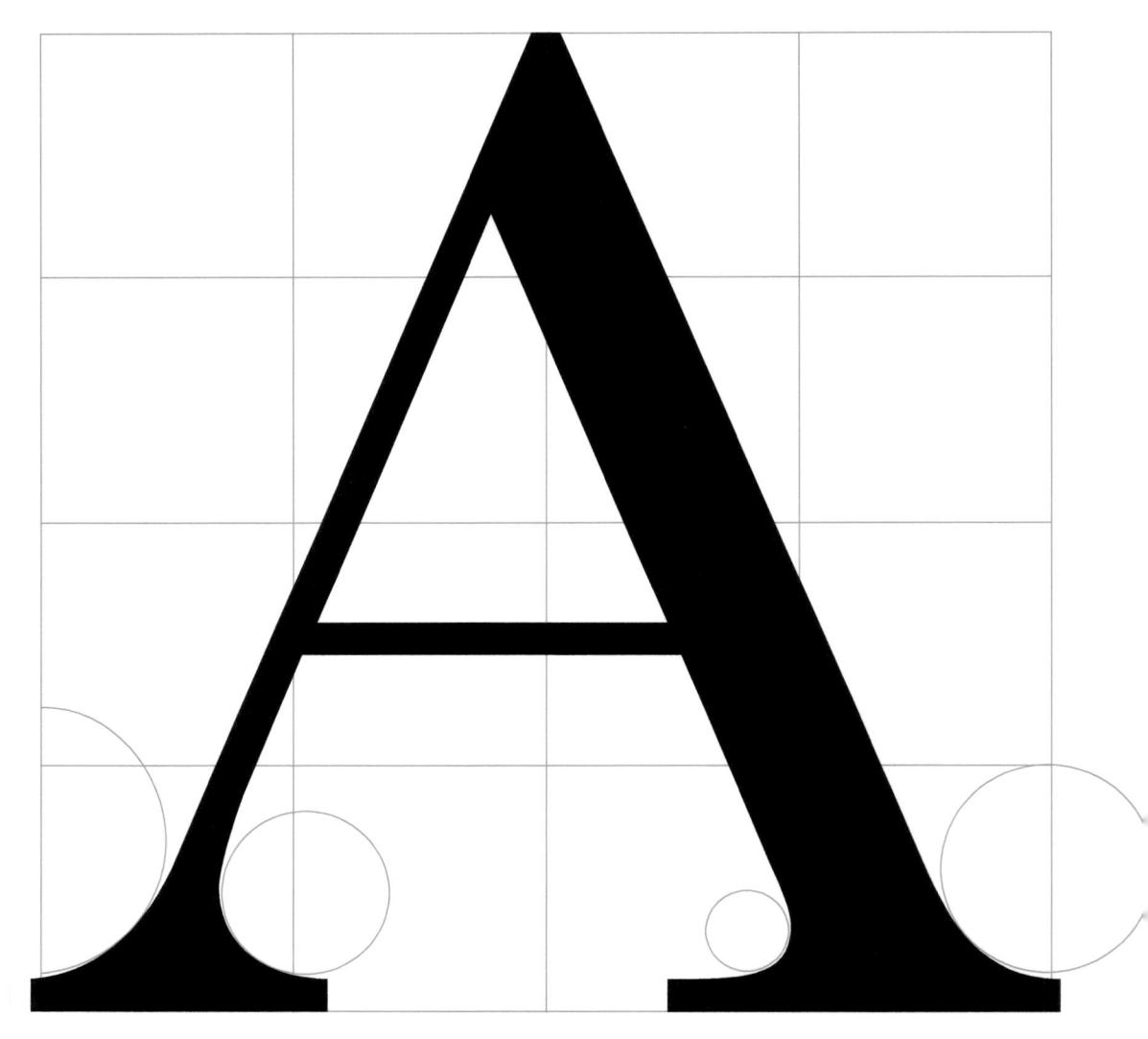

Here are two forms of a relatively simple letter—the uppercase 'a.' Both suggest the symmetry of the form as someone might print it, but neither is in fact symmetrical at all. It's easy to see the two different stroke weights of the Baskerville form (above); more noteworthy is the fact that each of the brackets connecting serif to stem expresses a unique arc.

The Univers form (opposite) may appear symmetrical, but a close examination shows that the width of the left stroke is thinner than that of the right stroke. Both demonstrate the meticulous care a type designer takes to create letterforms that are both internally harmonious and individually expressive.

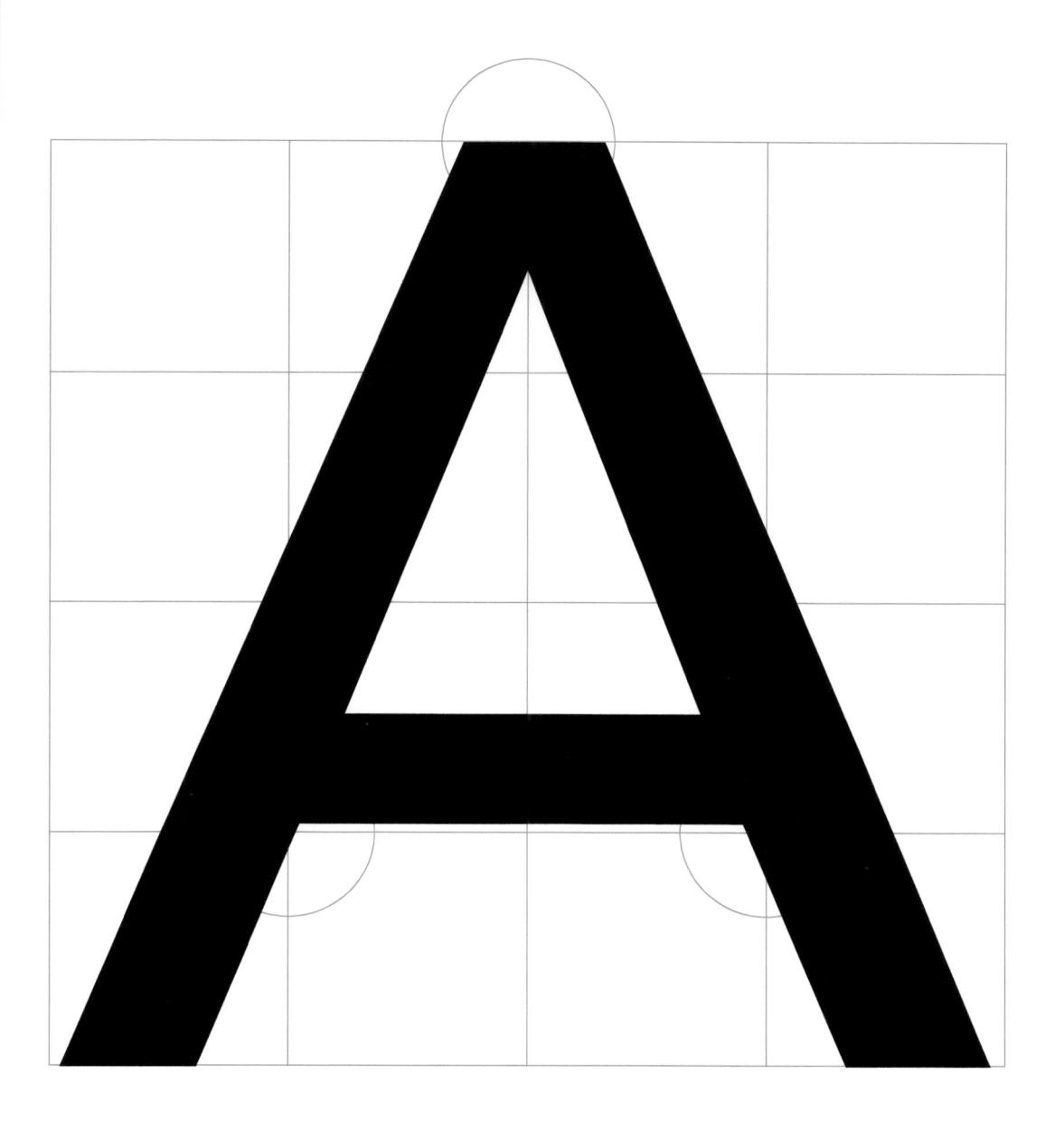

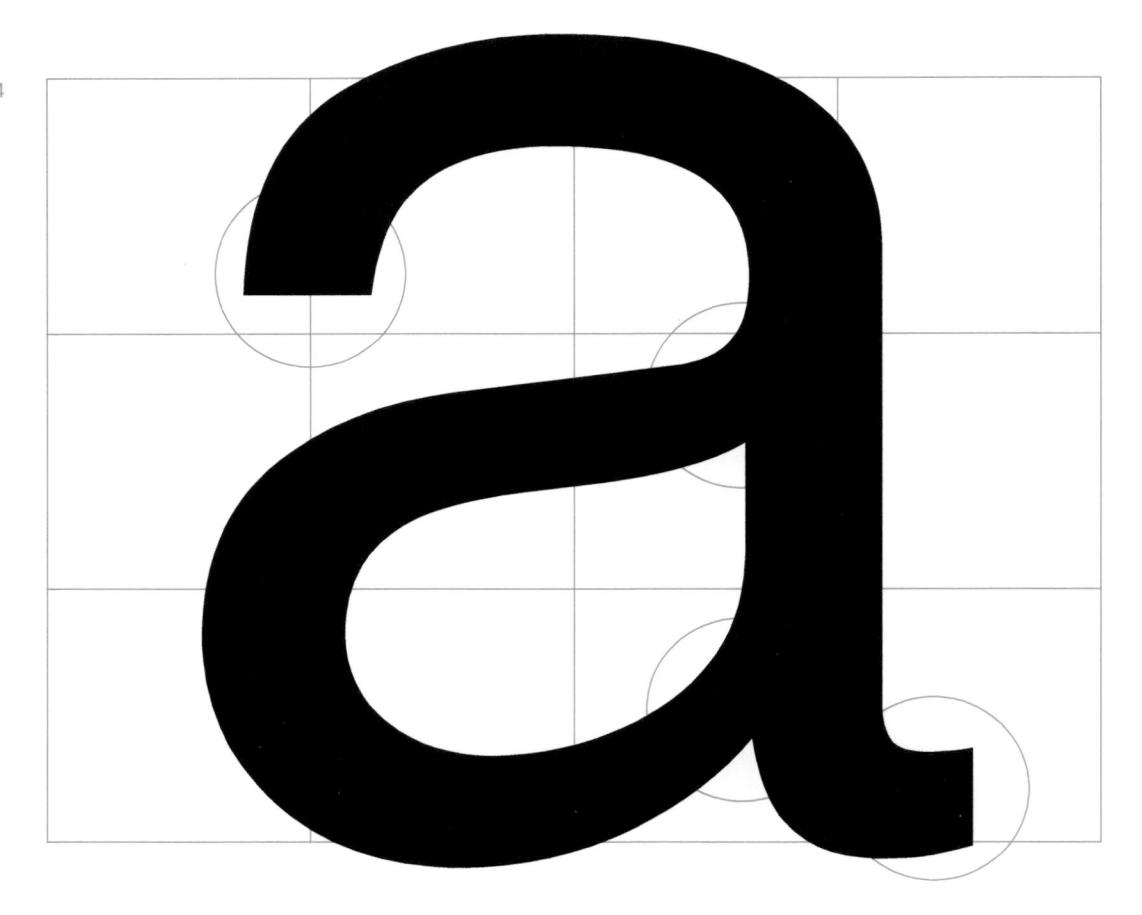

The complexity of each individual letterform is neatly demonstrated by examining the lowercase 'a' of two seemingly similar sans serif typefaces—Helvetica and Univers. A comparison of how the stems of the letterforms finish and how the bowls meet the stems quickly reveals the palpable difference in character between the two.

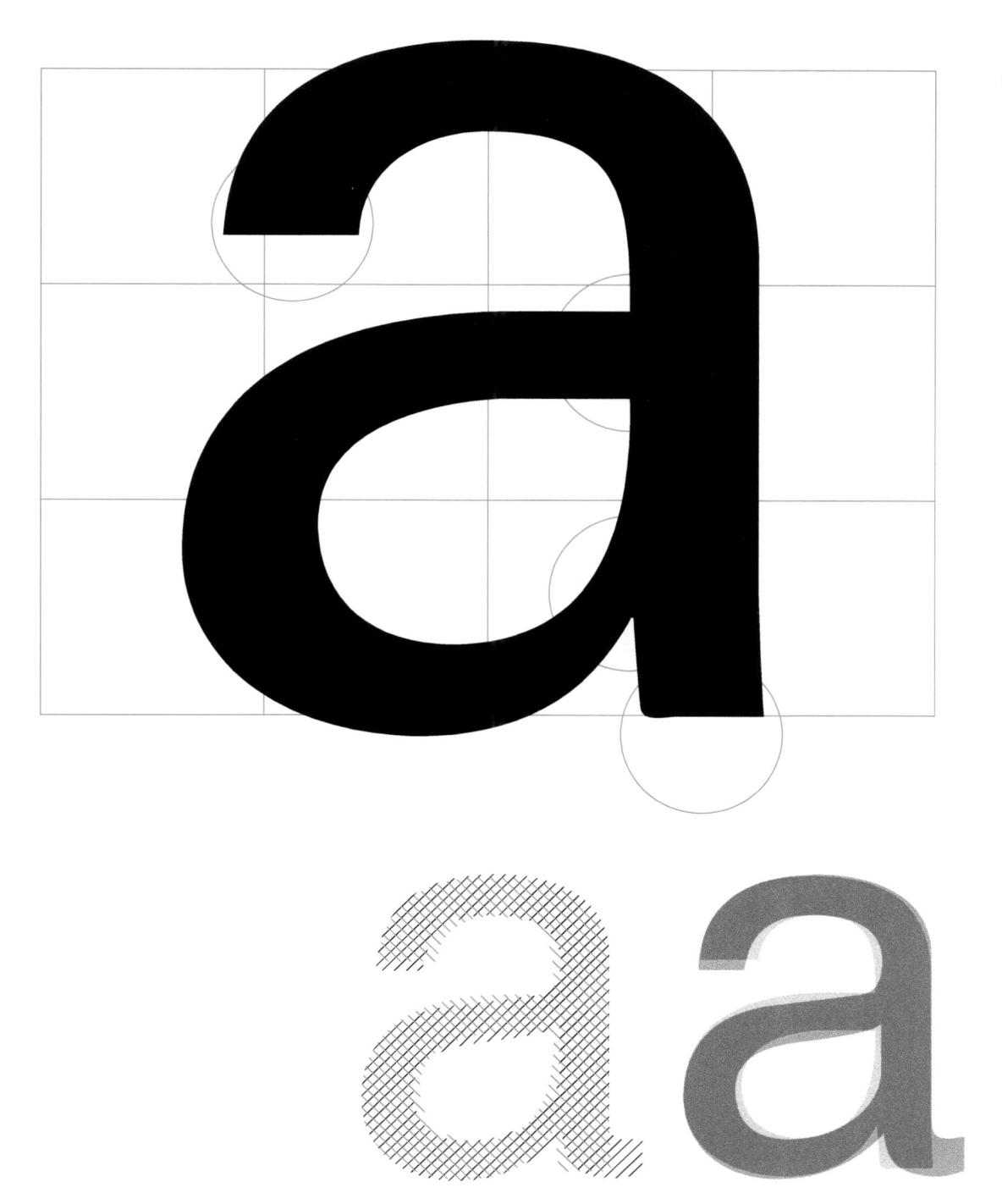

razors

median

baseline

As you already know, the x-height generally describes the size of lowercase letterforms. However, you should keep in mind that curved strokes, such as in 's', must rise above the median (or sink below the baseline) in order to appear to be the same size as the vertical and horizontal strokes they adjoin.

Compare the 'a' in the large examples above with the 'o' and 's.' The latter two characters clearly seem too small, and bounce around within the perceived x-height of the typeface, because they do not extend beyond the median or baseline.

Just as important as recognizing specific letterforms is developing a sensitivity to the counterform (or counter) - the space described, and often contained, by the strokes of the form. When letters are joined to form words, the counterform includes the spaces between them. The latter is a particularly important concept when working with letterforms like the lowercase 'r' that have no counters per se. How well you handle the counters when you set type determines how well words hang together-in other words, how easily we can read what's been set.

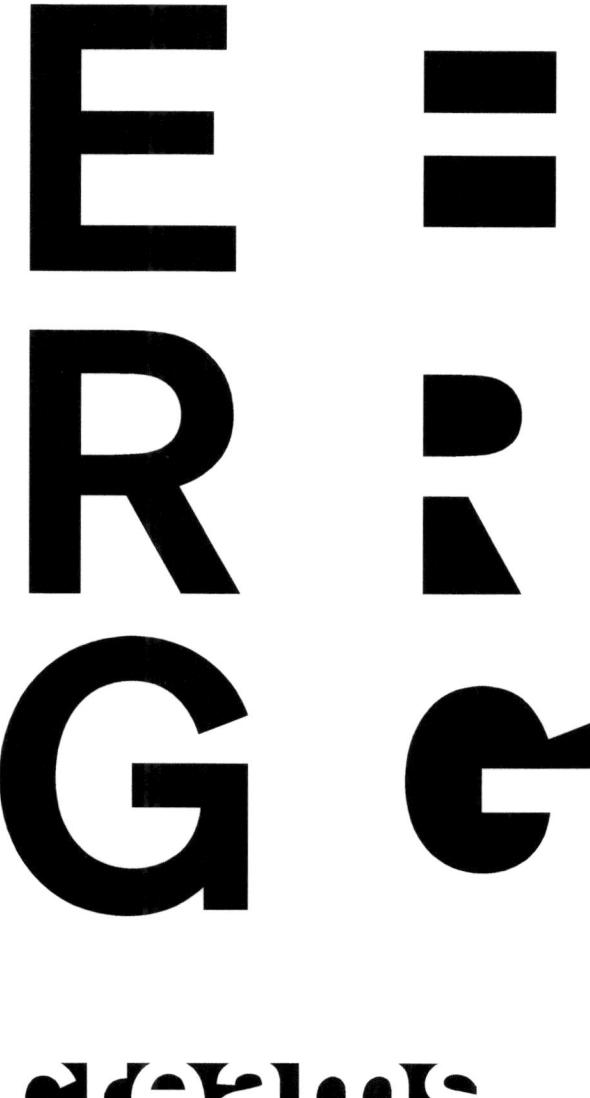

9(4:111)

Helvetica Black

One of the most rewarding ways to understand the form and counter of letters is to examine them in close detail. Beyond giving you an appreciation of the meticulous care that goes into each compound curve, these examinations also

provide a good feel for how the balance between form and counter is achieved and a palpable sense of a letterform's unique characteristics. It also gives you a glimpse into the process of letter-making.

It's worth noting here that the sense of the 'S' holds at each stage of enlargement, while the 'g' tends to lose its identity as individual elements are examined without the context of the entire letterform. g

Baskerville

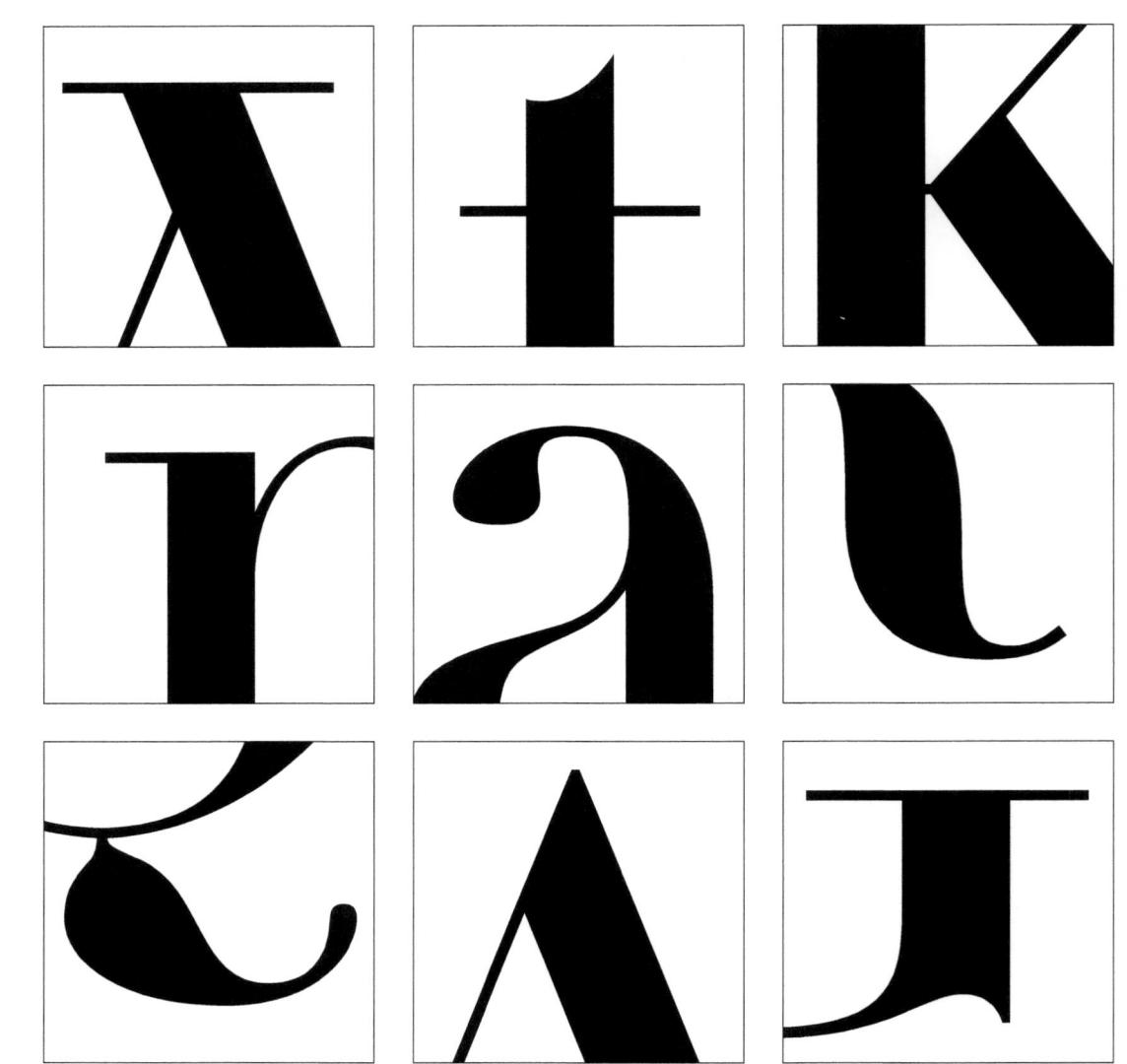

Linotype Didot

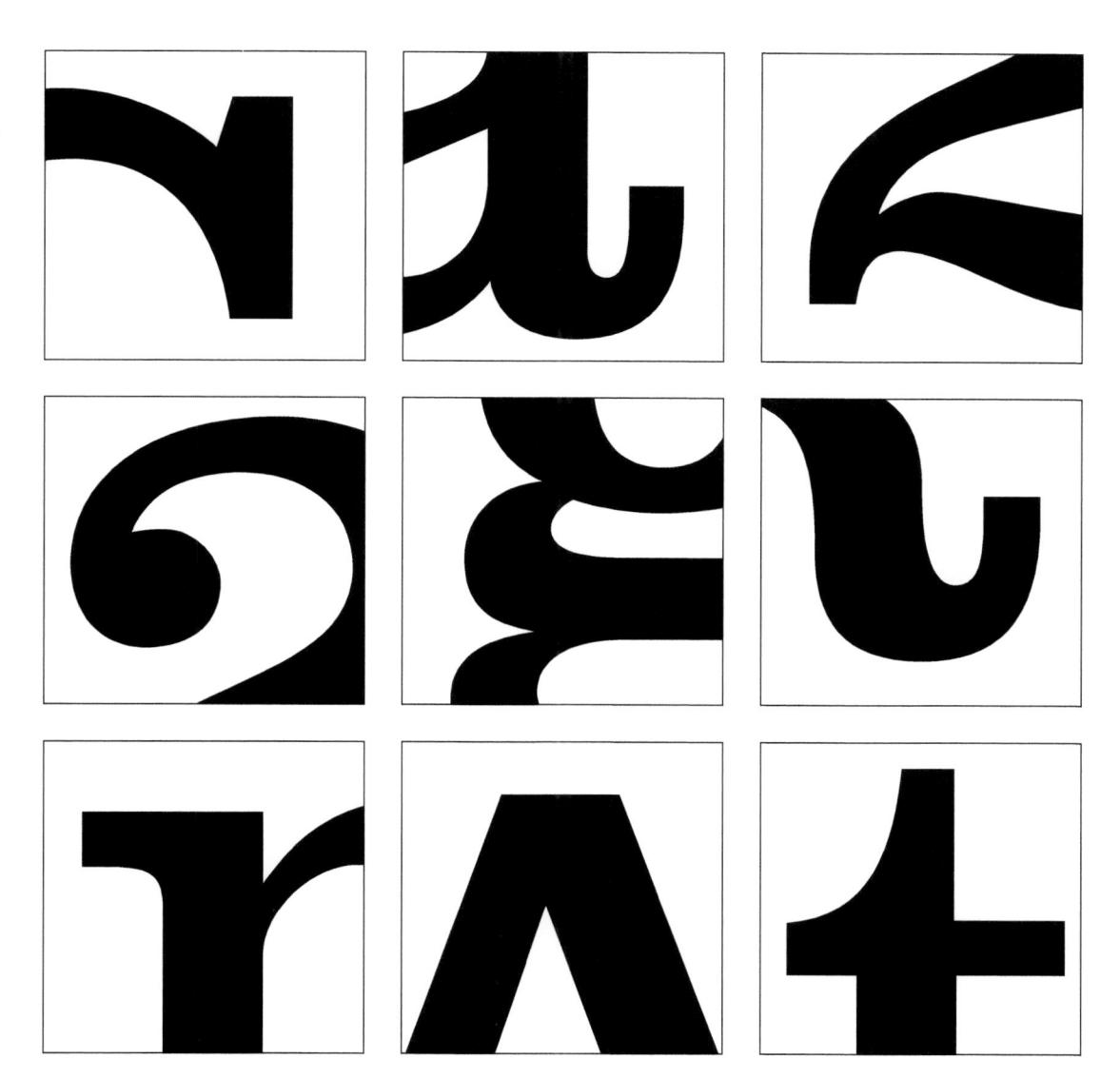

Clarendon

AA

BB

Light/bold

Condensed/extended

 $\mathsf{D}D$

Organic/machined

Roman/italic

The basic principles of graphic design apply directly to typography. Above, some examples of contrast—the most powerful dynamic in design—as applied to type, based on a format devised by Rudi Ruegg.

Combining these simple contrasts produces numerous variations: small+organic/large+machined; few+bold/many+light; etc. Adding color increases the possibilities even more (i.e. black/red).

Small/large

Positive/negative

Serif/sans serif

Ornate/simple

64

quiet

LOUD

miss ng

ad^ded

It's possible to find typographic equivalents for words. Simple choices in typeface, size, weight, and position on the page can strengthen representation of the concepts, objects, and actions that words describe. Here, we've stuck to one weight of one typeface, Akzidenz Grotesk Medium, but played with size and placement.

The examples above express some quality of the adjectives on display. 'Quiet' is small and lowercase, 'loud' large and uppercase. The second 'i' in 'missing' is, in fact, missing, and the second 'd' in 'added' is in the process of being added.

RAIN

bird

NONCON FORMIST

shadow

The examples above all carry some quality of the nouns expressed. In 'train,' for example, a Fibonacci sequence of type sizes (see page 109), aligned at the cap height, creates the illusion of perspective—we can easily imagine a long train receding into the distance—or, for that matter, pulling into a station.

The dot on the 'i' in 'bird' flies above the rest of the letters; the 'f' in 'nonconformist' does not conform with the other letters; 'shadow' casts a shadow. The examples of contrast in type on pages 62–63 offer a number of possibilities for building on these simple changes.

stand

u

j mp

hane

rise

The meaning of the verbs on this page is reinforced through placement within the frame. Direction is implied by how we read (left-to-right = forward; top-to-bottom = down, and so forth).

fly

Crash

float

Sint.

In the second row on this page, meaning is further enhanced by covering up some portion of the word (and, in the case of 'sink,' by tilting the type slightly downward). Imagine taking a bite out of 'eat.'

dance

a n c e

dance

dance

dance

dancedance

Here, simple placement of the word 'dance' in the square suggests the activity in a place, possibly a stage. Breaking the letters apart suggests a dancer moving.

Repetition of the word (this page and opposite) suggests different kinds of rhythm and, in fact, different kinds of dancing. dancedancedance dancedancedance dancedancedance dancedancedance dancedancedance dancedancedance dancedancedance dancedancedance dancedancedance dance
dance
dance
dance
dance
dance
dance
dancedance
dance
dance
dance
dance

Making sentences, finding sense

One way to make sentences (or, for that matter, sentence fragments) more expressive is to reinforce the sense of the words through type play. The examples shown here provide various methods of supporting (or subverting) the author's intent, by manipulating the size, weight, and placement of words.

70

The text in this sequence is taken from the *Déclaration des droits de l'homme et du citoyen* (Declaration of the Rights of Man and of the Citizen, 1789): 'Article 11. The free communication of ideas and opinions is one of the most precious of the rights of man. Every citizen may, accordingly, speak, write, and print with freedom, but shall be responsible for such abuses of this freedom as shall be defined by law.'

Flush left

Article 11

The free communication of ideas and opinions is one of the most precious of the rights of man. Every citizen may, accordingly, speak, write, and print with freedom, but shall be responsible for such abuses of this freedom as shall be defined by law.

Flush right

Article 11

The free communication of ideas and opinions is one of the most precious of the rights of man. Every citizen may, accordingly, speak, write, and print with freedom, but shall be responsible for such abuses of this freedom as shall be defined by law.

Simply, set the text.

Or, perhaps, not so simply. When setting type in a field, it's useful to keep in mind the expression 'lines of type.' Compositionally, they operate on a page in much the same way that simple lines do in a basic design study, with two important exceptions:

The Latin alphabet always reads left to right.

2

The quality of the line is determined by the size and weight of the typeface, by the inherent gray value of the typeface itself, and by the leading (space) between the lines of type.

Justified

Article 11

The free communication of ideas and opinions is one of the most precious of the rights of man. Every citizen may, accordingly, speak, write, and print with freedom, but shall be responsible for such abuses of this freedom as shall be defined by law.

At actual size (36 picas square). type is 14/17 Janson.

Centered

Article 11 The free communication of ideas and opinions is one of the most precious of the rights of man. Every citizen may, accordingly, speak, write, and print with freedom, but shall be responsible for such abuses of this freedom as shall be defined by law.

Narrow setting

Diagonal setting

Larger type

Placement of the type (see examples above) is as much about where type isn't as where it is. Designers working with type must always balance the importance of dynamic counterform with the need for type to remain readable; the most interesting composition may not be the most accessible.

Studies in perception have shown that readers' comprehension increases relative to the ease of scanning the text. In other words, fewer visual distractions lead to greater retention of content. This simple observation is most useful to keep in mind when setting extended text. Shorter settings such as we see here, however, reasonably allow for more 'play' in the presentation.

In short, while it may be possible to heighten meaning through distinctive and directed arrangement of type, direct consideration of the content and the reader should always be one's uppermost goals.

Article 11

The free communication of ideas and opinions is one of the most precious of the rights of man. Every citizen may accordingly, speak, write, and print with freedom, but shall be responsible for such abuses of this freedom as shall be defined by law Article 11

Article 11
The free communication of ideas and opinions is one of
the most precious of the rights of man. Every citizen may,
accordingly, speak, write, and print with freedom, but shall
be responsible for such abuses of this freedom as shall be
defined by law.

Article 11

The free communication of ideas and opinions is one of the most precious of the rights of man. Every citizen may, accordingly, speak, write, and print with freedom, but shall be responsible for such abuses of this freedom as shall be defined by law.

Article 11

The free communication of ideas and opinions is one of the most precious of the rights of man. Every citizen may, accordingly, speak, write, and print with freedom, but shall be responsible for such abuses of this freedom as shall be defined by law.

Choosing an appropriate typeface depends on a number of factors, some of them seemingly contradictory: the content of the text, the tone of the author's voice, the period in which the text was written, and the intended audience. Each of the examples above speaks to some quality of the text.

Top left: the script setting (Kuenstler Script) reflects the original, calligraphed presentation of the text to Louis XVI. Top right: this 16th-century typeface (Adobe Garamond) is closely identified with classic French printing.

Bottom left: the design of this French typeface (Linotype Didot), was contemporaneous with the first publication of the text. Bottom right: a sans serif font (Univers 55) speaks directly to the modern audience. Article 11
The free communication of ideas and opinions is one of
the most precious of the rights of man. Every citizen may,
accordingly, speak, write, and print with freedom,
but shall be responsible for such abuses of this freedom
as shall be defined by law.

Here we see two approaches that work against any serious communication. Top: a typeface so distinctive (Mistral) that it interrupts direct access to the content. Bottom: a 'formal' typeface (Trajan), set in all caps, that needlessly dresses up the text (what the French might describe as péter plus haut que son cul).

In both cases, before the reader can get to the matter, he or she must see through the effect of the type-faces themselves (in all likelihood, this also occurred when coming upon the script example on page 72). These examples highlight the problems inherent in using display typefaces for setting text (see page 14).

ARTICLE 11
THE FREE COMMUNICATION OF IDEAS AND
OPINIONS IS ONE OF THE MOST PRECIOUS
OF THE RIGHTS OF MAN. EVERY CITIZEN MAY,
ACCORDINGLY, SPEAK, WRITE, AND PRINT
WITH FREEDOM, BUT SHALL BE RESPONSIBLE
FOR SUCH ABUSES OF THIS FREEDOM AS SHALL
BE DEFINED BY LAW.

Article 11
The free communication
of ideas and opinions
is one of the most precious of the rights of man.
Every citizen may, accordingly,
speak, write, and print with freedom,
but shall be responsible
for such abuses of this freedom
as shall be defined by law.

Examine the syntax.

One way to make short text more expressive is to break it up for sense. In the example above, the two sentences in Article 11 have been set so that each line contains one discrete component of the thought.

The irregularity of the rag, something to be avoided assiduously in longer text settings, in this instance provides both cues for how to read the text and a lively interraction of form and counterform. Article 11
The free communication
of ideas and opinions
is one of the most precious
of the rights
of man.

Every citizen may, accordingly,
speak,
write, and
print with freedom,
but shall be responsible
for such abuses of this freedom
as shall be defined
by law.

Above, the idea is taken one step further by organizing the sense of the text both horizontally and vertically. Visualizing the syntax in this way generates rich, complex counterform on the page. Text set in this manner is called asymmetric because it does not conform to the typical methods of typesetting displayed on pages 72 and 73. In practice, lines in asymmetric type are broken as much for appearance on the page as for the sense of the text.

Article 11
The free communication
of ideas and opinions
is one of the most precious of the rights of man.
Every citizen may, accordingly,
speak, write, and print with freedom,
but shall be responsible
for such abuses of this freedom
as shall be defined by law.

Find the core message.

Highlighting the key words in the text, by changing either their weight or their size, keys the reader in to the heart of the text, separated from its natural grammatical setting.

Notice that there is no shift from roman to italic. Despite its long use in text to call out certain words, phrases, and titles, italic does not provide enough visual difference from roman to serve the purpose of this exercise.

Above: A bold sans serif (Univers 75) has been paired with the roman (Linotype Didot). For a discussion of this approach, see pages 128–129.

Article 11
The free communication
of ideas and opinions
is one of the most precious
of the rights of man.
Every citizen may, accordingly,
speak, write, and print with freedom,
but shall be responsible
for such abuses of this freedom
as shall be defined by law.

Above: Change in scale highlights key phrases in the text.

Article 11

The free communication of ideas and opinions is one of the most precious of the rights of man.

Every citizen may, accordingly, speak, write, and print with freedom,

 $\begin{array}{c} {\rm but\ shall\ be\ responsible} \\ {\rm for\ such\ abuses\ of\ this\ freedom} \\ {\rm as\ shall\ be\ defined\ } by\ law. \end{array}$

Combine scale and structure.

In the example above, the two previous strategies are combined. Both the organization of the text and the use of scale support the meaning.

Article 11

The free communication of ideas and opinions

is one of the most precious of the rights of man. Every citizen may, accordingly, speak, write, and print with freedom, but shall be responsible for such abuses of this freedom as

shall be defined by law.

As you can see above, and as we have all seen in countless real world examples, scale, weight, and organization conspire to subvert the intended meaning of the text.

Type and color

As the previous examples demonstrate, typography continually offers the designer opportunities to exploit color on a page, even in a 'one-color' situation. Each typeface—assembled in regularly occurring lines, grouped into paragraphs and columns, or set in single words or simple phrases—creates a unique tone on the page. As the samples of Akzidenz Grotesk (right) demonstrate, changes in weight and compression or expansion of the letterforms all contribute to a palette of typographic tones.

Condensed

Akzidenz Grotesk Light

The guiding attitudes behind what follows are those that heve vitalized most twentieth-century art: content dictates form; less is more; god is in the details. These three tenets neatly identify the typographer's job: appropriate, clear expression of the author's message, intelligent economy of means, and a deep undestanding of craft.

Akzidenz Grotesk Regular

The guiding attitudes behind what follows are those that have vitalized most twentieth-century art: content dictates form; less is more; god is in the details. These three tenets neatly identify the typographer's job: appropriate, clear expression of the author's message, intelligent economy of means, and a deep understanding of craft.

Akzidenz Grotesk Medium

The guiding attitudes behind what follows are those that have vitalized most hwentieth-century art: content dictates form; less is more; god is in the details. These three tenets neatly identify the typographar's job: appropriate, clear expression of the author's message, intelligent economy of means, and a deep understanding of craft.

Akzidenz Grotesk Bold

The guiding attitudes behind what follows are those that have vitalized most twentieth-century art: content dictates form; less is more; god is in the details. These three tenets neatly identify the typographer's job: appropriate, clear expression of the author's message, intelligent economy of means, and a deep understanding of craft.

Akzidenz Grotesk Extra Bold

The guiding attitudes behind what follows are those that have vitalized most twentieth-century art: content dictates form; less is more; god is in the details. These three tenets neathy identify the typographer's job: appropriate, clear expression of the author's message, intelligent economy of means, and a deep understanding of craft.

Akzidenz Grotesk Super

Roman

The guiding attitudes behind what follows are those that have vitalized most twentieth-century art: content dictates form; less is more; god is in the details. These three tenets neatly identify the typographer's job: appropriate, clear expression of the author's message, intelligent economy of means, and a deep understanding of craft.

The guiding attitudes behind what follows are those that have vitalized most twentieth-century art: content dictates form; less is more; god is in the details. These three tenets neatly identify the typographer's job: appropriate, clear expression of the author's message, intelligent economy of means, and a deep understanding of craft.

The guiding attitudes behind what follows are those that have vitalized most twentieth-century art: content dictates form; less is more; god is in the details. These three tenets neatly identify the typographer's job: appropriate, clear expression of the author's message, intelligent economy of means, and a deep understanding of craft.

The guiding attitudes behind what follows are those that have vitalized most twentieth-century art: content dictates form; less is more; god is in the details. These three tenets neatly identify the typographer's job: appropriate, clear expression of the author's message, intelligent economy of means, and a deep understanding of craft.

The guiding attitudes behind what follows are those that have vitalized most twentleth-century art: content dictates form; less is more; god is in the details. These three tenets neatly identify the typographer's job: appropriate, clear expression of the author's message, intelligent economy of means, and a deep understanding of craft.

The guiding attitudes behind what follows are those that have vitalized most twentieth-century art: content dictates form; less is more; god is in the details. These three tenets neatly identify the typographer's job: appropriate, clear expression of the author's message, intelligent economy of

Italic

The guiding attitudes behind what follows are those that have vitalized most twentieth-century art: content dictates form; less is more; god is in the details. These three tenets neatly identify the typographer's job: appropriate, clear expression of the author's message, intelligent economy of means, and a deep understanding of craft.

The guiding attitudes behind what follows are those that have vitalized most twenti-eth-century art: content dictates form; less is more; god is in the details. These three tenets neatly identify the typographer's job: appropriate, clear expression of the author's message, intelligent economy of means, and a deep understanding of craft.

The guiding attitudes behind what follows are those that have vitalized most twentieth-century art: content dictates form; less is more; god is in the details. These three tenets neatly identify the typographer's job: appropriate, clear expression of the author's message, intelligent economy of means, and a deep understanding of craft.

Extended

The guiding attitudes behind what follows are those that have vitalized most twentieth-century art: content dictates form; less is more; god is in the details. These three tenets neatly identify the typographer's job: appropriate, clear expression of the author's message, intelligent economy of means, and a deep under-

The guiding attitudes behind what follows are those that have vitalized most twentieth-century art: content dictates form; less is more; god is in the details. These three tenets neatly identify the typographer's job: appropriate, clear expression of the author's message, intelligent economy of means, and a deep

The guiding attitudes behind what follows are those that have vitalized most twentieth-century art: content dictates form; less is more; god is in the details. These three tenets neatly identify the typographer's job: appropriate, clear expression of the author's message,

The guiding attitudes behind what follows are those that have vitalized most twentieth-century art: content dictates form; less is more; god is in the details. These three tenets neatly identify the typographer's job: appropriate, clear expression of the author's message,

In addition to properties best discussed elsewhere—hue, saturation, temperature—each color has a specific value, a tone that describes the color's weight on the page as a percentage of black.

100% color

Consider the color shown opposite, Pantone 032. Compare how the color meets black, white, and tints of black. We can see that it provides more or less the same contrast to white as to black, and neither advances nor recedes when seen next to a 50% screen of black. We can therefore describe it as having a gray value of approximately 50%.

Understanding—being able to see—gray value contributes significantly to readability in simple 'two-color' printing situations.

This is a li 90% black This is a line of type This is a line of type 70% black This is a line of type This is a line of type 50% black This is a line of type This is a line of type 30% black This is a line of type This is a line of type 10% black This is a li This is a line of type 50% black This is a line of type

Because, as we already know, full saturation of our color has a gray value of 50%, it will always be lighter than a similar percentage of black. For example, 90% of this color has a gray value of more or less 50% x 90%, or 45%. Note that straight math is only an approximate indicator. Trust your eye.

Although ink on paper remains a strictly two-dimensional phenomenon, we can imply a sense of depth on any page by manipulating contrast between colors. As these examples show, greater contrast between colors suggests a greater distance from front to back, figure to ground if you will. Less contrast suggests proximity.

One obvious use of color is to reinforce typographic hierarchy. In the examples on this page the black 'a's, because they provide more contrast with the white background, are clearly more important than the red or gray 'a's.

In these examples above, the 'a' seems to advance because it contrasts most strongly with the tones in both the background and the 'A.'

Here (above), the maximum contrast exists between the 'A' and the background. As a result, the 'a' tends to recede, confusing what appears to be the intention of the composition.

Although we tend to think of color as a way to highlight text elements within the black-and-white environment, the fact is that color—because it reduces contrast to the white background—often weakens readability, making text recede into, rather than advancing from, the page. See pages 127—129 for examples of how the convention of color contrast competes with the goal of emphasis.

Article 11

speak,

The free communication of ideas and opinions

write, and

is one of the most precious of the rights of man.

print

Every citizen may, accordingly, speak, write, and print with

with

freedom, but shall be responsible for such abuses of this

freedom

freedom as shall be defined by law.

Here, color and scale work together to reinforce the main thrust of the black text. If you can't make it good,
make it

If you can't make it big,
make it

red.

Here, simple contrast of scale, weight, and color is used to dramatic effect to demonstrate the idea of the statement. A characteristic of type design is that the letterforms themselves have evolved as a response to handwriting—the marks we make as we scrawl across a page. One of the identifiable features of those marks is that we make them as part of a horizontal flow, from left to right. This is something we all take for granted, as natural a part of written language as the use of upper- and lowercase.

Not all languages are written this way. Hebrew and Arabic, for instance, read right to left, and books in those languages begin at what we would consider the back. Look how illegible English would be if we encountered it set from right to left:

eb dluow hsilgnE elbigelli woh kooL thgir morf tes ti deretnuocne ew fi :tfel ot

Letterforms in typefaces have any number of attributes intended to reinforce the left-to-right flow of the written language: ascenders, descenders, consistent x-height, counters in lowercase forms typically appearing to the right. All these contribute to the sense of a line of text. And from the moment when we first learn to read, our brain assimilates these characteristics as essential for readable type.

Now to the point: written Chinese, unlike English, is not based on an alphabet; rather it is written in a series of characters called pictographs—forms that express an entire word or idea without necessarily indicating how to pronounce it.

Until recently, Chinese characters were typically read top to bottom, right to left, like this:

The simple fact that all Chinese characters are drawn to the same width makes this reading very simple. You can see in the example above that the characters descending the page make natural and obvious columns.

Occasionally, you will come across English type that has been set like Chinese:

As you can see, English letterforms are not all drawn to the same width. In left-to-right reading, the difference in widths presents no problem to readability; in fact, it adds to variety and color on the page. In vertical reading, all the type can do is create a shape. (Look at the profiles created by the difference between the wide W and the less-wide O, or between the N and the I.) When you consider that the primary purpose of type is to convey information with as little intrusion as possible, and that letterforms exist as a response to the lateral gestures of hand writing, then it should be clear that setting type vertically is inherently anti-typographic.

When the composition calls for vertical type, be mindful of the properties of the letterforms themselves, and set the type accordingly.

Improving

While you're at it, keep in mind how the baseline of the vertical type can, or cannot, relate to the vertical axes suggested by the rest of your type (in this instance, the left margin of the text).

Text

Originally, the term 'kern' described the portion of a letterform that extended beyond the body of the type slug. As the example on the right shows, this adaptation was required in letterforms with angled strokes, so that spacing between letters within a word would remain optically consistent. Today the term 'kerning' describes the automatic adjustment of space between letters as prescribed by a table embedded within the digital font.

Because kerning removes space between letters, it is often mistakenly referred to as 'letterspacing.' In fact, letterspacing means adding space between letters, not removing it. For our purposes, the term 'tracking,' used in most computer programs that incorporate typesetting, best describes the addition or removal of space between letters. Keep in mind that even the best tracking table sometimes requires minor adjustments, especially at larger point sizes.

Without kerning

With kerning

Without kerning

With kerning

Yellow rifts

Normal tracking

Yellow rifts

Loose tracking (letterspacing)

Yellow rifts

Tight tracking (kerning)

As type size increases, particularly into display sizes of 24 pt. and up, it's often a good idea to tighten the tracking slightly.

91

step

Univers 55

Normal tracking

Tight tracking

Loose tracking

92

When setting text, tracking is critical to maintain easy reading. Note how loosely tracked text practically disintegrates right on the page, whereas tightly tracked text sacrifices readability as it comes to resemble no more than a series of stripes.

Normal tracking Miss Brooke had that kind of beauty which seems to be thrown into relief by poor dress. Her hand and wrist were so finely formed that she could wear sleeves not less bare of style than those in which the Blessed Virgin appeared to Italian painters; and her profile as well as her stature and bearing seemed to gain the more dignity from her plain garments, which by the side of provincial fashion gave her the impressiveness of a fine quotation from the Bible—or from one of

Loose tracking

Miss Brooke had that kind of beauty which seems to be thrown into relief by poor dress. Her hand and wrist were so finely formed that she could wear sleeves not less bare of style than those in which the Blessed Virgin appeared to Italian painters; and her profile as well as her stature and bearing seemed to gain the more dignity from her plain garments, which by the side of provincial fashion gave her the impressiveness of a fine

Tight tracking

Miss Brooke had that kind of beauty which seems to be thrown into relief by poor dress. Her hand and wrist were so finely formed that she could wear sleeves not less bare of style than those in which the Blessed Virgin appeared to Italian painters; and her profile as well as her stature and bearing seemed to gain the more dignity from her plain garments, which by the side of provincial fashion gave her the impressiveness of a fine quotation from the Bible—or from one of the elder poets—in a paragraph of today's newspaper.

Designers often letterspace uppercase letters, but there has long been strong resistance within the type community to letterspacing lowercase letters within text. The reason for this resistance is quite clear if you look at the examples here. Uppercase forms are drawn to be able to stand on their own (consider their epigraphic origins). Lowercase forms require the counterform created between letters to maintain the line of reading (consider their origins in calligraphy).

Even though, when displayed alone and not as text, lowercase forms allow for some play in tracking, a moment occurs when readability is sacrificed for effect and meaning is lost.

IN MEMORIAM

In Memoriam

AFFLUENCE

affluence

EPISTEMOLOGY

e p i s t e m o l o g y

Formatting text

Flush left

94

This format most closely mirrors the asymmetrical experience of handwriting. Each line starts at the same point but ends wherever the last word on the line ends. Spaces between words are consistent throughout the text, allowing the type to create an even, gray value.

Flush left, ragged right (fl, rr) If you know Starkfield, Massachusetts, you know the post-office. If you know the post-office you must have seen Ethan Frome drive up to it, drop the reins on his hollow-backed bay and drag himself across the brick pavement to the white colonnade; and you must have asked who he was.

Centered

This format imposes symmetry upon the text, assigning equal value and weight to both ends of any line. It transforms fields of text into shapes, thereby adding a pictorial quality to material that is non-pictorial by nature. Because centered type creates such a strong shape on the page, it's important to amend line breaks so that the text does not appear too jagged.

Centered (cent.)

If you know Starkfield, Massachusetts, you know the post-office. If you know the post-office you must have seen Ethan Frome drive up to it, drop the reins on his hollow-backed bay and drag himself across the brick pavement to the white colonnade; and you must have asked who he was.

Flush right

This format places emphasis on the end of a line as opposed to its start. It can be useful in situations (like captions) where the relationship between text and image might be ambiguous without a strong orientation to the right.

Flush right, ragged left (fr. rl) If you know Starkfield, Massachusetts, you know the post-office. If you know the post-office you must have seen Ethan Frome drive up to it, drop the reins on his hollow-backed bay and drag himself across the brick pavement to the white colonnade; and you must have asked who he was.

Justified

Like centering, this format imposes a symmetrical shape upon the text. It is achieved by expanding or reducing spaces between words and, sometimes, between letters. The resulting openness of lines can occasionally produce 'rivers' of white space running vertically through the text. Careful attention to line breaks and hyphenation is required to amend this problem whenever possible.

Justified (just.)

If you know Starkfield, Massachusetts, you know the post-office. If you know the post-office you must have seen Ethan Frome drive up to it, drop the reins on his hollow-backed bay and drag himself across the brick pavement to the white colonnade; and you must have asked who he was.

All text, 10/13.5 Janson

Designers tend to set type one way or another depending upon several factors, not the least of which are tradition and personal preference. Prevailing culture and the need to express oneself play important, inevitable roles in any piece of communication. However, when setting a field of type, keep in mind the typographer's first job-clear, appropriate presentation of the author's message. Type that calls attention to itself before the reader can get to the actual words is simply interference, and should be avoided. Quite simply, if you see the type before you see the words, change the type.

Anna Klein, Mitchell King

and their families

invite you to join them

in the celebration of

their wedding.

23 June 2001 Village Hall Framingham Center 1.30 p.m. Reception to follow:

R.S.V.P.

Preconceptions about how something should look often interfere with effective, appropriate design of the message at hand. The formality of a wedding invitation, for example, is not necessarily tied to centered type—nor to script, for that matter.

Anna Klein, Mitchell King and their families invite you to join them in the celebration of their wedding. 23 June 2001 Village Hall Framingham Center 1:30 P.M. Reception to follow.

R.S.V.P.

Texture

96 Beyond learning about the unique characteristics of each typeface – and understanding its place in history—it's very important to understand how different typefaces feel as text. Different typefaces suit different messages. A good typographer has to know which typeface best suits the message at hand.

On pages 12–13 we discussed how typefaces 'felt' different from each other. On the next three pages, you can see how those ten typefaces compare with each other in identical text settings. Here you can see that the difference between typefaces is expressed not only in individual letterforms but also—and most importantly—in lines of type massed together to form blocks of text.

Consider too the different textures of these typefaces. Type with a relatively generous x-height or relatively heavy stroke width produces a darker mass on the page than type with a relatively smaller x-height or lighter stroke. Sensitivity to these differences in color is fundamental for creating successful layouts.

Call me Ishmael. Some years ago—never mind how long precisely—having little or no money in my purse, and nothing particular to interest me on shore, I thought I would sail about a little and see the watery part of the world. It is a way I have of driving off the spleen, and regulating the circulation. Whenever I find myself growing grim about the mouth; whenever it is a damp, drizzly November in my soul; whenever I find myself pausing before coffin warehouses, and bringing up the rear of every funeral I meet; and especially whenever my hypos get such an upper hand of me, that it requires a strong moral principle to prevent me from deliberately step-

10/13.5 Bembo

Call me Ishmael. Some years ago—never mind how long precisely—having little or no money in my purse, and nothing particular to interest me on shore, I thought I would sail about a little and see the watery part of the world. It is a way I have of driving off the spleen, and regulating the circulation. Whenever I find myself growing grim about the mouth; whenever it is a damp, drizzly November in my soul; whenever I find myself pausing before coffin warehouses, and bringing up the rear of every funeral I meet; and especially whenever my hypos get such an upper hand of me, that it requires a strong moral principle to prevent me from deliber-

10/13.5 Adobe Caslon

Call me Ishmael. Some years ago—never mind how long precisely—having little or no money in my purse, and nothing particular to interest me on shore, I thought I would sail about a little and see the watery part of the world. It is a way I have of driving off the spleen, and regulating the circulation. Whenever I find myself growing grim about the mouth; whenever it is a damp, drizzly November in my soul; whenever I find myself pausing before coffin warehouses, and bringing up the rear of every funeral I meet; and especially whenever my hypos get such an upper hand of me, that it requires a strong moral principle to prevent me from deliberately stepping into the

10/13.5 Adobe Garamond

Call me Ishmael. Some years ago—never mind how long precisely—having little or no money in my purse, and nothing particular to interest me on shore, I thought I would sail about a little and see the watery part of the world. It is a way I have of driving off the spleen, and regulating the circulation. Whenever I find myself growing grim about the mouth; whenever it is a damp, drizzly November in my soul; whenever I find myself pausing before coffin warehouses, and bringing up the rear of every funeral I meet; and especially whenever my hypos get such an upper hand of me, that it requires a strong moral principle to prevent me from deliberately

Call me Ishmael. Some years ago—never mind how long precisely—having little or no money in my purse, and nothing particular to interest me on shore, I thought I would sail about a little and see the watery part of the world. It is a way I have of driving off the spleen, and regulating the circulation. Whenever I find myself growing grim about the mouth; whenever it is a damp, drizzly November in my soul; whenever I find myself pausing before coffin warehouses, and bringing up the rear of every funeral I meet; and especially whenever my hypos get such an upper hand of me, that it requires a strong

10/13.5 Janson

Call me Ishmael. Some years ago—never mind how long precisely—having little or no money in my purse, and nothing particular to interest me on shore, I thought I would sail about a little and see the watery part of the world. It is a way I have of driving off the spleen, and regulating the circulation. Whenever I find myself growing grim about the mouth; whenever it is a damp, drizzly November in my soul; whenever I find myself pausing before coffin warehouses, and bringing up the rear of every funeral I meet; and especially whenever my hypos get such an upper hand of me, that it requires a strong

Call me Ishmael. Some years ago—never mind how long precisely—having little or no money in my purse, and nothing particular to interest me on shore, I thought I would sail about a little and see the watery part of the world. It is a way I have of driving off the spleen, and regulating the circulation. Whenever I find myself growing grim about the mouth; whenever it is a damp, drizzly November in my soul; whenever I find myself pausing before coffin warehouses, and bringing up the rear of every funeral I meet; and especially

mind how long precisely—having little or no money in my purse, and nothing particular to interest me on shore, I thought I would sail about a little and see the watery part of the world. It is a way I have of driving off the spleen, and regulating the circulation. Whenever I find myself growing grim about the mouth; whenever it is a damp, drizzly November in my soul; whenever I find myself pausing before coffin warehouses, and bringing up the rear of every funeral I meet; and especially whenever my hypos get such an upper hand of me, that it

Call me Ishmael. Some years ago—never

10/13.5 Serifa

10/13.5 Futura Book

Call me Ishmael. Some years ago—
never mind how long precisely—having
little or no money in my purse, and
nothing particular to interest me on
shore, I thought I would sail about a
little and see the watery part of the
world. It is a way I have of driving off the
spleen, and regulating the circulation.
Whenever I find myself growing grim
about the mouth; whenever it is a damp,
drizzly November in my soul; whenever I find myself pausing before coffin
warehouses, and bringing up the rear
of every funeral I meet; and especially

Call me Ishmael. Some years ago — never mind how long precisely — having little or no money in my purse, and nothing particular to interest me on shore, I thought I would sail about a little and see the watery part of the world. It is a way I have of driving off the spleen, and regulating the circulation. Whenever I find myself growing grim about the mouth; whenever it is a damp, drizzly November in my soul; whenever I find myself pausing before coffin warehouses, and bringing up the rear of every funeral I meet; and especially whenever my hypos get such an upper hand of me, that it requires a strong
Typing is not typesetting

For the better part of the 20th century, the distinctive forms of typewriter type (notably its single character width and unstressed stroke) characterized the immediacy of thought: getting the idea down without dressing it up. Now that computers have replaced typewriters, most word processing programs default to Helvetica or Times Roman (or their derivatives) as the typographic expression of simple typing (see below). E-mail-currently the most immediate form of typed communication-appears on our computer screens as an electronically neutered serif or sans serif, any individuality scraped off in deference to the requirements of the pixel.

As a typographer, you should recognize the difference between typing and typesetting. Time and usage may ultimately make Inkjet Sans the expected typeface for letters. For now, however, on paper, typewriter type (like Courier, shown below) is still the best expression of the intimate, informal voice—direct address. Imitating the formalities of typesetting in a letter is always inappropriate because it suggests an undeserved permanence—the end of a discussion, not its continuation.

I have great trouble, and some comfort, to acquaint you with. The trouble is, that my good lady died of the illness I mentioned to you, and left us all much grieved for the loss of her; for she was a dear good lady, and kind to all us her servants. Much I feared, as I was taken by her ladyship to wait upon her person, I should be quite destitute again, and forced to return to you and my poor mother, who have enough to do to maintain yourselves; and, as my lady's goodness had put

10/12 Courier

I have great trouble, and some comfort, to acquaint you with. The trouble is, that my good lady died of the illness I mentioned to you, and left us all much grieved for the loss of her; for she was a dear good lady, and kind to all us her

10/12 Helvetica

I have great trouble, and some comfort, to acquaint you with. The trouble is, that my good lady died of the illness I mentioned to you, and left us all much grieved for the loss of her; for she was a dear good lady, and kind to all us her servants. Much I feared,

Leading and line length

I had taken Mrs. Prest into my confidence; in truth without her I should have made but little advance, for the fruitful idea in the whole business dropped from her friendly lips. It was she who invented the short cut, who severed the Gordian knot. It is not supposed to be the nature of women to rise as a general thing to the largest and most liberal view—I mean of a practical scheme; but it has struck me that they sometimes throw off a bold conception—such as a man would not

I had taken Mrs. Prest into my confidence; in truth without her I should have made but little advance, for the fruitful idea in the whole business dropped from her friendly lips. It was she who invented the short cut, who severed the Gordian knot. It is not supposed to be the nature of women to rise as a general thing to the largest and most liberal view—I mean of a practical scheme; but it has struck me that they sometimes throw off

10/10 Janson 10 pt. type 10 pt. line

100

10/11 Janson 10 pt. type 11 pt. line

I had taken Mrs. Prest into my confidence; in truth without her I should have made but little advance, for the fruitful idea in the whole business dropped from her friendly lips. It was she who invented the short cut, who severed the Gordian knot. It is not supposed to be the nature of women to rise as a general thing to the largest and most liberal view—I mean of a practical scheme; but it has struck me that they sometimes throw off

I had taken Mrs. Prest into my confidence; in truth without her I should have made but little advance, for the fruitful idea in the whole business dropped from her friendly lips. It was she who invented the short cut, who severed the Gordian knot. It is not supposed to be the nature of women to rise as a general thing to the largest and most liberal view—I mean of a practical scheme; but it has struck me that they sometimes throw off

10/10.5 Janson 10 pt. type 10.5 pt. line **10/11.5 Janson** 10 pt. type 11.5 pt. line

The goal in setting text type is to allow for easy, prolonged reading. At the same time, a field of type should occupy the page much as a photograph does.

Type size

Text type should be large enough to be read easily at arm's length—imagine yourself holding a book in your lap.

Leading

Text that is set too tightly encourages vertical eye movement; a reader can easily lose his or her place. Type that is set too loosely creates striped patterns that distract the reader from the material at hand.

Virtually every computer program assumes a default leading of 120% of type size (10 pt. type is set to a 12 pt. line, 12 pt. type is set to a 14.4 pt. line, etc.). If your program says your type is leaded to 'default', fix it.

I had taken Mrs. Prest into my confidence; in truth without her I should have made but little advance, for the fruitful idea in the whole business dropped from her friendly lips. It was she who invented the short cut, who severed the Gordian knot. It is not supposed to be the nature of women to rise as a general thing to the largest and most liberal view—I mean of a practical scheme; but it

10/12 Janson 10 pt. type 12 pt. line I had taken Mrs. Prest into my confidence; in truth without her I should have made but little advance, for the fruitful idea in the whole business dropped from her friendly lips. It was she who invented the short cut, who severed the Gordian knot. It is not supposed to be the nature of women to rise as a general thing to the largest and most liberal view—I mean of a practical scheme; but it

10/13 Janson 10 pt. type 13 pt. line

I had taken Mrs. Prest into my confidence; in truth without her I should have made but little advance, for the fruitful idea in the whole business dropped from her friendly lips. It was she who invented the short cut, who severed the Gordian knot. It is not supposed to be the nature of women to rise as a general thing to the largest and most liberal view—I mean of a practical scheme; but it

10/12.5 Janson 10 pt. type 12.5 pt. line I had taken Mrs. Prest into my confidence; in truth without her I should have made but little advance, for the fruitful idea in the whole business dropped from her friendly lips. It was she who invented the short cut, who severed the Gordian knot. It is not supposed to be the nature of women to rise as a general thing to the largest and most liberal

10/13.5 Janson 10 pt. type 13.5 pt. line

Line length

Appropriate leading for text is as much a function of line length as it is a question of type size and leading. Shorter lines require less leading; longer lines, more.

In general text settings—specifically not including captions and headlines—a good rule of thumb is to keep line length somewhere between 35 and 65 characters. In practice, limitations of space or the dictates of special use may require longer or shorter lengths. In any event, be sensitive to that moment when extremely long or short line lengths impair easy reading.

I had taken Mrs. Prest into my confidence; in truth without her I should have made but little advance, for the fruitful idea in the whole business dropped from her friendly lips. It was she who invented the short cut, who severed the Gordian knot. It is not supposed to be the nature of women to rise as a general thing to the largest and most liberal view—I mean of a practical scheme; but it has struck me that they sometimes throw off a bold conception—such as a man would not have risen to-with singular serenity. "Simply ask them to take you in on the footing of a lodger"—I don't think that unaided I should have risen to that. I was beating about the bush, trying to be ingenious, wondering by what combination of arts I might have become an acquaintance, when she offered this happy suggestion that the way to become an acquaintance was first to become an inmate. Her actual knowledge of the Misses Bordereau was scarcely larger than mine, and indeed I had

10/12 Janson x 22p3

I had taken Mrs. Prest into my confidence; in truth without her I should have made but little advance, for the fruitful idea in the whole business dropped from her friendly lips. It was she who invented the short cut, who severed the Gordian knot. It is not supposed to be the nature of women to rise as a general thing to the largest and most liberal view—I mean of a practical scheme; but it has struck me that they sometimes throw off a bold conception—such as a man would not have risen to—with singular serenity. "Simply ask them to take you in on the footing of a lodger"—I don't think that unaided I should have risen to that. I was beating about the bush, trying to be ingenious, wondering by what combination of arts I might have become an acquaintance, when she offered this happy suggestion that the way to become an acquaintance was first to become an inmate. Her actual knowledge of the Misses

I had taken Mrs. Prest into my confidence; in truth without her I should have made but little advance, for the fruitful idea in the whole business dropped from her friendly lips. It was she who invented the short cut, who severed the Gordian knot. It is not supposed to be the nature of women to rise as a general thing to the largest and most liberal view-I mean of a practical scheme; but it has struck me that they sometimes throw off a bold conception—such as a man would not have risen to—with singular serenity. "Simply ask them to take you in on the footing of a lodger"—I don't think that unaided I should have risen to that. I was beating about the bush, trying to be ingenious, wondering by

10/12 Janson x 16p3

I had taken Mrs. Prest into my confidence; in truth without her I should have made but little advance, for the fruitful idea in the whole business dropped from her friendly lips. It was she who invented the short cut, who severed the Gordian knot. It is not supposed to be the nature of women to rise as a general thing to the largest and most liberal view—I mean of a practical scheme; but it has struck me that they sometimes throw off a bold conception—such as a man would not have risen to—with singular serenity. "Simply ask them to take you in on the footing of a lodger"—I don't think that unaided I should have risen to that. I was beating about the

I had taken Mrs. Prest into my confidence; in truth without her I should have made but little advance, for the fruitful idea in the whole business dropped from her friendly lips. It was she who invented the short cut, who severed the Gordian knot. It is not supposed to be the nature of women to rise as a general thing to the largest and most liberal view-I mean of a practical scheme; but it has struck me that they sometimes throw off a

10/12 Janson x 10p4

I had taken Mrs. Prest into my confidence; in truth without her I should have made but little advance, for the fruitful idea in the whole business dropped from her friendly lips. It was she who invented the short cut, who severed the Gordian knot. It is not supposed to be the nature of women to rise as a general thing to the largest and most liberal view—
I mean of a practical scheme; but it has struck me that

Lorem jusum dolor sit smet, consecuence adipiscing ellit, sed diam nommy nihe eissend tincidum tu alorest dolore magna aliquam erat volutpat. Ur wisi enim ad minim veniam, quis nostrud exercit tation allamoorper. Suscipi loborsi in liu aliquip e ne commodo consequat. Duis autem vel emi hirrie dolor in hendrerit in vulquature velit esse molestic consequat, veli illum dolore en feuglat mulla facilisis at vero eros et accumsan. Isatro odio dignissim qui blandit preseent huptrum zarril delenit sugue duis dolore te feuglat mulla facilisis at vero eros et accumsan. Isatro odio dignissim qui blandit preseent huptrum zarril delenit sugue duis dolore te feuglat mulla facilisi. Lorem ipsum dolore sit amen, consecuence adjuscing elli, sed diam nonummy nihh esismod tincidunt ut laorest dolore magna aliquam erat volutpat. Ur wisi enim and minim veniam, quis nostrud exerci tation ulliamoorper suscipit loborits inist ut aliquip et es commodo consequat. Duis sutem vel emi intrue dolor in hendrerit in vulpuotate velit esse molestic consequat, vel illum dolore es feugiat nulla facilisis. Nam ilber tempor cum soluta nobis eleifend option congue nihil imperedite doming id quod mazim placerat facer possim assum. Lorem ipsum dolore ai teme, consecuent soluta nobis eleifend option congue nihil imperedite doming id quod mazim placerat facer possim assum. Lorem ipsum dolore ai teme, consecuent placerat facer possim assum. Lorem ipsum dolore un feuglat nulla facilisi at vero reto est executam el vita eva deventa devert attorio ulliamoorper suscipit loboret in lendrerit in vulputate velit esse molestiec consequat, veli illum dolore en feuglat nulla facilisia at vero consecuent plum dolore en feuglat nulla facilisia at vero est escumsan et insto odio dignissim qui blandit reseent la velit esse molestiec consequat, velit illum dolore en feugiat nulla facilisia at vero est escumsan et uni vulquate velit esse molestiec consequat. Vul visi enim adminim veniam, quis norture devert atton ullamoorper suscipit lobortis amet, consecuentere adjatic

Lorem ipsum dolor sit amet, consectetuer adipiscing elit, sed diam nonummy nibh euismod tincidunt ut laoreet dolore magna aliquam erat volutpat. Ut wisi enim ad minim veniam, quis nostrud exerci tation ullamcorper. Suscipit lobortis nisl ut aliquip ex ea commodo consequat. Duis autem vel eum iriure dolor in hendrerit in vulputate velit esse molestie consequat, vel illum dolore eu feugiat nulla facilisis at vero eros et accumsan. Iusto odio dignissim qui blandit praesent luptatum zzril delenit augue duis dolore te feugait nulla facilisi. Lorem ipsum dolor sit amet, consectetuer adipiscing elit, sed diam nonummy nibh euismod tincidunt ut laoreet dolore magna aliquam erat volutpat. Ut wisi enim ad minim veniam, quis nostrud exerci tation ullamcorper suscipit lobortis nisl ut aliquip ex ea commodo consequat. Duis autem vel eum iriure dolor in hendrerit in vulputate velit esse molestie consequat, vel illum dolore eu feugiat nulla facilisis at vero eros et accumsan et iusto odio dignissim qui blandit praesent luptatum zzril delenit augue duis dolore te feugait nulla facilisi. Nam liber tempor cum soluta nobis eleifend option congue nihil imperdiet doming id quod mazim placerat facer possim assum. Lorem ipsum dolor sit amet, consectetuer adipiscing elit, sed diam nonummy nibh euismod tincidunt ut laoreet dolore magna aliquam erat volutpat. Ut wisi enim ad minim veniam, quis nostrud exerci tation ullamcorper suscipit lobortis nisl ut aliquip ex ea commodo consequat. Duis autem vel eum iriure dolor in hendrerit in vulputate velit esse molestie consequat, vel illum dolore eu feugiat nulla facilisis at vero eros et accumsan et justo odio dignissim qui blandit praesent luptatum zzril delenit augue duis dolore te feugait nulla facilisi. Lorem ipsum dolor sit amet, consectetuer adip Lorem ipsum dolor

Compositional requirements

Text type should create a field that can occupy the page much as a photograph does. Think of your ideal text as having a middle gray value (above, left), not as a series of stripes (above, right).

It is often useful to enlarge type 400% on the screen to get a clear sense of the relationship between descenders on one line and ascenders on the line below. Here you can clearly see the difference one point of leading can make—a difference that is unrecognizable at 100% on most monitors.

Keep in mind that nothing replaces looking closely at an actual print-out of your work. The best screen is still an electronic approximation of the printed page.

I had taken Mrs. Prest into my confidence; in truth without her I should have made but little advance, for the fruitful idea in the whole business dropped from her friendly lips. It was she who invented the short cut, who

10/12 Janson @ 400%

I had taken Mrs. Prest into my confidence; in truth without her I should have made but little advance, for the fruitful idea in the whole business dropped from her friendly lips. It was she who

Kinds of proportion

A designer's first consideration is the size and shape of the page. Although practical limitations—particularly economies of paper—often limit the designer's options, it is extremely useful to understand how the proportions we work with have evolved, and then to test your own responses against the received wisdom. Remember that these proportions—like so much else in typography and design in general—are the result of direct observation of, and interaction with, the world around us. Only your own practice

and experimentation will give you

a feel for what page size is most

appropriate for each project.

106

The golden section

A dominant influence on the sense of proportion in Western art is the golden section. The term 'golden section' describes a relationship that occurs between two numbers when the ratio of the smaller to the larger is the same as the ratio of the larger to the sum of the two. The formula expressing this relationship is $\mathbf{a}: \mathbf{b} = \mathbf{b}: (\mathbf{a} + \mathbf{b}).$

The aspect ratio described by a golden section is 1:1.618.

The golden section has existed as a model for proportion since classical times, employed by architects and visual artists in determining composition at all scales, from the shape of a page to the façade of a building. Its relation to contemporary graphic design, however, has become somewhat attenuated (see page 113).

To find the golden section in a square:

1 Draw the square abcd.

2 Bisect the square with line ef. Draw an isoceles triangle cde.

3
Project the line ce along the base of the square, forming line cg.

When you remove the square from a golden rectangle, you are left with another golden rectangle.

Project the line de along the base of the square, forming line dk.

Draw the new rectangles efgh and efkj.

Both rectangles **efgh** and **efkj** have the proportions of the golden section; the relationship of **eh** to **gh** is the same as the relationship of **gh** to **(eh + gh)**. Similarly, the relationship of **ej** to **jk** is the same as the relationship of **jk** to **(ej + jk)**—all are 1:1.618.

108 Fibonacci sequence

Another useful model when considering proportions is the Fibonacci sequence. Named for Italian mathematician Leonardo Fibonacci (c.1170–1240), a Fibonacci sequence describes a sequence in which each number is the sum of the two preceding numbers:

0 1 [1+0] 2 [1+1] 3 [1+2] 5 [2+3] 8 [3+5] 13 [5+8] 21 [8+13] 34 [13+21]

As the numbers in a Fibonacci sequence increase, the proportion between any two numbers very closely approximates the proportion in a golden section (1:1.618). For example, 21:34 approximately equals 1:1.618. Nature is full of examples of the Fibonacci sequence and the golden section, from the intervals of branches on a tree to the shell of a chambered nautilus.

Fibonacci's sequence always began with 1 but the proportion between any two numbers remains constant when the sequence is multiplied:

0	0	0
2	3	4
2	3	4
4	6	8
6	9	12
10	15	20
16	24	32
26	39	52
42	63	84
68	102	136

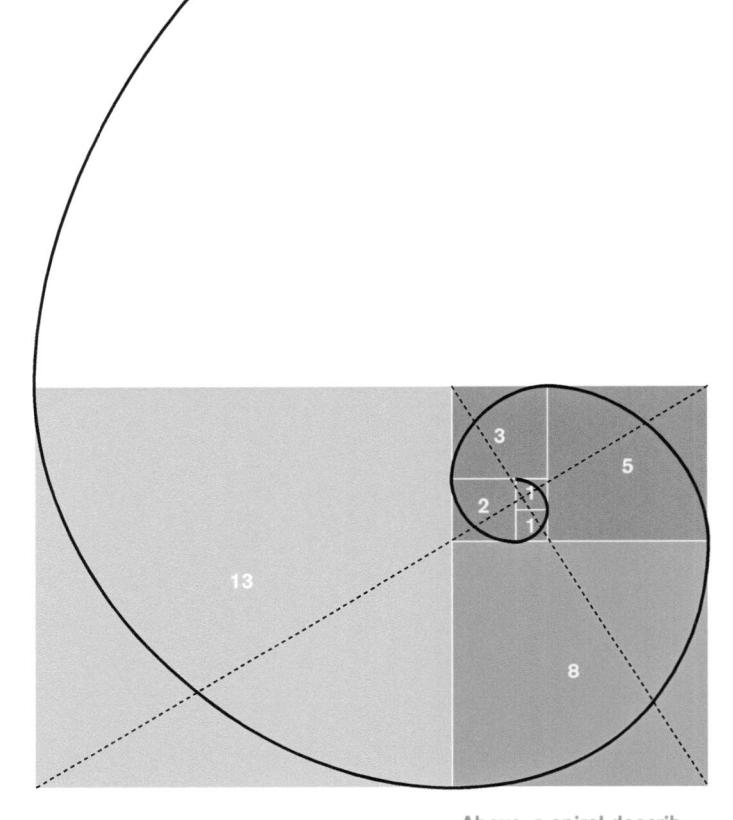

2 3

Above, a spiral describing a Fibonacci series (and the growth of a chambered nautilus). The red rectangle on the upper right approximates a golden section. As each square in the sequence is added, the orientation of the golden section changes from vertical to horizontal.

Left, one of the many examples of a Fibonacci sequence is the musical octave as seen on a piano—eight white keys and five black keys (separated into a group of two and a group of three).

Series of type sizes based on a Fibonacci sequence:

The basic sequence (beginning at 1): 5 pt., 8 pt., 13 pt., 21 pt., 34 pt., and 55 pt.

The sequence doubled: 6 pt., 10 pt., 16 pt., 26 pt., 42 pt., and 68 pt.

The first and second sequences interlaced: 6 pt., 8 pt., 10 pt., 13 pt., 16 pt., 21 pt., 26 pt., 34 pt., and 42 pt.

Compare with a straightforward arithmetic sequence (+5): 5 pt., 10 pt., 15 pt., 20 pt., 25 pt., 30 pt., 35 pt., and 40 pt.

Or, a geometric sequence (x2): 4 pt., 8 pt., 16 pt., 32 pt., and 64 pt. MAA Aa Aa Aa Aa Aa Aa Aa

AAA AA AA AA

Traditional page sizes

For the first 300 years of printing, the standard printing sheet ran anywhere between 16 x 20 in (406 x 508 mm) and 19 x 24 in (482 x 609 mm). Page sizes were referred to as folio (half sheet), quarto (quarter sheet), and octavo (eighth sheet). Specific dimensions of these page sizes varied according to size of the basic sheet. Note that only the folio and octavo sizes approximate the golden section.

Standard American paper sizes

In American printing (and in those countries dependent upon American suppliers), most paper sizes are based on a page size of 8.5 x 11 in (216 x 279 mm) or 9 x 12 in (229 x 305 mm). As you can see opposite, these sizes derive from the traditional sheet, although they have been modified based on the economies of the current standard printing sheet. There is no longer any relationship to the golden section except for the 5.5 x 8.5 in (140 x 216 mm) sheet.

8.5 x 11 in (216 x 279 mm) sheet Aspect ratio 1:1.294

9 x 12 in (229 x 355 mm) sheet Aspect ratio 1:1.333

5.5 x 8.5 in (140 x 216 mm) sheet Aspect ratio 1:1.545

6 x 9 in (152 x 229 mm) sheet Aspect ratio 1:1.5

An A0 sheet, divided into component parts. An A0 sheet measures exactly 1m².

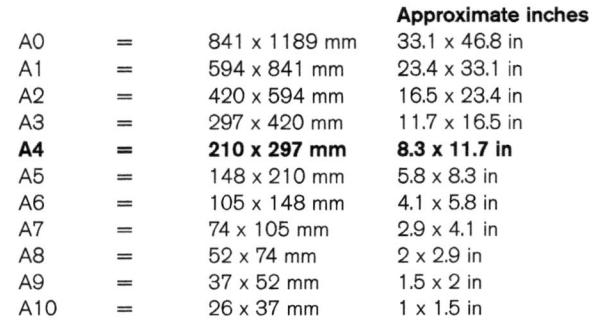

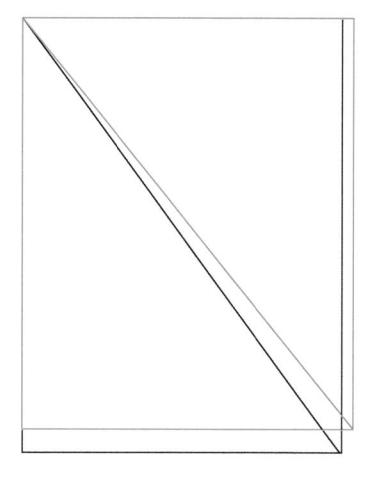

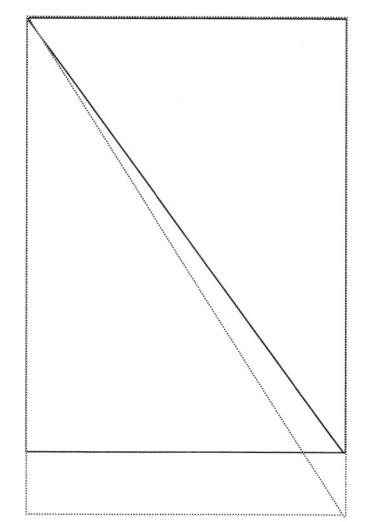

Relative size and proportion of A4 (black), 8.5 x 11 in (216 x 279 mm; red), and golden section taken from A4 (dotted black) and 8.5 x 11 in (216 x 279 mm; dotted red)

European paper: the ISO system In Europe—and many other parts of the world—paper sizes are based on what is called the ISO (International Organization for Standardization) system. The ISO system was originated at the beginning of the 20th century by Nobel laureate Wilhelm Ostwald, who proposed an aspect ratio of 1 to the square root of 2 (1.414) as the basis for all printed matter—from postage stamps to oversized posters. The beauty of this ratio is that any sheet of paper trimmed to this format, when cut or folded in half, produces a sheet with exactly the same aspect ratio (1:1.414). The basic ISO sheet sizes are:

A0 (841 x 1189 mm) B0 (1000 x 1414 mm) C0 (917 x 1297 mm) In practical applications, the A series is the basic page size (A4 is the equivalent of the American 8.5 x 11 inch sheet). The B series is often used for books and flyers; this book is trimmed to the B5 format (6.9 x 9.8 in; 176 mm x 250 mm).

Other than the mathematical elegance of the ISO system and the possible esthetic preference for its proportions, nothing necessarily recommends ISO over American format other than use. And there is nothing to say that only standard sizes are appropriate for any particular task, as we shall see later.

Components of the text page

Verso

When designing a book with sequential text, we need to be familiar with the terms that describe what makes up a page.

Recto

114

The right-hand page. In book work, this page is always odd-numbered (i.e. page 1 is always a recto).

Verso

The left-hand page. This page is always even-numbered.

Text page

(Top) This is the area of the page that is used exclusively for text. The size of this area depends upon several factors: the size of the page itself, the size of the text type, and the length of a line of text. Common sense should dictate all three. For example, a book meant to be handheld can be much smaller than a book intended to rest on a flat reading surface. Text type should typically be readable approximately half a meter (19 inches) away from the eye. Finally, the ideal line length is no more than 65 characters maximum.

Margins

(Bottom) This is the part of the page where text isn't. This area must be large enough to accommodate any marginalia (see following), the amount of paper hidden by the book's binding, and, perhaps most importantly, the space needed for one's hands—specifically one's thumbs—to hold the book open without obscuring the text.

Recto

Top: A spread showing text pages

Bottom: A spread showing margins

Folios/headers

Folios (page numbers) and headers are material in the margins that tells the reader where he or she is in the text. Depending where on the page they appear, headers are referred to as running heads (top), running shoulders (sides), or running feet (bottom). Headers may display the book or part title on the verso and the chapter title on the recto, or chapter title on the recto. Folios may appear in any of these locations. (See also pages 186–187.)

1 Running heads 2 Running shoulders 3 Running feet

1.5 1.5 Dorem ipsum dolor sit amet, consectetuer adipiscing elit, Lorem ipsum dolor sit amet, consectetuer adipiscing elit, sed diam nonummy nibh euismod tincidunt ut Jaoreet sed diam nonummy nibh euismod tincidunt ut laoreet dolore magna aliquam erat volutpat. Ut wisi enim ad dolore magna aliquam erat volutpat. Ut wisi enim ad minim veniam, quis nostrud exerci tation ullamcorper minim veniam, quis nostrud exerci tation ullamcorper suscipit lobortis nisl ut aliquip ex ea commodo consequat. suscipit lobortis nisl ut aliquip ex ea commodo consequat. Duis autem vel eum iriure dolor in hendrerit in vulputate Duis autem vel eum iriure dolor in hendrerit in vulputate velit esse molestie consequat, vel illum dolore eu feugiat velit esse molestie consequat, vel illum dolore eu feugiat nulla facilisis at vero eros et accumsan et iusto odio nulla facilisis at vero eros et accumsan et iusto odio dignissim qui blandit praesent luptatum zzril delenit augue sim qui blandit praesent luptatum zzril delenit augue duis dolore te feugait nulla facilisi. Lorem ipsum dolor sit duis dolore te feugait nulla facilisi. Lorem ipsum dolor sit amet, consectetuer adipiscing elit, sed dism nonummy nibh amet, consectetuer adipiscing elit, sed diam nonummy nibh euismod tincidunt ut laoreet dolore magna aliquam erat volutpat. Ut wisi enim ad minim veniam, quis nostrud euismod tincidunt ut laoreet dolore magna aliquam erat volutpat. Ut wisi enim ad minim veniam, quis nostrud exerci tation ullamcorper suscipit lobortis nisl ut aliquip ex exerci tation ullamcorper suscipit lobortis nisl ut aliquip ex ea commodo consequat. Duis autem vel eum iriure dolor in ea commodo consequat. Duis autem vel eum iriure dolor in hendrerit in vulputate velit esse molestie consequat, vel hendrerit in vulputate velit esse molestie consequat, vel illum dolore eu feugiat nulla facilisis at vero eros et accumsan et iusto odio dignissim qui blandit praesent illum dolore eu feugiat nulla facilisis at vero eros et accumsan et iusto odio dignissim qui blandit praesent luptatum zzril delenit augue duis dolore te feugait nulla luptatum zzril delenit augue duis dolore te feugait nulla facilisi. Nam liber tempor cum soluta nobis eleifend option facilisi. Nam liber tempor cum soluta nobis eleifend option congue nihil imperdiet doming id quod mazim placerat congue nihil imperdiet doming id quod mazim placerat facer possim assum. Lorem ipsum dolor sit amet, consectetuer adipiscing elit, sed diam nonummy nibh facer possim assum. Lorem ipsum dolor sit amet, consectetuer adipiscing elit, sed diam nonummy nibh euismod tincidunt ut laoreet dolore magna aliquam erat euismod tincidunt ut laoreet dolore magna aliquam erat volutpat. Ut wisi enim ad minim veniam, quis nostrud volutpat. Ut wisi enim ad minim veniam, quis nostrud exerci tation ullamcorper suscipit lobortis nisi ut aliquip ex exerci tation ullamcorper suscipit lobortis nisl ut aliquip ex ea commodo consequat. Duis autem vel eum iriure dolor in ea commodo consequat. Duis autem vel eum iriure dolor in hendrerit in vulputate velit esse molestie consequat, vel hendrerit in vulputate velit esse molestie consequat, vel illum dolore eu feugiar nulla facilisis at vero eros et illum dolore eu feugiat nulla facilisis at vero eros et accumsan et iusto odio dignissim qui blandit praesent accumsan et iusto odio dignissim qui blandit prae Juptatum zzril delenit augue duis dolore te feugait nulla luptatum zzril delenit augue duis dolore te feugait nulla 3 3

Just as the golden section can be seen as one ideal of proportion, there is also an ideal layout based on the golden section. Shown above, this layout has been considered an ideal since the creation of illuminated books in the Middle Ages, although by the advent of printing it was a 'custom more honored in the breach than the observance' (Shakespeare).

The rules for this layout are simple:

The height of the text field equals the width of the full page (——).

The placement of the text field is determined by the diagonals that describe both the page and the field.

The margins at the gutter of the spread (along the spine of the book) define 1 unit of measure. The margin at the top of the page equals 1.5 units. The margins to the outside of the page equal 2 units. And the margin at the bottom equals 3 units.

Note that part of what makes this layout appealing is the tension created by the different margins. Text occupies approximately 40% of the page area.

Lorem ipsum dolor sit amet, consectetuer adipiscing elit, sed diam nonummy nibh euismod tincidunt ut laoreet dolore magna aliquam erat volutpat. Ut wisi enim ad minim veniam, quis nostrud exerci tation ullamcorper suscipit lobortis nisl ut aliquip ex ea commodo consequat. Duis autem vel eum iriure dolor in hendrerit in vulpu velit esse molestie consequat, vel illum dolore eu feugiat nulla facilisis at vero eros et accumsan et justo odio dignissim qui blandit praesent luptatum zzril delenit augus duis dolore te feugait nulla facilisi. Lorem ipsum dolor sit amet, consectetuer adipiscing elit, sed diam nonummy nibh euismod tincidunt ut laoreet dolore magna aliquam erat volutpat. Ut wisi enim ad minim veniam, quis nostrud exerci tation ullamcorper suscipit lobortis nisl ut aliquip ex ea commodo consequat. Duis autem vel eum iriure dolor in hendrerit in vulputate velit esse molestie conseguat, vel illum dolore eu feugiat nulla facilisis at vero eros et accumsan et iusto odio dignissim qui blandit praesent luptatum zzril delenit augue duis dolore te feugait nulla facilisi. Nam liber tempor cum soluta nobis eleifend option congue nihil imperdiet doming id quod mazim placerat facer possim assum. Lorem ipsum dolor sit amet, consectetuer adipiscing elit, sed diam nonummy nibh euismod tincidunt ut laoreet dolore magna aliquam erat volutpat. Ut wisi enim ad minim veniam, quis nostrud exerci tation ullamcorper suscipit lobortis nisl ut aliquip ex ea commodo consequat. Duis autem vel eum iriure dolor in hendrerit in vulputate velit esse molestie consequat, vel illum dolore eu feugiat nulla facilisis at vero eros et accumsan et iusto odio dignissim qui blandit praesent luptatum zzril delenit augue duis

Lorem ipsum dolor sit amet, consectetuer adipiscing elit sed diam nonummy nibh euismod tincidunt ut laoreet dolore magna aliquam erat volutpat. Ut wisi enim ad minim veniam, quis nostrud exerci tation ullamcorper suscipit lobortis nisl ut aliquip ex ea commodo consequat. Duis autem vel eum iriure dolor in hendrerit in vulputate velit esse molestie consequat, vel illum dolore eu feugiat nulla facilisis at vero eros et accumsan et justo odio dignisim qui blandit praesent luptatum zzril delenit augue duis dolore te feugait nulla facilisi. Lorem ipsum dolor sit amet, consectetuer adipiscing elit, sed diam nonumn nibh euismod tincidunt ut laoreet dolore magna aliquam erat volutpat. Ut wisi enim ad minim veniam, quis nostrud exerci tation ullamcorper suscipit lobortis nisl ut aliquip ex ea commodo consequat. Duis autem vel eum iriure dolor in hendrerit in vulputate velit esse molestie consequat, vel illum dolore eu feugiat nulla facilisis at vero eros et accumsan et iusto odio dignissim qui blandit praesent luptatum zzril delenit augue duis dolore te feugait nulla facilisi. Nam liber tempor cum soluta nobis eleifend option congue nihil imperdiet doming id quod mazim placerat façer possim assum. Lorem ipsum dolor sit amet, consectetuer adipisc ing elit, sed diam nonummy nibh euismod tincidunt ut oreet dolore magna aliquam erat volutpat. Ut wisi enim ad minim veniam, quis nostrud exerci tation ullamcorper suscipit lobortis nisl ut aliquip ex ea commodo consequat. Duis autem vel eum iriure dolor in hendrerit in vulputa velit esse molestie consequat, vel illum dolore eu feugiat nulla facilisis at vero eros et accumsan et iusto odio dignissim qui blandit praesent luptatum zzril delenit augue duis

8.5 x 11 in (216 x 279 mm)

Δ4

The requirements of contemporary printing take us far away from the medieval ideal. The examples above show how the layout principle in the golden rectangle page (width of page equals height of text) do not convert to an 8.5 x 11 in (216 x 279 mm) or an A4 sheet. Clearly, the proportions of these pages require their own set of rules. We live in an era when xerography rules, and, as often as not, whatever comes most easily out of the copier or laser printer determines the most appropriate paper sizes-none of which approximates a golden rectangle.

Book printing allows for more freedom in choosing page sizes, but economies of paper typically demand far narrower margins and longer lines than the ancients would have tolerated (look at any textbook). Commerce demands printed pieces that are best suited to sizes and shapes of paper unimagined in 1455 (consider flyers, mailers, brochures, folders, schedules—and on and on). Very few of the messages in these pieces demand the kind of sustained reading best served by a single field of text carefully placed on the page.

So typographers now operate in a world where readability, meaning, clarity, and appropriateness are constantly being tested against the realities of the marketplace and the specific requirements of the page. Our task becomes that of applying what we can of the old principles to contemporary situations.

Because reading is a physical act, the first goal of designing text is to make the experience pleasurable. On the page opposite, a first page of text (in this case, Jane Austen's Pride and Prejudice) displays several of the considerations that contribute to successful text setting. Page size (B5) makes for a portable book, comfortable in the hand, easy to read in a variety of environments. Margins provide adequate room for the reader to hold the pages open without obscuring text. Type size and leading (11/14 Janson Text) is clear to the reader when the book is held at arm's length. Moderate line length (approximately 65 characters) helps prevent fatigue as the eye jumps from the end of one line to the beginning of the next.

While satisfying the larger requirements, text design allows for a variety of details that can ornament the page without intruding on easy, pleasurable reading. Some of the widely used options for chapter openers are displayed on this page.

Note that title pages do not have headers, but do have folios.

Chapter I It is a work universally released upon of a wing, man in possession of a good fermen must be in was of a wing. However fine bloomer the facility or wisse of must man may be a facility or the state of the state of the state of the state of the displaying or the state of the

Text: flush left, ragged right Head: Centered, rule above Folios: Flush out

Chapter I

To a rech subverselly school-edged that a shight man in possession.
Let's good ferrom some be in ware of a wide.

Let's good ferrom some be in ware of a wide.

In the contract of
Text: Justified First line: Drop cap Head: Flush left, rule above Folios: Flush out Chapter I

Li is study university advocation of a good former must be in water of a wide.

However limit known the feelings or views of each a same my be.

However limit known the feelings or views of each a same my be to the sinks of the conventing faults, the size of the conventing faults, that he is considered as the righted property of some one or other of their deaphore.

My day and Kommar, and he had yet has no each place my so he and Mr. Beaust registed the had not. Put it, it is remard day, but had been a size of the siz

Text: flush left, ragged right First line: Centered indent with

initial cap

Head: Centered italic Folios: Centered

Li is a much unbraumily admossfulged that a single mass in possession of a good forman much to in water of a with. However limit however the finding overed goods a man may be on its first enumering a sandphoschool, this such is on well fined in the right of the property of somes more or when of their deal parts in the rightfull property of somes more or when of their deapleters. "My four Mr. Banner," add his buf yo him come days, 'however, bushed than Northendell's Park is live in task. "Me. Banner registed such is held not. Then is in,' ermound day, 'for Mos. Long shay be shown have, and due said since all shown in.' Mr. Banner much no narrow. "Do you not want to licen who has saiden its' crited his with, imperiently." "This was invitation, moragin. "This was invitation moragin. "Why, my dans, you must know, Mrs. Long says than Netherfield is

Text: flush left, ragged right, line space between paragraphs

First line: Initial cap Head: Flush left Folios: Flush out

Opposite: Flush left head and text, paragraph indent 1 em. Note that the folio aligns visually with the right rag, not with the absolute right edge of the text page.

Chapter I

It is a truth universally acknowledged that a single man in possession of a good fortune must be in want of a wife.

However little known the feelings or views of such a man may be on his first entering a neighborhood, this truth is so well fixed in the minds of the surrounding families, that he is considered as the rightful property of some one or other of their daughters.

'My dear Mr. Bennet,' said his lady to him one day, 'have you heard that Netherfield Park is let at last?'

Mr. Bennet replied that he had not. 'But it is,' returned she, 'for Mrs. Long has just been here, and she told me all about it.'

Mr. Bennet made no answer.

'Do you not want to know who has taken it?' cried his wife, impatiently.

'You want to tell me, and I have no objection to hearing it.' This was invitation enough.

'Why, my dear, you must know, Mrs. Long says that Netherfield is taken by a young man of large fortune from the north of England; that he came down on Monday in a chaise-and-four to see the place, and was so much delighted with it that he agreed with Mr. Morris immediately; that he is to take possession before Michaelmas, and some of his servants are to be in the house by the end of next week.'

'What is his name?'

'Bingley.'

'Is he married or single?'

'Oh, single, my dear, to be sure! A single man of large fortune—four or five thousand a year. What a fine thing for our girls!'

'How so? How can it affect them?'

'My dear Mr. Bennet,' replied his wife, 'how can you be so tiresome? You must know that I am thinking of his marrying one of them.'

'Is that his design in settling here?'

'Design? nonsense, how can you talk so! But it is very likely that he may fall in love with one of them, and therefore you must visit him as soon as he comes.'

'I see no occasion for that. You and the girls may go, or you may send them by themselves, which perhaps will be still better; for as you are as handsome as any of them, Mr. Bingley may like you the best of the party.'

'My dear, you flatter me. I certainly have had my share of beauty, but I do not pretend to be anything extraordinary now. When a woman has five grownup daughters, she ought to give over thinking of her own beauty.'

'In such cases a woman has not often much beauty to think of.'

'But, my dear, you must indeed go and see Mr. Bingley when he comes into the neighborhood.'

'It is more than I engage for, I assure you.'

'But consider your daughters. Only think what an establishment it would be for one of them! Sir William and Lady Lucas are determined to go, merely on that account; for in general, you know, they visit no newcomers. Indeed, you must go, for it will be impossible for us to visit him, if you do not.'

'You are over-scrupulous, surely. I dare say Mr. Bingley will be very glad to see you; and I will send a few lines by you to assure him of my hearty consent to his marrying whichever he chooses of the girls; though I must throw in a good word for my little Lizzy.'

'I desire you will do no such thing. Lizzy is not a bit better than the others; and I am sure she is not half so handsome as Jane, nor half so goodhumored as Lydia. But you are always giving her the preference.'

'They have none of them much to recommend them,' replied he. 'They are all silly and ignorant like other girls; but Lizzy has something more of quickness than her sisters.'

'Mr. Bennet, how can you abuse your own children in such a way? You take delight in vexing me. You have no compassion on my poor nerves.'

'You mistake me, my dear. I have a high respect for your nerves. They are my old friends. I have heard you mention them with consideration these twenty years at least.'

PRIDE AND PREJUDICE

'Oh, single, my dear, to be sure! A single man of large fortune-four or five thousand a year. What a fine thing for our girls! 'How so? How can it affect them?'

'My dear Mr. Bennet,' replied his wife, 'how can you be so tiresome? You must know that I am thinking of his marrying one of them." 'Is that his design in settling here?'

CHAPTER ONE

'Design? nonsense, how can you talk so! But it is very likely that he may fall in love with one of them, and therefore you must visit him as soon as he comes.'

'I see no occasion for that. You and the girls may go, or you may send them by themselves, which perhaps will be still better; for as you are as handsome as any of them, Mr. Bingley may like you the best

PRIDE AND PREIIIDICE

'Oh. single, my dear, to be sure! A single man of large fortune-four or five thousand a year. What a fine thing for our girls!

'How so? How can it affect them?'

'My dear Mr. Bennet,' replied his wife, 'how can you be so tiresome? You must know that I am thinking of his marrying one of them.' 'Is that his design in settling here?'

CHAPTER ONE

'Design? nonsense, how can you talk so! But it is very likely that he may fall in love with one of them, and therefore you must visit him as soon as he comes."

'I see no occasion for that. You and the girls may go, or you may send them by themselves, which perhaps will be still better; for as you are as handsome as any of them, Mr. Bingley may like you the best

PRIDE AND PRESUDICE

'Oh, single, my dear, to be sure! A single man of large fortune—four or five thousand a year. What a fine thing for our girls!'
'How so? How can it affect them?'
'My dear Mr. Bennet,' replied his wife, 'how can you be so tiresome?

You must know that I am thinking of his marrying one of them.' 'Is that his design in settling here?'

CHAPTER ONE

'Design? nonsense, how can you talk so! But it is very likely that he may fall in love with one of them, and therefore you must visit him as soon as he comes.'

'I see no occasion for that. You and the girls may go, or you ma send them by themselves, which perhaps will be still better; for as you are as handsome as any of them, Mr. Bingley may like you the best

PRIDE AND PREIUDICE

'Is that his design in settling here?'

'Oh, single, my dear, to be sure! A single man of large fortune—four or five thousand a year. What a fine thing for our girls!' 'How so? How can it affect them?' 'My dear Mr. Bennet,' replied his wife, 'how can you be so tiresome? You must know that I am thinking of his marrying one of them.

'Design? nonsense, how can you talk so! But it is very likely that he may fall in love with one of them, and therefore you must visit him as 'I see no occasion for that. You and the girls may go, or you may

send them by themselves, which perhaps will be still better; for as you are as handsome as any of them, Mr. Bingley may like you the best

PRIDE AND PREJUDICE

'Oh, single, my dear, to be sure! A single man of large fortune—four or five thousand a year. What a fine thing for our girls! 'How so? How can it affect them?'
'My dear Mr. Bennet,' replied his wife, 'how can you be so tiresome? You must know that I am thinking of his marrying one of them.'

CHAPTER ONE

3

'Design? nonsense, how can you talk so! But it is very likely that he may fall in love with one of them, and therefore you must visit him as

soon as he comes.

I see no occasion for that. You and the girls may go, or you may
send them by themselves, which perhaps will be still better; for as
are as handsome as any of them, Mr. Bingley may like you the best

Opposite: Sans serif text (10.5/14 Meta Book) set flush left, ragged right, paragraph indent 1 em. Note that the folio and running head align left with the text.

Is that his design in settling here?"

Above: Five simple variations on placement of running heads: centered, centered with rule above, flush out, flush left with rule above, and flush in with folios flush out. The possibilities

It should be easy to imagine that the possibilities are just as numerous for placement of folios.

Front matter, back matter

Material preceding or following the text proper is called **front matter** and **back matter**. The content and sequencing of these pages has evolved over the centuries since Gutenberg, and continues to be adjusted to fit particular circumstances (the Table of Contents and Introduction in this book, for instance, begin on versos as opposed to rectos). Consider the list here to be suggestive, and, except for pages i—iv (half title through copyright page), not prescriptive.

122

Pages in front matter are numbered in lowercase roman numerals. Back matter pages continue the arabic numerals of the text. The visual presentation of these pages should grow logically out of the typefaces, type sizes, and margins used in the main body of the text.

ver Vándy of Vien Jerra, a poudulind

Page i Half title THE
History of
Tom Jones,
A FOUNDLING
Henry Fielding

Page iii
Full title
(Page ii-frontispiece-is blank)

Contents

- tx Deficati
 - 1 BOOK ! CONTAINING AS MUCH OF THE EIRTH OF THE FOUNDLING AS IS NECESSARY OR PROPER TO ACQUAINT THE READER WITH IN THE
- 25 Chapter 1 The introduction to the work, or bill of fare to the feast.
- 37 Chapter 11 A short description of squire Allworthy, and a fuller account of Miss Bridget Allworthy, his sister.
- An odd accident which befel Mr Allworthy at his return home. The decent behaviour of Mrs Deborah Wilkins, with some proper animadversions on bastards.
- The reader's neck brought into danger by a description; his escape; and the great condescension of Miss Bridger Allworthy.

Table of contents

No matter where the front matter ends, remember that the text proper begins on page 1, which is always a recto.

Front matter

These pages include everything that precedes the first page of Chapter One.

i

Half title (also called bastard title)

The first page, containing only the title of the book. No folio on this page.

ii

Frontispiece

Although typically blank, the page opposite the title page may display artwork. In some cases, it lists other books by the same author. No folio on this page.

iii

Title page

The page shows the title, subtitle, author's name, and publisher. If the book is a new edition of a previous publication, the number of the edition will appear after the title. No folio on this page.

iv

Copyright page

This page lists the rights for the book, as well as any other important bibliographic information.

Dedication/epigraph/acknowledgments

This page is the author's chance to thank those who helped him or her, or to provide a quote that sets the tone for the text.

Table of contents

This page is treated as any first page in a chapter of text. The table of contents takes as many pages as required.

Foreword/introduction/preface

The foreword is typically written by someone other than the author. The introduction states the goals of the book. The preface describes the book's origins, and may include the acknowledgments.

Back matter

These pages round out the text, explaining technical terms, expanding notes, citing sources, cross-referencing important terms, and describing the physical production of the book. It may (but does not have to) include:

Appendix(ces) Addendum

This material is supplemental to, and typically supports, the main work.

Glossarv

This contains alphabetized definitions of words and terms central to a full understanding of the text.

Bibliography

This is a list, alphabetized by author, citing texts that inform, or have been quoted in, the book. It also includes websites, listed separately.

Footnotes

These may occur at the foot or the shoulder of the page where cited, at the end of the chapter, or at the end of the book.

Index

This is an alphabetized list of key names or terms used in the text, followed by the pages on which they appear.

Colophon

The colophon is a brief description usually located at the end of a book, describing production notes relevant to the edition and may include a printer's mark or logotype.

Indicating paragraphs

There are several options for indicating paragraphs. In the first example, (top left) we see the **pilcrow** (¶), a holdover from medieval manuscripts and seldom used today.

In the second example (top right), paragraphs are indicated simply by the start of a new line. If you employ this method, keep in mind that a long line at the end of one paragraph may make it difficult to read the start of the next. Similarly, a sentence within a paragraph that happens to fall at the beginning of a line may be mistaken for a new paragraph.

The example shown bottom left (and throughout this book) is a line space between paragraphs. Some designers occasionally set this space to be less than a full line, a solution that can be elegant in pages with a single column of text, but one that works against cross-alignment in layouts with multiple columns.

In the example bottom right, you can see the standard indentation. Typically, the indent is either an em—the size of the type—or the leading (as shown in this example—in this case, 13.5 pts.).

The nonsense words used on the pages shown here are called 'greeking,' despite the fact that most of the words are Latin or corruptions of Latin words. Typesetters have used greeking files to generate sample type since the 16th century. For the history and source of greeking, go to www.lipsum.com.

ullamcorper suscipit lobo ex ea commodo consequa vel eum iriure dolor in he tate velit esse molestie co dolore eu feugiat nulla fa et accumsan et iusto odic blandit praesent luptatun augue duis dolore. ¶ Ut minim veniam, quis nosti ullamcorper suscipit lobo ex ea commodo consequa eum iriure dolor in hend velit esse molestie consed dolore eu feugiat nulla fa et accumsan et justo odid blandit praesent luptatun augue duis dolore te feug Nam liber tempor cum s eleifend option congue n doming id quod mazim p

Lorem ipsum dolor sit ar adipiscing elit, sed diam a euismod tincidunt ut laor aliquam erat volutpat. Ut minim veniam, quis nost ullamcorper suscipit lobo ex ea commodo consequa

Duis autem vel eum iriur drerit in vulputate velit e sequat, vel illum dolore e facilisis at vero eros et ac odio dignissim qui blandi tum zzril delenit augue d gait nulla facilisi. Lorem amet elit, sed diam nonu mod tincidunt ut laoreet quam erat volutpat.

Ut wisi enim ad minim v

Lorem ipsum dolor sit ar adipiscing elit, sed diam s euismod tincidunt ut laos aliquam erat volutpat.

Duis autem vel eum iriur drerit in vulputate velit e sequat, vel illum dolore e facilisis at vero eros et ac odio dignissim qui blandi tum zzril delenit augue d gait nulla facilisi.

Lorem ipsum dolor sit ar nonummy nibh euismod laoreet dolore magna alic pat.

Ut wisi enim ad minim v trud exerci tation ullamo lobortis nisl ut aliquip ex consequat. Duis autem ve dolor in hendrerit in vul

Lorem ipsum dolor sit ar adipiscing elit, sed diam a euismod tincidunt ut laor aliquam erat volutpat. Ut minim veniam, quis nost ullamcorper suscipit lobo ex ea commodo consequa

Duis autem vel eum ir hendrerit in vulputate ve consequat, vel illum dolo facilisis at vero eros et ac odio dignissim qui blandi tum zzril delenit augue d gait nulla facilisi. Lorem amet elit, sed diam nonu mod tincidunt ut laoreet quam erat volutpat.

Ut wisi enim ad minir nostrud exerci tation ulla lobortis nisl ut aliquip ex Lorem ipsum dolor sit amet, consectetuer adipiscing elit, sed diam nonummy nibh euismod tincidunt ut laoreet dolore magn aliquam erat volutpat. Ut wisi enim ad minim veniam, quis nostrud exerci tation ullamcorper suscipit lobortis nisl ut aliqui ex ea commodo consequat.

Duis autem vel eum iriur dolor in hendrerit in vulputate velit esse molestie consequat, vel illum dolore eu feugiat nulla facilisis at vero eros et accur san et iusto odio dignissim qui blandit praesent luptatum zzril delenit augue duis dolore.

Ut wisi enim ad minim veniam, quis nostrud exerci tation ullam-corper suscipit lobortis nisl ut aliquip ex e commodo consequat. Duis autem vel eum iriure dolor in hendrerit in vulputate velit esse molestie consequat, vel illum dolore

Lorem ipsum dolor sit amet, consectetuer adipiscing elit, sed diam nonummy nib euismod tincidunt ut laoreet dolore magna aliquam erat volutpat. Ut wisi enim ad minim veniam, quis nostrud exerci tation ullamcorper suscipit lobor tis nisl ut aliquip ex ea commodo consequat.

Duis autem vel eum iriure dolor in hendrerit in vulputate velit esse molestie consequat, vel illum dolore eu feugiat nulla facilisis at vero eros et accumsan et iusto odio dignissim qui blandit prae sent luptatum zzril delenit augue duis dolore.

Ut wisi enim ad minim veniam, quis nostrud exerci tation ullamcorper suscipit lobortis nisl ut aliquip ex ea commodo consequat. Duis autem vel eum iriure dolor in hendrerit in vulputate velit ess

Above, two less predictable methods for indicating new paragraphs. In the first, type indents radically. This approach requires great care if the creation of widows (see page 136) at the end of the paragraph (as seen in the second paragraph above) is to be avoided. In the second example, the first line of the paragraph is **exdented** (as opposed to indented). This method creates unusually wide gutters between columns of text. Despite these problems, there can be strong compositional reasons for considering either option.

126

Lorem ipsum dolor sit amet, consadipiscing elit, sed diam nonumm euismod tincidunt ut laoreet dolo aliquam erat volutpat. Ut wisi eni minim veniam, quis nostrud exercullamcorper.

Suscipit lobortis nisl ut aliquip ex ea consequat. Duis autem vel eum iriun hendrerit in vulputate velit esse mole quat, vel illum dolore eu feugiat nul at vero eros et accumsan.

Iusto odio dignissim qui blandit p luptatum zzril delenit augue duis feugait nulla facilisi. Lorem ipsun sit amet, consectetuer adiniscing Lorem ipsum dolor sit amet, con adipiscing elit, sed diam nonumm euismod tincidunt ut laoreet dolo aliquam erat volutpat. Ut wisi eni minim veniam, quis nostrud exercullamcorper.

Suscipit lobortis nisl ut aliquip commodo consequat. Duis aut eum iriure dolor in hendrerit i tate velit esse molestie consequillum dolore eu feugiat nulla fa vero eros et accumsan.

Iusto odio dignissim qui blandit p luptatum zzril delenit augue duis feugait nulla facilisi. Lorem insur

Italic type

Boldface serif type

Some simple ways to highlight content within a column of text are shown here. Note that different kinds of emphasis require different kinds of contrast.

In the first example, type is highlighted with italic, in the second with boldface. In terms of 'color,' the contrast established by the bold is obviously clearer. In the third example, a sans serif bold (Univers 75) is used instead of the bold serif type (Janson) for even stronger contrast. In this example, the size of the Univers 75 has been reduced to 8.5 pts. to make its x-height match that of the 10 pt. Janson (see detail opposite). Finally, the actual color itself is changed from black to red (refer to the discussion on page 85).

Lorem ipsum dolor sit amet, conadipiscing elit, sed diam nonumm euismod tincidunt ut laoreet dolo aliquam erat volutpat. Ut wisi eni minim veniam, quis nostrud exerullamcorper.

Suscipit lobortis nisl ut aliquip commodo consequat. Duis auto eum iriure dolor in hendrerit in tate velit esse molestie conseq illum dolore eu feugiat nulla fa vero eros et accumsan.

Iusto odio dignissim qui blandit p luptatum zzril delenit augue duis feugait nulla facilisi. Lorem insur

Boldface sans serif type

Lorem ipsum dolor sit amet, consadipiscing elit, sed diam nonumm euismod tincidunt ut laoreet dolo aliquam erat volutpat. Ut wisi eni minim veniam, quis nostrud exercullamcorper.

Suscipit lobortis nisl ut aliquip ex modo consequat. Duis autem vel ure dolor in hendrerit in vulputat esse molestie consequat, vel illum eu feugiat nulla facilisis at vero er accumsan.

Iusto odio dignissim qui blandit p luptatum zzril delenit augue duis feugait nulla facilisi. Lorem insur

Colored type

Lorepsum Lorepsum

Matching x-heights between typefaces. Top, 8.5 pt. Univers 75 against 10 pt. Janson. Bottom, 10 pt. Univers 75 against 10 pt. Janson. (Examples at 400%.) Lorem ipsum dolor sit amet, con adipiscing elit, sed diam nonumm euismod tincidunt ut laoreet dolo aliquam erat volutpat. Ut wisi eni minim veniam, quis nostrud exerullamcorper.

Suscipit lobortis nisl ut aliquip ex modo consequat. Duis autem vel ure dolor in hendrerit in vulputat esse molestie consequat, vel illum eu feugiat nulla facilisis at vero er accumsan.

Iusto odio dignissim qui blandit p luptatum zzril delenit augue duis feugait nulla facilisi. Lorem insur Lorem ipsum dolor sit amet, con adipiscing elit, sed diam nonumm euismod tincidunt ut laoreet dolo aliquam erat volutpat. Ut wisi eni minim veniam, quis nostrud exercullamcorper.

Suscipit lobortis nisl ut aliquip e commodo consequat. Duis aute eum iriure dolor in hendrerit in velit esse molestie consequat, ve dolore eu feugiat nulla facilisis a eros et accumsan.

Iusto odio dignissim qui blandit p luptatum zzril delenit augue duis feugait nulla facilisi. Lorem insur

Reversed type

Reversed, indented type

Here, the type has been highlighted by placing it in a field of color. In the first example, the type has simply been dropped out of a field the same color as the text. In the third example, the type is surprinted over a field in a second color. In both instances, the left axis of the type remains constant. The fields are expanded to accommodate the type. Keep in mind the importance of a gutter between columns large enough to allow space between two color fields.

Maintaining a consistent left type axis in these two examples facilitates reading, without compromising the purpose of the highlight. If the fields were to align with the text margins and the type subsequently indented (the second and fourth examples), reading suffers.

Lorem ipsum dolor sit amet, con adipiscing elit, sed diam nonumm euismod tincidunt ut laoreet dolo aliquam erat volutpat. Ut wisi eni minim veniam, quis nostrud exerullamcorper.

Suscipit lobortis nisl ut aliquip ex modo consequat. Duis autem vel ure dolor in hendrerit in vulputat esse molestie consequat, vel illum eu feugiat nulla facilisis at vero er accumsan.

Iusto odio dignissim qui blandit p luptatum zzril delenit augue duis feugait nulla facilisi. Lorem insur Lorem ipsum dolor sit amet, con adipiscing elit, sed diam nonumm euismod tincidunt ut laoreet dolo aliquam erat volutpat. Ut wisi eni minim veniam, quis nostrud exerullamcorper.

Suscipit lobortis nisl ut aliquip e commodo consequat. Duis aute eum iriure dolor in hendrerit in velit esse molestie consequat, ve dolore eu feugiat nulla facilisis a eros et accumsan.

Iusto odio dignissim qui blandit p luptatum zzril delenit augue duis feugait nulla facilisi. Lorem insur

Surprinted, indented type

Surprinted type

Lorem ipsum dolor sit amet, conadipiscing elit, sed diam nonumm euismod tincidunt ut laoreet dolo aliquam erat volutpat:

- Ut wisi enim ad minim veniam
- Quis nostrud exerci tation ullar suscipit
- Lobortis nisl ut aliquip ex ea co consequat.

Duis autem vel eum iriure dolor i drerit in vulputate velit esse mole sequat, vel illum dolore eu feugia facilisis at vero eros et accumsan odio dignissim qui blandit praese tum zzril delenit augue duis dolor gait nulla facilisi. Lorem insum d Lorem ipsum dolor sit amet, con adipiscing elit, sed diam nonumm euismod tincidunt ut laoreet dolo aliquam erat volutpat:

- Ut wisi enim ad minim veniam
- Quis nostrud exerci tation ullamo suscipit
- Lobortis nisl ut aliquip ex ea com consequat.

Duis autem vel eum iriure dolor drerit in vulputate velit esse mole sequat, vel illum dolore eu feugia facilisis at vero eros et accumsan odio dignissim qui blandit praese tum zzril delenit augue duis dolo gait nulla facilisi. Lorem insum d

Exdenting text

Sometimes it's necessary to place certain typographic elements outside the left margin of a column of type (exdenting, as opposed to indenting) in order to maintain a strong visual axis.

Notice, in the first example, that even though the bulleted list aligns with the left type margin, the bullets themselves produce obvious indents, thereby weakening the left axis. In the second example, the bullets have been exdented, maintaining the axis. "Lorem ipsum dolor sit amet, con adipiscing elit, sed diam nonumm euismod tincidunt ut laoreet dolo aliquam erat volutpat. Ut wisi en minim veniam, quis nostrud exer ullamcorper suscipit lobortis nisl ex ea commodo consequat.

"Duis autem vel eum iriure dolor drerit in vulputate velit esse mole sequat, vel illum dolore eu feugia facilisis at vero eros et accumsan odio dignissim qui blandit praese tum zzril delenit augue duis dolo gait nulla facilisi. Lorem ipsum d amet, consectetuer adipiscing elit diam nonummy nibh euismod tir

Quotation marks, like bullets, can create a clear indent when they are aligned with the text margin. Compare the exdented quote at the top of the column with the aligned quote in the middle.

This is a good time to point out that a prime is not a single quote or an apostrophe, nor are double primes quotes. Compare:

The prime is an abbreviation for feet or for the minutes of arc. The double prime is an abbreviation for inches or the seconds of arc. Because of the limited number of keys, they were used on typewriters as substitutes for single and double quotes and apostrophes, and came to be known as 'dumb quotes.' When used as quotes in typesetting, they aren't just 'dumb'—they're criminal.

Many kinds of text have sub-divisions within major sections (such as chapters), which are typically indicated by subheads within the text. These subheads are labeled according to the level of their importance: A heads, B heads, C heads, etc. (only the most technically written texts have three or more levels of subheads). The typographer's task is to make sure that these heads clearly signify to the reader both their relative importance within the text and their relationship to each other.

A heads

A heads indicate a clean break between topics within a section. They need to offer the reader a palpable pause, a chance to catch a breath. Space—typically, more than one line space—between topics clearly suggests this sense of resting. In the first examples here, A heads are shown set larger than the text, set in small caps, and set in bold. The fourth example shows an A head exdented to the left of the text.

euismod tincidunt ut laoree aliquam erat volutpat. Ut v minim veniam, quis nostru ullamcorper.

A head

Suscipit lobortis nisl ut aliq modo consequat. Duis aute ure dolor in hendrerit in vi

euismod tincidunt ut laoreet dolore magr aliquam erat volutpat. Ut wisi enim ad minim veniam, quis nostrud exerci tation ullamcorper.

A head in bold

Suscipit lobortis nisl ut aliquip ex ea com modo consequat. Duis autem vel eum iriure dolor in hendrerit in vulputate velit esse molestie consequat, vel illum dolore eu feugiat nulla facilisis at vero eros et accumsan.

Iusto odio dignissim qui blandit praesent luptatum zzril delenit augue duis dolore te feugait nulla facilisi. Lorem euismod tincidunt ut laored aliquam erat volutpat. Ut w minim veniam, quis nostru ullamcorper.

A HEAD IN SMALL CAPS

Suscipit lobortis nisl ut aliq modo consequat. Duis aute ure dolor in hendrerit in vu

euismod tincidunt aliquam erat volut minim veniam, qu ullamcorper.

A head in bold

Suscipit lobortis n modo consequat. I ure dolor in hendr esse molestie cons eu feugiat nulla fa

B heads

Subordinate to A heads, B heads indicate a new supporting argument or example for the topic at hand. As such, they should not interrupt the text as strongly as A heads do. Here, B heads are shown in small caps, italic, bold serif, and bold sans serif.

aliquam erat volutpat. Ut w minim veniam, quis nostru ullamcorper.

B HEAD IN SMALL CAPS
Suscipit lobortis nisl ut aliq
modo consequat. Duis aute
ure dolor in hendrerit in vi

aliquam erat volutpat. Ut w minim veniam, quis nostru ullamcorper.

B head in bold

Suscipit lobortis nisl ut aliq modo consequat. Duis aute ure dolor in hendrerit in vi aliquam erat volutpat. Ut w minim veniam, quis nostru ullamcorper.

B head in italics Suscipit lobortis nisl ut alic modo consequat. Duis aute ure dolor in hendrerit in vi

aliquam erat volutpat. Ut w minim veniam, quis nostru ullamcorper.

B head in bold

Suscipit lobortis nisl ut aliq modo consequat. Duis aute ure dolor in hendrerit in vi

C heads

Although not common, C heads highlight specific facets of material within B head text. They should not materially interrupt the flow of reading. As with B heads, these C heads are shown in small caps, italics, serif bold, and sans serif bold. C heads in this configuration are followed by at least an em space, to distinguish them from the text that follows.

aliquam erat volutpat. Ut w minim veniam, quis nostru ullamcorper.

C HEAD IN SMALL CAPS Susc ut aliquip ex ea commodo o autem vel eum iriure dolor vulputate velit esse molesti

aliquam erat volutpat. Ut w minim veniam, quis nostru ullamcorper.

C head in bold Suscipit le aliquip ex ea commodo cor autem vel eum iriure dolor vulputate velit esse molesti aliquam erat volutpat. Ut w minim veniam, quis nostru ullamcorper.

C head in italics Suscipit lol aliquip ex ea commodo cor autem vel eum iriure dolor vulputate velit esse molesti

aliquam erat volutpat. Ut w minim veniam, quis nostru ullamcorper.

C head in bold Suscipit l aliquip ex ea commodo cor autem vel eum iriure dolor vulputate velit esse molesti

Putting together a sequence of subheads: hierarchy

Here are three examples of subhead treatment within text. In the first, hierarchy of subheads is indicated by size and style of type. In the second, a hierarchy of consistently bold subheads is indicated simply by the relationship of head to text. In the third, hierarchy is established by color of type (bold/italic) and position relative to text.

Obviously, there is no single way to express hierarchy within text; in fact, the possibilities are virtually limitless. Once clarity has been established, the typographer can—and should—establish a palette of weights and styles that best suits the material at hand and the voice of the author.

euismod tincidunt ut laoreet dolo aliquam erat volutpat. Ut wisi eni minim veniam, quis nostrud exerc ullamcorper.

A head

Suscipit lobortis nisl ut aliquip ex modo consequat. Duis autem vel ure dolor in hendrerit in vulputat esse molestie consequat, vel illum eu feugiat nulla facilisis at vero er accumsan.

B HEAD IN SMALL CAPS

Iusto odio dignissim qui blandit p luptatum zzril delenit augue duis feugait nulla facilisi. Lorem ipsun sit amet, consectetuer adipiscing diam nonummy nibh euismod tin laoreet dolore magna aliquam era pat.

C head in italic Ut wisi enim ad n veniam, quis nostrud exerci tation corper suscipit lobortis nisl ut alic commodo consequat. Duis autem iriure dolor in hendrerit in vulpu
euismod tincidunt ut laoreet dolo aliquam erat volutpat. Ut wisi eni minim veniam, quis nostrud exerc ullamcorper.

A head in bold

Suscipit lobortis nisl ut aliquip ex modo consequat. Duis autem vel ure dolor in hendrerit in vulputat esse molestie consequat, vel illum eu feugiat nulla facilisis at vero er accumsan.

B head in bold

Iusto odio dignissim qui blandit p luptatum zzril delenit augue duis feugait nulla facilisi. Lorem ipsun sit amet, consectetuer adipiscing diam nonummy nibh euismod tin laoreet dolore magna aliquam era pat.

C head in bold Ut wisi enim ac veniam, quis nostrud exerci tatior corper suscipit lobortis nisl ut alic commodo consequat. Duis autem iriure dolor in hendrerit in vulpu

euismod tincidunt i aliquam erat volutp minim veniam, quis ullamcorper.

A head in bold

Suscipit lobortis nis modo consequat. D ure dolor in hendre esse molestie conse eu feugiat nulla faci accumsan.

B head in bold

Iusto odio dignissin luptatum zzril deler feugait nulla facilisi sit amet, consectetu diam nonummy nib laoreet dolore magi pat.

C bead in italic Ut veniam, quis nostru corper suscipit lobo commodo consequa iriure dolor in hencesse molestie conse eu feugiat nulla faci

Widows and orphans

136 In traditional typesetting (the kind that still endures among fine book publishers and conscientious commercial publishers), there are two unpardonable gaffes-widows

and orphans.

A widow is a short line of type left alone at the end of a column of text. An orphan is a short line of type left alone at the start of a new column. (An easy mnemonic device: orphans start out alone, widows end up alone.) Consider the example opposite. You know already that text is meant to read as a field of a more-or-less middle tone. You can see how an unusually short line at the top or bottom of a paragraph disrupts that reading - in fact, creates a shape that draws attention away from simple reading.

In justified text, both widows and orphans are serious gaffes. Flush left, ragged right text is somewhat more forgiving toward widows, but only a bit. Orphans remain unpardonable.

The only solution to widows is to rebreak your line endings throughout your paragraph so that the last line of any paragraph is not noticeably short. Orphans, as you might expect, require more care. Careful typographers make sure that no column of text starts with the last line of the preceding paragraph.

Eleifend option congue nihil imperdiet doming id quod mazim placerat facer possim assum. Lorem insum dolor sit amet. consectetuer adipiscing elit, sed diam nonummy nibh euismod tincidunt ut laoreet dolore magna aliquam erat volutpat. Ut wisi enim ad minim veniam, quis nostrud exerci tation ullamcorper suscipit lobortis nisl ut aliquip ex ea commodo consequat. Duis autem vel eum iriure dolor in hendrerit in vulputate velit esse molestie consequat, vel illum dolore eu feugiat nulla facilisis at vero eros et accumsan et iusto odio dignissim qui blandit praesent lupta-

zzril delenit augue duis dolore te feugait nulla racilisi. Lorem ipsum dolor sit amet, consectetuer adip Lorem ipsum dolor sit amet, consectetuer adipiscing elit, sed diam nonummy nibh euismod tincidunt ut laoreet dolore magna aliquam erat volutpat. Ut wisi enim ad minim veniam, quis nostrud exerci tation ullamcorper suscipit lobortis nisl ut aliquip ex ea commodo consequat. Duis autem vel eum iriure dolor in hendrerit in vulputate velit esse molestie conseguat, vel illum dolore eu feugiat nulla facilisis at vero eros et accumsan et iusto odio dignissim qui blandit praesent luptatum zzril delenit augue duis dolore te feugait nulla facilisi. Lorem ipsum dolor sit amet, consectetuer adipiscing elit, sed diam nonummy nibh euismod tincidunt ut laoreet dolore magna aliquam erat volutpat. Ut wisi enim ad minim veniam, quis nostrud exerci tation ullamcorper suscipit lobortis nisl ut aliquip

liber tempor cum soluta nobis eleifend option congue nihil imperdiet doming id quod mazim placerat facer possim assum. Lorem ipsum dolor sit amet, consectetue adipiscing elit, sed diam nonummy nibh euismod tincidunt ut laoreet dolore magna aliquam erat volutpat. Ut wisi enim ad minim veniam, quis nostrud exerci tation ullamcorper suscipit lobortis nisl ut aliquip ex ea commodo consequat. Duis autem vel eum iriure dolor in hendrerit in vulputate velit esse molestie consequat, vel illum dolore eu feugiat nulla facilisis at vero eros et accumsan et iusto odio dignissim qui blandit praesent luptatum zzril delenit augue duis dolore te feugait nulla facilisi. Lorem ipsum dolor sit amet, consectetuer adip

Two widows and an orphan (above).

Columnar organization

Lorem ipsum dolor sit amet

Lorens josum dolor sit unter, consectenture dilpicaing elit, sed diam nonummy table outleand of tocidant or liserest dolore magas alsquam eru
in the control of the control of the control care of the co

mail ut alteque es accommendo consequent. Duns autent well com in interes diode in humberlois in valquiomento de la compania del co

A two-column layout

It is often useful to think of your text area divided into columns—consistent horizontal intervals that allow for more than one field of text per page. Working with columnar layouts helps you maintain a manageable line length and allows white space onto the page in places other than the margins. Keep in mind the dynamic relationship between type size, leading, and line length. Altering the last always affects the first and the second.

Lorem ipsum dolor sit amet

Loreni pieme dolor et susce, consecuentes ellipsicia gili sel si consecuentes ellipsicia gili sel si consecuentes ellipsicia gili sel si consecuente si consecuente si consecuente si consecuente si consecuente del consecuente del consecuente si co

doice in handereit in volpousse with one nonlessed consequent with a contract of the contract

delort magus aliquan ext volutura, quis nerror darreit salon ma, quis nerror darreit salon ma, quis nerror darreit salon ma, quis nerror darreit salon que l'acceptat del proposition de que l'acceptat de l'acceptat del consideration de l'acceptat del del l'acceptat del secteurs aliquetat del l'acceptat del secteurs del l'acceptat del l'acceptat del l'acceptat del l'acceptat del secteurs del l'acceptat del l'acceptat del l'acceptat del l'acceptat del l'acceptat del secteurs del l'acceptat del l

A three-column layout

The use of columnar layouts in printing dates right back to Gutenberg's 42-line bible (1455).

Lorem ipsum dolor sit armet Lorem journ dolor sit armet Lorem journ dolor sit armet, concentrater edipticing sit, sed diem nonminimal fandame und playing sit, and all production and sit and sit and sit and playing sit and sit and sit and sit all sit and and sit and sit and sit and sit and sit all sit and and sit and sit and sit and sit all sit and and sit and sit and sit and sit all sit and and sit and sit and sit and sit and sit and and sit and sit and sit and sit and and sit and sit and sit and sit and and sit and sit and sit and sit and and sit and sit and and sit and sit and sit and and sit and s

A five-column layout

Notice how a five-column layout allows for two fields of text and a third, narrower field for secondary information, such as notes, author profile, etc. The narrower field may in fact be too narrow for any kind of sustained reading.

Loren jpssum dolor sit amet Loren jpssum dolor sit amet Loren jpssum dolor sit smet, consequence sequence seq

An eight-column layout

You can see how this application does much the same as a five-column layout, with slightly narrower fields of text and a wider field for supplemental information. Obviously, many other variations are possible.

Horizontal layouts allow for wider fields of text, which tend to support sustained reading more comfortably than narrower fields.

Lorem ipsum dolor sit amet Lorem ipsum dolor sit amet Lorem ipsum dolor sit une, consecretare edipicing elit, sed diam nommury mish enimod discident wi lorese dolore magus aliquam erax voltegat. Ut visit mish at aliquip or a commodo consequat. Dais aurem vide un intrare dolor in handwerks in volpenare with see modesto consequat. We illum dolore en feur handwerks in volpenare with see sem coloresto consequat. Vest in the handwerks in volpenare with sees sem coloresto consequat. Vest in the celescond discolates we lore or commodo consequat. Dais aurem vide un tritore dolor in handwerks in volpenare with seas sem coloresto consequat. Vest in the entire of the colorest in the colorest in the colorest in the entire of the colorest in the colorest in the colorest in the entire of the colorest in the colorest in the colorest in the derivation of the colorest in the colorest in the colorest in the derivation in volpenare with seas modester consequent, vest in the plantame and defend sugge duich dolores to freight malified field. Vest liber derivation in volpenare with seas modester consequent, vest derivation in volpenare with seas modester consequent, vest in the plantame and defend sugges duich dolores to freight malifie quality for consequent to the colorest in the major corm solves nobel assisted option consequent hall importate decoing it quot massing plantame to the colorest plantame and defend sugges duich dolores to freight in decorate the position aurent of decir in the colorest for plantame and defend sugges duich dolores to freight in decorate the colorest in the colorest for plantame and defend sugges duich dolores to freight in decorate the colorest in the colorest for plantame and defend sugges duich dolores to freight in decorate decorat

A two-column layout

Lorem ipsum dolor	sit amet	
Lorent jumm delor de tiner, consectenter seligio- lag elle, sed diam nomumny milhe estemod tin- cidant te howeve delore magna faligam ert velor- ter. Ut wit einm el minit veniem, qui sonorral enter i tinto miliancoper emelpit botoria silu et maria deloria miliancoper emelpit botoria silu et maria delori miliancoper emelpit botoria silu et maria delori miliancoper emelpit botoria silu et maria delori miliancoper emelpit botoria silu et maria pet handit possesse lapuram mari di milian facilità es tros ore a eccamum en telmo ollo diginali ma pi biandit possesse lapuram maria di contrato per delori delori delirazione delirazione delirazione della milianti sentina, qui notorra delirazione della minianti sentina, qui notorra delori della minianti sentina, qui notorra denni fattera delori in handiere in valquate vitti casa molarita colori in handiere in valquate vitti esse molarita consequenti, villian delori en ficalizza mila facilità si vero ore en eccamum erita deligination qui biandit presente l'apparten un'ella degianti qui biandit presente l'apparten meri di dispianti qui biandit presente l'apparten meri di milianti presente l'apparten meri di milianti presente l'apparten meri di milianti presente l'apparten della della della della consequence della della della della della della della milianti presente l'apparten della dell	dian nonamny nibh esiamod daeidum ut koewet dolore magna aliquam erst volutpat. Ut wist esim ad minim wenkun, quia normed aezet unton tilmeroper saciegit holoren sind ut indipi e es commodo consequer. Dela menta wil ean intirus dolor qua, will lime dolore es fengiar mild facilità se vero area e accument e la composita del	boords niel er dejesje es a commodo conseque. Dais auem vel eum hister dolor in henderet in vulgatuss wille esse molestie conseques, vel illem vel des en financia et au vel eus molestie conseques, vel illem vel des en fesquis mils festiliss et vere eus ex exemunes es hans odos diguistius qui haufet persona des en fesquis mals festilis et vere en ex exemunes es hans odos diguistius qui haufet persona nobre additud oppien conque mila imperilet roma haufe additud oppien conque mila imperilet roma haufet des en fesquis velle mentale persona deber et unest, consectement adjudicular est locared donne rate locared donne et locared debror magna deliguam et architectul est adjusta est de la consecte del consecte de la consecte del consecte de la consecte

A three-column layout

	Lorem ipsum dolor sit a	met
Large layer for the first feet of the second comments of the layer feet of the second comments of the layer feet of the second comments o	Lorum jumm dolor sit anne, romoncomen adigincing alia, sod diam nonummuy mihr esiamod tindelmet ut korrest dolor mangan aliquam erur volupas. Ur visit mina ad minim vesiama, quin norturel aerus tom literacoper aerus politici hosturi nai et aliaqui per est commondo consequez. Data sutera vele ema iriture dolor in hamberieri in valquetane vele me modeles consequez. And ante a minime visitame si vele mendeles consequez. And ante a minime visitame si vele mendeles consequez. And ante conference del consequeza del minime vestama, quata neutra del consequeza del minime vestama, quata neutra del consequeza del consequeza del minime vestama, quata neutra del consequeza del minime vestama, quata neutra del consequeza del minime vestama, quata neutra del consequeza del minime vestama del consequeza del minime del consequeza del minime vestama del conseque	shiere in fouglat mills facilities a viveo nere et accumans et teuto des diguisation qui bhardif juzienere legarium auril defen le suque duis dolore ne fouglat mills facilitis. Loreni jumm dolor sit anne, consecuteure dill, Dereni jumm dolor sit anne, consecuteure dill, Dereni jumm dolor sit anne, consecuteure dill, Dereni jumm dolor sit anne consecuteure dill'accustion qui di maniformate in leane dellore magnati allume met avolapset. Protection della della materiale della materiale di materiale della materiale di materiale della

A five-column layout

	Lorem ipsum dolor	sit amet	
Loren from deler di erec, commente elipsing di, sel den manage del minera deler manage del minera suppre deleren en coloque, con que en coloque, con que marrie danni univer- tario del marrie danni suive-	Leven, ipoum daier et met, concentrare adipie- ing elli, sed diam nommenty allé entemod tim- cidente et lacever doice magna aliquam ente volu- les. Ut wite einem ad minim-ventum, pois noterval enerel cation tillancorper susipiri loberta indi ut aliquit en en controlo consequen. Dels autens vel ener diaton tillancorper susipiri loberta indi ut aliquit en en controlo consequen. Dels autens vel enum intre doice in heusterich in veljaturan vellt esse malis ficilishe ser verse et genommen et hans collo diguission qui bhardit priesses lupatumn zuril delinier supue duit doice ser fengate tundi facilish. Lorem ipsum deloir et unate, consectenze adipie- leanier supue duit doice ser fengate tundi facilish. Lorem ipsum deloir et unate, consectenze adipie- leanier supue duit doice ser fengate tundi sentine. Jac. Ut wait entim ad minitur-ventum, quès noterval un intere doice in heustreles in vulgatura veller esse molante consequen, vul l'ilbar delore es fengate un intere doice in heustreles in vulgatura veller esse molante consequen, vul l'ilbar delore es fengate un intere doice in heustreles in vulgatura veller esse molante consequen, vul l'ilbar delore es fengate delories supue duit doice ve fengate unità facilis. Nava liber transpor commobian noble eleffend optoin congue mili imperette donning ell quo- condition delore en consecuence sellicionel ells, soul	dian nommeny mith seisend dischter et kover- dobre magnu aligame ete rhologas. Ur visi eine, sdiminin vealam, quis joorned exerci uston ultim- sei minin vealam, quis joorned exerci uston ultim- noolo conseque. Dais senten vel eum intere dolor- modo conseque. Dais senten vel eum intere dolor- in hendretti tu hojuquas veld eum endicate conse- quas, vei illum dolore en fengier milit facilitàs et handler pessente hippatian seit dicheste supe chis- dolore in finquit rulla facilità. Lorem ipsum dolor et unec, consecuteure aligh Josem plemm dolor et unec, consecuteure aligh Josem plemm dolor et unec, consecuteure aligh Josem plemm dolor et unec, consecuteure aligh Josem plem dolor et unec, consecuteure aligh Josem plem dolor et unec, consecuteure aligh Joseph ge as con- modo conseque. Dais senten vel eum istrue dolor modo conseque. Dais senten vel eum istrue dolor handler pessente hippatian velle dachte sage da velle della	Letter from Aller it mee, common adjulge fall, and common adjulge fall of the common adjulge fall of the common adjulge (Control of the common adjulge (Con

A six-column layout

Six columns allow for two wide fields and two narrow fields per page, which can be useful in heavily annotated documents.

from Josephin & House Com- ment of Spirits & Land Com- ley Company of the Com- ley Company of the Com- pany of the Company of the Com-	Learn layers solve the raw, consumers applying the Art is as a some of the layer in both of the raw that is a some of the layer in both of the layer in the layer is a solvent of the layer in	delition in leight and list feelfile at very own or excoration of latest on the light and list feelfile at very latest and list all lists and list and list and lists and list and list and lists and list and lists and list and list and lists and list and list and lists and list and lists and list and lists and list and lists and lists and list and lists an	Lames i pares de la reta de la compositione de depuis qui de la destante de la compositione de la compositio	home to the signature, as illustically generate begames used follows: In super fast factors to the group with Saladi. Leaves to the salar to the pass of the size	
	Lorem ipsum dolor sit ar				

Cross Special Section 2 and a	Lowns in power door of more, tem- turing with a classification of the classification of the classification of the classification of the classification of the more district of the classification of the classification of the classification of the classification of t	while the model consequent, of them control co	Learn lyarm follow of most, case measures of the color of	ichem dehr in haberheit in virgionen wirden dem eine der sich eine Ausgeber der sich eine dem eine der sich eine dem eine der sich eine dem eine dem einem eine dem eine der sich eine dem eine dem eine der sich eine dem

Most often, text layouts will involve spreads (two facing pages) and not single sheets. Always keep the spread in mind when you're setting up your page. You can see here how different a spread of horizontal pages (top) feels from a spread of vertical pages (bottom).

	Lorem ipsum dolor sit a	imet			
Lorem ipsum dolor sit amet	Lorem ipsum dolor sit amet, con- sectetuer adipiscing elit, sed diam nonummy nibb euismod inicidunt ut laoreet dolore magna aliquam erat voluptar. Ut wisi cnim ad minim veniam, quis nostrud exerci tation ullamoropre suscipit loboritis nisl ut aliquip ex ea commodo con- sequat. Duis autem wel eum iriure	Consecteter adiplecing elit	Nibh euismod tincidunt ut laoreet dolore magna aliquam erat volut- pat. Ut wis einm ad minim veniam, quis nostrud exerci tation ullamoor- per suscipit lobortis nisl u aliquip ex ea commodo consequat. Duis autem vel eum iriure dolor in hen- drerit in vulputate velit esse molestie consequat, vel illum	Ut wisi enim ad minim	Lobortis nisl ut aliquip ex ea com- modo consequat. Duis autem vel cum iriure dolori in hendreiri in vulputate velit esse molestie conse- quat, vei illum dolore ut feugiat nulla facilisis at vero eros et accum- san et iusto odio dignissim qui blandit
	dolor in hendrerit in valputate velit esse molestie consequat, vel illum dolore eu feugiat mulla facilisis at vero eros et accumsan et iusto odio dignissim qui blandit praesent lup- tatum zazil delenit augue duis dolore te feugait nulla facilisi. Lorem ipsum dolor sit amet, con- sectetuer adipsicing elit, sed diam nonummy nibh euismod tincidunt ut laoreet dolore magna aliguam		dolore eu feugiat nulla facilisis at vero eros et accumsan et iusto odio dignissim qui blandit praesent luptatum zzril delenit sugue duis dolore te feugiat nulla facilisi. Lorem ipsum dolor sit amet, consectetuer adip Lorem ipsum dolor sit amet, consectetuer adip Lorem ipsum dolor sit amet, consectetuer adipiscing elit, sed diam nonummy nibh euismod	Veniem quis nostrud exerci tati	Praesent luptatum zzril delenit augue duis dolore te feugait nulla facilisi. Nam liber tempor cum soluta nobis eleifend option congue nihil imperdier doming id quod mazim placerat facer possim assum. Lorem ipsum dolor sit amet, consectetuer adipiscing elit, sed diam nonumny nibh euismod tincidunt ut laoreet dolore magna aliquam
	the storest colord magain anquain erat voltupat. Ut wisi enim ad minim veniam, quis nostrud exerci tation ullamoroper suscepit lobortis nisi ut aliquip ex ea commodo consequat. Duis autem wel eum iriure dolor in hendreit in vulputate velit esse molestie consequat, vel illum dolore eu feugiat nulla facilisis at vero eros et accumsan et iusto odio dignissim qui blandit praesent luptatum zzril delenit augue duis dolore te feugait nulla facilisi. Nam liber tempor cum solura nobis eleifend option congue nihi imperdiet doming id quod mazim placerat facer possim assum. Lorem ipsum dolor sit amet, consectetuer adipiscing elit, sed diam nonumny	Sed diam nonummy nibh	Tincidunt ut laoreet dolore magna aliquam erat volutpat. Ut wisi enim ad minim veniam, quisi nostrud exerci tation ullamoorper suscipit lobortis nisi ut aliquip ex ea commodo consequat. Duis autem vel eum iriure dolori in hendrenti in vulputate velit esse molestie consequat, vel illum dolore eu freugian nulla facilisis at vero eros et accumsan et iusto odio dignissim qui blandit praesent luptarum zaril delenit augue duis dolore te feugait nulla facilisi. Lorem ipsum dolor sit amet, consectetuer adipiscing elit, sed diam nonummy nibh euismod tincidunt ut laoreet dolore magna aliquam erat volutpat. Ut wisi enim ad minim veniam, quis nostrud exerci ation ullamoorper suscinit		erat volutpat. Ut wis eimin ad minim veniam, quis nostrud exerci tation ullamcorper suscipit lobortis insil ut aliquije et ea commodo consequat. Duis autem vel eum iriure dolor in hendrerit in vulputate velit esse molestic consequat, vel illum dolore eu feugiat nulla facilisis at vero eros et accumsan et iusto odio dignissim qui blandit praesent luptatum zzil delenit augue duis dolore te feugait nulla facilisi. Lorem ipsum dolor sit amet, consectetuer adipiscing elit, sed diam nonummy nibh euismod incidunt ut laoreet colore magna aliquam erat volutpat. Ut

Columnar layouts are effective for many different formats. Above, a three-column layout is applied to each of the three panels on an 8.5 x 11 in (216 x 279 mm) sheet.

Cross-alignment

1/1/1

Euismod tincidunt ut laoreet dolore magna aliquam erat volutpat. Ut wisi enim ad minim veniam, quis nostrud exerci tation ullamcorper suscipit lobortis nisl ut aliquip ex ea commodo conseguat. Duis autem vel eum iriure dolor in hendrerit in vulputate velit esse molestie consequat, vel illum dolore eu feugiat nulla facilisis at vero eros et accumsan et iusto odio dignissim qui blandit praesent luptatum zzril delenit augue duis dolore te feugait nulla facilisi. Lorem ipsum dolor Lorem ipsum dolor sit amet, consectetuer adipiscing elit, sed diam nonummy nibh euismod tincidunt ut laoreet dolore magna aliquam erat volutpat. Ut wisi enim ad minim veniam, quis nostrud exerci tation ullamcorper suscipit lobortis nisl ut aliquip ex ea commodo conseguat. Duis autem vel eum iriure dolor in hendrerit in vulputate velit esse molestie consequat. vel illum dolore eu feugiat nulla facilisis at vero eros et accumsan et iusto odio dignissim qui blandit praesent luptatum zzril delenit augue duis dolore te feugait nulla facilisi. Lorem ipsum dolor sit amet, consectetuer adipiscing elit, sed diam nonummy nibh euismod tincidunt ut laoreet dolore magna aliquam erat volutpat. Ut wisi enim ad minim veniam, quis nostrud exerci tation ullamcorper suscipit lobortis nisl ut aliquip ex ea commodo consequat. Duis autem vel eum iriure dolor in hendrerit in vulputate velit esse molestie consequat. vel illum dolore eu feugiat nulla facilisis at vero eros et accumsan et iusto odio dignissim qui blandit praesent luptatum zzril delenit augue duis dolore te feugait nulla facilisi. Nam liber tempor cum soluta nobis eleifend option conque nihil imperdiet doming id quod mazim placerat facer possim assum. Lorem ipsum dolor sit amet, consectetuer adipiscing elit, sed diam nonummy nibh euismod tincidunt ut laoreet dolore magna aliquam erat volutpat. Ut wisi enim ad minim veniam,

7/9 Univers 75 x 10p4

10/13.5 Janson x 22p3

Cross-aligning headlines and captions with text type reinforces the architectural sense of the page—the structure—while articulating the complementary vertical rhythms. In this example, four lines of caption type (leaded to 9 pts.) cross-align with three lines of text type (leaded to 13.5 pts.).

Lorem ipsum dolor sit amet, consectetuer quam erat volutpat.

Ut wisi enim ad minim veniam, quis nostrud exercitation

24/27 Janson x 16p (top) 14/18 Univers 75 x 10p4 (bottom) Lorem ipsum dolor sit amet, consectetuer adipiscing elit, sed diam nonummy nibh euismod tincidunt ut laoreet dolore magna aliquam erat volutpat. Ut wisi enim ad minim veniam, quis nostrud exerci tation ullamcorper suscipit lobortis nisl ut aliquip ex ea commodo conseguat. Duis autem vel eum iriure dolor in hendrerit in vulputate velit esse molestie consequat, vel illum dolore eu feugiat nulla facilisis at vero eros et accumsan et iusto odio dignissim qui blandit praesent luptatum zzril delenit augue duis dolore te feugait nulla facilisi. Lorem insum dolor sit amet, consectetuer adipiscing elit, sed diam nonummy nibh euismod tincidunt ut laoreet dolore magna aliquam erat volutpat. Ut wisi enim ad minim veniam, quis nostrud exerci tation ullamcorper suscipit lobortis nisl ut aliquip ex ea commodo consequat. Duis autem vel eum iriure dolor in hendrerit in vulputate velit esse molestie consequat, vel illum dolore eu feugiat nulla facilisis at vero eros et accumsan et

10/13.5 Janson x 16p

Above, (top left) one line of headline type cross-aligns with two lines of text type, and (bottom left) four lines of headline type cross-align with five lines of text type. Later on, we'll look at ways of choosing proportional text sizes. For now, it's important simply to keep in mind this relationship between different leadings.

Expressing hierarchy

In most circumstances, a designer's first goal is to make material comprehensible to a reader. In other words, you should understand the material well enough to know how someone else needs to read it to make the best sense out of it. This understanding happens on two levels: content and form.

The recipe on the right is a fairly straightforward presentation of the making of an apple tart. With the exception of one or two terms specific to cooking, its content does not require any special knowledge. However, in its form—the manner in which information is set and placed on a page—the process it describes can be made clearer than it appears as plain typescript.

To understand the form, you must first understand the kinds of information the recipe contains and then rank them according to levels of importance, thereby creating a hierarchy. In this recipe there are the following levels of information:

title (1) subtitles (2) text (3)

Within the text there are:

ingredient lists (3A) oven temperature instructions (3B) directions (3C)

Successfully setting this recipe in type requires that you make each of these distinctions clear to the reader. Using some of the kinds of contrast discussed on pages 62–63 and the methods outlined on pages 132–135 will help you express these distinctions.

Apple tart

The shell

- 7 tablespoons frozen butter*
- 1 cup frozen flour*
- 3 tablespoons ice-cold water*
- 1 teaspoon cider vinegar
- A pinch of kosher salt
- $\boldsymbol{\ast}$ It is important to have these ingredients as cold as possible.

Preheat the oven to 400°.

In a food processor fitted with a steel blade, combine all the ingredients until they form a solid mass that rises above the blade. You can add extra water by the tablespoon if the mass does not congeal within the first minute. Tiny pieces of butter should still be visible in the dough when it's done. Remove the dough from the bowl and work it quickly into a ball on a lightly floured surface. Cover with plastic wrap and refrigerate for at least half an hour.

After the dough has rested in the refrigerator, roll it out on a lightly floured surface until it forms a circle approximately 13 inches in diameter. Center the circle of dough in a 10-inch tart pan with a removeable bottom. Use your knuckles to make sure that the dough tucks neatly against the edge of the pan and run the rolling pin around the rim to remove the excess. Cover and refrigerate again for at least half an hour.

Line the tart shell with aluminum foil, being careful to cover the edges. Pierce the aluminum and the dough several times with a fork and fill the shell with dried lentils. Bake for 20 minutes. Remove the aluminum and the lentils and continue baking until the shell is golden brown, about 15 minutes more.

The apples

6 Granny Smith apples Juice of one lemon Cinammon to taste Nutmeg to taste

Peel, core, and halve the apples. Either by hand or with a food processor, cut the apple halves crosswise into thin (less than 1/4-inch) slices. In a large bowl, toss the apples in the lemon juice, cinammon, and nutmeg. Cover and set aside.

The pastry cream

Unset text (left and opposite)

- 1/4 cup sugar
- 1 tablespoon flour
- 2 teaspoons cornstarch
- 1 large egg
- 1 cup milk
- 3 tablespoons unsalted butter
- 1/4 teaspoon vanilla extract

Sift the sugar, flour, and cornstarch together into a mixing bowl. Add the egg and beat until light. In a heavy-bottomed saucepan, bring the milk to a boil. Stir half the milk into the egg mixture, then pour the whole mixture back into the saucepan. Cook over high heat, stirring constantly, until the center bubbles and the mixture is very thick. Remove from heat and stir in the vanilla and the butter. Pour the pastry cream into a bowl, cover tightly with plastic wrap, and refrigerate. (Be sure to press the plastic wrap right onto the cream to prevent a skin from forming.)

The assembly and baking

- 2 tablespoons sugar
- 8 ounces currant jelly

Preheat the oven to 375°.

Spread the pastry cream over the bottom of the shell. Arrange the apple slices in a circle around the outer edge of the shell, making sure the slices overlap. When the outer circle is completed, make a smaller circle, overlapping about half of the outer circle. If there's room, make a third circle. Fill the hole in the center with pieces of a few slices—let them stand upright. Cover the tart with a circle of wax paper and bake for 25 minutes. Remove the wax paper and sprinkle the sugar over the apples. Bake uncovered for 5-10 minutes more, until the sugar melts.

Boil the currant jelly until it reduces by one-third. With a pastry brush, paint the top of the tart with the currant glaze. Allow time for the glaze to set and the tart to cool before serving (10 minutes).

The shell

Preheat the oven to 400°.

I cup frozen flour* 3 tablespoons ice-cold water* I teaspoon cider vinegar A pinch of kosher salt * It is important to have these ingredients as cold as possible.

7 tablespoons frozen butter*

In a food processor fitted with a steel blade, combine all the ingredients until they form a solid mass that rises above the blade. You can add extra water by the tablespoon if the mass does not congeal within the first minute. Tiny pieces of butter should still be visible in the dough when it's done. Remove the dough from the bowl and work it quickly it into a ball on a lightly floured surface. Cover with plastic wrap and refrigerate for at least half an hour.

After the dough has rested in the refrigerator, roll it out on a lightly floured surface until it forms a circle approximately 13" in diameter. Center the circle of dough in a 10-inch tart pan with a removeable bottom. Use your knuckles to make sure that the dough tucks neatly against the edge of the pan and run the rolling pin around the rim to remove the excess. Cover and refrigerate again for at least half an hour.

Line the tart shell with aluminum foil, being careful to cover the edges. Pierce the aluminum and the dough several times with a fork and fill the shell with dried lentils. Bake for 20 minutes. Remove the aluminum and the lentils and continue baking until the shell is golden brown, about 15 minutes more.

The apples

Peel, core and halve the apples. Either by hand or with a food processor, cut the apple halves crosswise into thin (less than ¼") slices. In a large bowl, toss the appples in the lemon juice, cinammon and nutmeg. Cover and set aside.

The pastry cream

Sift the sugar, flour and cornstarch together in a mixing bowl. Add the egg and beat until light. In a heavy-bottomed saucepan, bring the milk to a boil. Stir half the milk into the egg mixture, then pour the whole mixture back into the saucepan. Cook over high heat, stirring constantly, until the center bubbles and the mixture is very thick. Remove from heat and stir in the vanilla and the butter. Pour the pastry cream into a bowl, cover tightly with plastic wrap and refrigerate. (Be sure to press the plastic wrap right onto the cream to prevent a skin from forming.)

The assembly and baking

Preheat the oven to 375°.

Spread the pastry cream over the bottom of the shell. Arrange the apple slices in a circle around the outer edge of the shell, making sure the slices overlap. When the outer circle is completed, make a smaller circle, overlapping about half of the outer circle. If there's room, make a third circle. fill the hole in the center with pieces of a few slices-let them stand upright. Cover the tart with a circle of wax paper and bake for 25 minutes. Remove the wax paper and sprinkle the sugar over the apples. Bake uncovered for 5-10 minutes more, until the sugar melts.

Boil the currant jelly until it reduces by one-third. With a pastry brush, paint the top of the tart with the currant glaze. Allow time for the glaze to set before serving (10 minutes).

6 Granny Smith apples Juice of one lemon Cinammon to taste

Nutmeg to taste

1/4 cup sugar

- 1 tablespoon flour
- 2 teaspoons cornstarch
- I large egg
- 1 cup milk
- 3 tablespoons unsalted butter
- 1/4 teaspoon vanilla extract

2 tablespoons sugar 8 ounces currant jelly

Establishing a format

After analyzing and organizing the content, devise a format that expresses differences within the text. In Option 1 (opposite), all the ingredients are separated from the directions. Because the line length required for easy reading of directions is more or less twice the line length required for a list of ingredients, the area within the margins of the sheet is divided vertically into three intervals, or columns. Ingredients occupy the first column, directions the second and third columns. Groups of ingredients cross-align with the directions that refer to them.

against the edge of the pan an Cover and refrigerate again fo

Line the tart shell with alumin and the dough several times we utes. Remove the aluminum a brown, about 15 minutes more

The apples

Peel, core and halve the apple crosswise into thin (less than a cinempton and nutmer. Cover

Establishing a hierarchy

Single line spaces indicate breaks between paragraphs. Double line spaces indicate breaks between sections of text. 1/4 cup sugar

- 1 tablespoon flour
- 2 teaspoons cornstarch
- 1 large egg
- I cup milk
- 3 tablespoons unsalted butter
- 1/4 teaspoon vanilla extract

Typeface choice

When numbers and fractions occur frequently in the text, choose a type-face with an expert set that includes lowercase numerals and fraction characters. (See page 6 for a brief discussion of lowercase numerals.)

essor fitted with a rises above the bleal within the first 's done. Remove to d surface. Cover v

Ligatures

Virtually all text typefaces have ligatures for f/i and f/l combinations. Some also have ligatures for f/f, f/f/i, and f/f/l.

The shell

Preheat the oven to 400°.

7 tablespoons frozen butter*

1 cup frozen flour*
3 tablespoons ice-cold water*
1 teaspoon cider vinegar
A pinch of kosher salt
* It is important to have these ingredients as
cold as possible.

In a food processor fitted with a steel blade, combine all the ingredients until they form a solid mass that rises above the blade. You can add extra water by the tablespoon if the mass does not congeal within the first minute. Tiny pieces of butter should still be visible in the dough when it's done. Remove the dough from the bowl and work it quickly it into a ball on a lightly floured surface. Cover with plastic wrap and refrigerate for at least half an hour.

After the dough has rested in the refigerator, roll it out on a lightly floured surface until it forms a circle approximately 13" in diameter. Center the circle of dough in a 10-inch tart pan with a removeable bottom. Use your knuckles to make sure that the dough tucks neatly against the edge of the pan and run the rolling pin around the rim to remove the excess. Cover and refrigerate again for at least half an hour.

Line the tart shell with aluminum foil, being careful to cover the edges. Pierce the aluminum and the dough several times with a fork and fill the shell with dried lentils. Bake for 20 minutes. Remove the aluminum and the lentils and continue baking until the shell is golden brown, about 15 minutes more.

The apples

6 Granny Smith apples Juice of one lemon Cinammon to taste Nutmeg to taste Peel, core and halve the apples. Either by hand or with a food processor, cut the apple halves crosswise into thin (less than ¼") slices. In a large bowl, toss the appples in the lemon juice, cinammon and nutmeg. Cover and set aside.

The pastry cream

¼ cup sugar I tablespoon flour 2 teaspoons cornstarch I large egg I cup milk 3 tablespoons unsalted butter ¼ teaspoon vanilla extract Sift the sugar, flour and cornstarch together in a mixing bowl. Add the egg and beat until light. In a heavy-bottomed saucepan, bring the milk to a boil. Stir half the milk into the egg mixture, then pour the whole mixture back into the saucepan. Cook over high heat, stirring constantly, until the center bubbles and the mixture is very thick. Remove from heat and stir in the vanilla and the butter. Pour the pastry cream into a bowl, cover tightly with plastic wrap and refrigerate. (Be sure to press the plastic wrap right onto the cream to prevent a skin from forming.)

The assembly and baking

2 tablespoons sugar 8 ounces currant jelly Preheat the oven to 375°.

Spread the pastry cream over the bottom of the shell. Arrange the apple slices in a circle around the outer edge of the shell, making sure the slices overlap. When the outer circle is completed, make a smaller circle, overlapping about half of the outer circle. If there's room, make a third circle. Fill the hole in the center with pieces of a few slices—let them stand upright. Cover the tart with a circle of wax paper and bake for 25 minutes. Remove the wax paper and sprinkle the sugar over the apples. Bake uncovered for 5-10 minutes more, until the sugar melts.

Boil the currant jelly until it reduces by one-third. With a pastry brush, paint the top of the tart with the currant glaze. Allow time for the glaze to set before serving (to minutes).

The shell
Preheat the oven to 400°.

In a food processor fitted with a steel blade, combine all the ingredients until they form a solid mass that rise above the blade. Not can add extra water by the tablespoon if the mass does not conseque within the firm intune. They picked to brave should like without in the steel blade to compare the steel of the stee

Reinforcing structure

Setting the ingredients flush right against the gutter between the first and second columns strengthens the formal organization of the page. Keep in mind that setting type flush-right causes you to read the shape created by the type before you read the actual text. Similarly, the counterform created by the gutter between the two kinds of text (ingredients and directions) becomes a dominant, possibly intrusive element on the page.

The shell

Preheat the oven to 400°.

In a food processor fitted with a steel blade, combine all the ingredients until they form a solid mass that rises above the blade. You can add extra water by the tablespoon if the mass does not congeal within the first minute. Tiny pieces of butter should still be visible in the dough when it's done. Remove the dough from the bowl and work it quickly it into a ball on a lightly floured surface. Cover with plastic wrap and refrigerate for at least half an hour.

After the dough has rested in the refigerator, roll it out on a lightly floured surface until it forms a circle approximately 13" in diameter. Center the circle of dough in a 10-inch tart pan with a removeable bottom. Use your knuckles to make sure that the dough tucks neatly against the edge of the pan and run the rolling pin around the rim to remove the excess. Cover and refrigerate again for at least half an hour.

Line the tart shell with aluminum foil, being careful to cover the edges. Pierce the aluminum and the dough several times with a fork and fill the shell with dried lentils. Bake for 20 minutes. Remove the aluminum and the lentils and continue baking until the shell is golden brown, about 15 minutes more.

The apples

Peel, core and halve the apples. Either by hand or with a food processor, cut the apple halves crosswise into thin (less than 1/4") slices. In a large bowl, toss the appples in the lemon juice, cinammon and nutmeg. Cover and set aside.

The pastry cream

Sift the sugar, flour and cornstarch together in a mixing bowl. Add the egg and beat until light. In a heavy-bottomed saucepan, bring the milk to a boil. Stir half the milk into the egg mixture, then pour the whole mixture back into the saucepan. Cook over high heat, stirring constantly, until the center bubbles and the mixture is very thick. Remove from heat and stir in the vanilla and the butter. Pour the pastry cream into a bowl, cover tightly with plastic wrap and refrigerate. (Be sure to press the plastic wrap right onto the cream to prevent a skin from forming.)

The assembly and baking

Preheat the oven to 375°.

Spread the pastry cream over the bottom of the shell. Arrange the apple slices in a circle around the outer edge of the shell, making sure the slices overlap. When the outer circle is completed, make a smaller circle, overlapping about half of the outer circle. If there's room, make a third circle. Fill the hole in the center with pieces of a few slices—let them stand upright. Cover the tart with a circle of wax paper and bake for 25 minutes. Remove the wax paper and sprinkle the sugar over the apples. Bake uncovered for 5-10 minutes more, until the sugar melts.

Boil the currant jelly until it reduces by one-third. With a pastry brush, paint the top of the tart with the currant glaze. Allow time for the glaze to set before serving (10 minutes).

- 7 tablespoons frozen butter* I cup frozen flour
- 3 tablespoons ice-cold water*
- I teaspoon cider vinegar
- A pinch of kosher salt
- * It is important to have these ingredients as cold as possible

6 Granny Smith apples Juice of one lemon Cinammon to taste Nutmeg to taste

- 1/4 cup sugar 1 tablespoon flour
- 2 teaspoons cornstarch
- 1 large egg I cup milk
- 3 tablespoons unsalted butter
- 1/4 teaspoon vanilla extract
- 2 tablespoons sugar 8 ounces currant jelly

The shell

Preheat the oven to 400°.

In a food processor fitted with a solid mass that rises above the b does not congeal within the firs

Title treatment

Enlarging the size of the title not only reinforces hierarchy, but also provides an unambiguous starting point for reading. Line the tart shell with aluminu and the dough several times wi utes. Remove the aluminum an brown, about 15 minutes more.

The apples

Peel, core and halve the apples. crosswise into thin (less than 1/4 cinammon and nutmeg. Cover

Secondary heads

Using italic for secondary heads reinforces their place in the overall hierarchy already indicated by the additional line space.

7 tablespoons frozen butter*
1 cup frozen flour*
3 tablespoons ice-cold water*
1 teaspoon cider vinegar
A pinch of kosher salt

* It is important to have these ingra as cold as possible.

Italic within the text

Italic within the list of ingredients indicates information that affects the items in use. Note also how the exdented asterisk (see page 130) strengthens the left margin of the type. Compare with Option 1.

The shell

7 tablespoons frozen butter*
1 cup frozen flour*
3 tablespoons ice-cold water*
1 teaspoon cider vinegar
A pinch of kosher salt

* It is important to have these ingredients as cold as possible.

6 Granny Smith apples Juice of one lemon Cinammon to taste

Nutmeg to taste

¹/₄ cup sugar I tablespoon flour 2 teaspoons cornstarch I large egg

I cup milk
3 tablespoons unsalted butter
1/4 teaspoon vanilla extract

2 tablespoons sugar 8 ounces currant jelly In a food processor fitted with a steel blade, combine all the ingredients until they form a solid mass that rises above the blade. You can add extra water by the table-spoon if the mass does not congeal within the first minute. Tiny pieces of butter should still be visible in the dough when it's done. Remove the dough from the bowl and work it quickly it into a ball on a lightly floured surface. Cover with plastic wrap and refrigerate for at least half an hour.

After the dough has rested in the refigerator, roll it out on a lightly floured surface until it forms a circle approximately 13" in diameter. Center the circle of dough in a 10-inch tart pan with a removeable bottom. Use your knuckles to make sure that the dough tucks neatly against the edge of the pan and run the rolling pin around the rim to remove the excess. Cover and refrigerate again for at least half

Line the tart shell with aluminum foil, being careful to cover the edges. Pierce the aluminum and the dough several times with a fork and fill the shell with dried lentils. Bake for 20 minutes. Remove the aluminum and the lentils and continue baking until the shell is golden brown, about 15 minutes more.

The apples

Peel, core and halve the apples. Either by hand or with a food processor, cut the apple halves crosswise into thin (less than 1/4") slices. In a large bowl, toss the appples in the lemon juice, cinammon and nutmeg. Cover and set aside.

The pastry cream

Sift the sugar, flour and cornstarch together in a mixing bowl. Add the egg and beat until light. In a heavy-bottomed saucepan, bring the milk to a boil. Stir half the milk into the egg mixture, then pour the whole mixture back into the saucepan. Cook over high heat, stirring constantly, until the center bubbles and the mixture is very thick. Remove from heat and stir in the vanilla and the butter. Pour the pastry cream into a bowl, cover tightly with plastic wrap and refrigerate. (Be sure to press the plastic wrap right onto the cream to prevent a skin from forming.)

The assembly and baking

Spread the pastry cream over the bottom of the shell. Arrange the apple slices in a circle around the outer edge of the shell, making sure the slices overlap. When the outer circle is completed, make a smaller circle, overlapping about half of the outer circle. If there's room, make a third circle. Fill the hole in the center with pieces of a few slices—let them stand upright. Cover the tart with a circle of wax paper and bake for 25 minutes. Remove the wax paper and sprinkle the sugar over the apples. Bake uncovered for 5-10 minutes more, until the sugar melts.

Boil the currant jelly until it reduces by one-third. With a pastry brush, paint the top of the tart with the currant glaze. Allow time for the glaze to set before serving (10 minutes).

Preheat the oven

Preheat the oven to 375°.

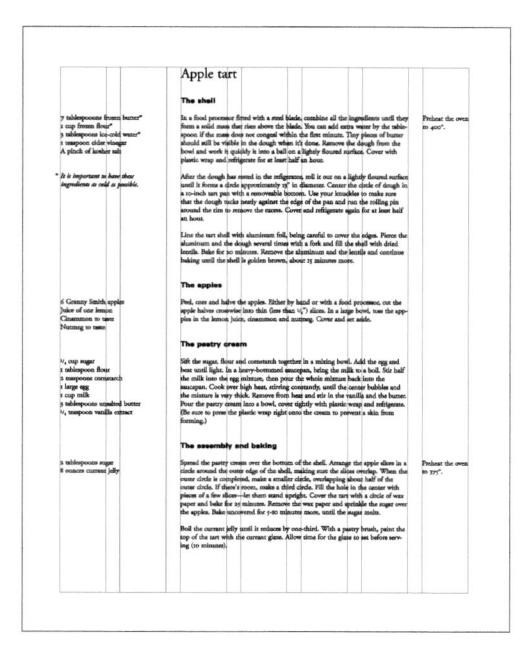

Revised format

Dividing the type area into seven columns provides a new, separate column for oven settings, creates a narrower (and easier to read) line length for instructions, and increases white space on the page.

Tabular matter

156

Designers often encounter typographic problems that are not based on narrative or instructions ('This happened, then this happened,' or 'Do this, then do this'). Timetables, financial statements, lists of dates, weather charts—many kinds of information design—often need to accommodate reading in two directions simultaneously. Setting up columns and rows that read clearly requires a thorough understanding of working with tabs.

The timetable to the right (actual size: 6 in or 152 mm square) demonstrates many of the problems with overdesigning tabular matter. Extraneous rules, both vertical and horizontal, have been imposed on the basic typographic organization to correct for unfortunate first choices about type size, leading, and placement.

SATURDAYS AND	SUNDAYS
---------------	---------

INBOUND	1204	1208	1212	1216	1220	1224
READ DOWN	A.M.	A.M.	P.M.	P.M.	P.M.	P.M.
Dep: Haverhill	7 15	10 15	1 15	4 15	7 15	10 15
Bradford	7 17	10 17	1 17	4 17	7 17	10 17
Lawrence	7 26	10 26	1 26	4 26	7 26	10 26
Andover	7 31	10 31	1 31	4 31	7 31	10 31
Ballardvale	f7 36	f10 36	fl 36	f4 36	f7 36	f10 36
North Wilmington	f7 42	f10 42	f1 42	f4 42	f7 42	f10 42
Reading	7 51	10 51	1 51	4 51	7 51	10 51
Wakefield	7 57	10 57	1 57	4 57	7 57	10 57
Greenwood	f8 00	f11 00	f2 00	f5 00	f8 00	f11 00
Melrose Highlands	8 02	11 02	2 02	5 02	8 02	11 02
Melrose/Cedar Park	f8 04	f11 04	f2 04	f5 04	f8 04	fl1 04
Wyoming Hill	f8 06	f11 06	f2 06	f5 06	f8 06	fl1 06
Malden Center	8 09	11 09	2 09	5 09	8 09	11 09
Arr: North Station	8 19	11 19	2 19	5 19	8 19	11 19
OUTBOUND	1205	1209	1213	1217	1221	1225
OUTBOUND READ DOWN	A.M.	A.M.	P.M.	P.M.	P.M.	P.M.
		A.M. 11 45	P.M. 2 45	P.M. 5 45	P.M. 8 45	P.M. 11 30
READ DOWN Dep: North Station Malden Center	8 45 8 55	A.M. 11 45 11 55	P.M. 2 45 2 55	P.M. 5 45 5 55	P.M. 8 45 8 55	P.M. 11 30 11 40
READ DOWN Dep: North Station Malden Center Wyoming Hill	8 45 8 55 f8 58	A.M. 11 45 11 55 f11 58	P.M. 2 45 2 55 f2 58	P.M. 5 45 5 55 f5 58	P.M. 8 45 8 55 f8 58	P.M. 11 30 11 40 f11 43
READ DOWN Dep: North Station Malden Center	8 45 8 55 f8 58 f9 00	A.M. 11 45 11 55 f11 58 f12 00	P.M. 2 45 2 55 f2 58 f3 00	P.M. 5 45 5 55 f5 58 f6 00	P.M. 8 45 8 55 f8 58 f9 00	P.M. 11 30 11 40 f11 43 f11 45
READ DOWN Dep: North Station Malden Center Wyoming Hill	A.M. 8 45 8 55 f8 58 f9 00 9 02	A.M. 11 45 11 55 f11 58 f12 00 12 02	P.M. 2 45 2 55 f2 58 f3 00 3 02	P.M. 5 45 5 55 f5 58 f6 00 6 02	P.M. 8 45 8 55 f8 58 f9 00 9 02	P.M. 11 30 11 40 f11 43 f11 45 11 47
READ DOWN Dep: North Station Malden Center Wyoming Hill Melrose/Cedar Park	A.M. 8 45 8 55 f8 58 f9 00 9 02 f9 04	A.M. 11 45 11 55 f11 58 f12 00 12 02 f12 04	P.M. 2 45 2 55 f2 58 f3 00 3 02 f3 04	P.M. 5 45 5 55 f5 58 f6 00 6 02 f6 04	P.M. 8 45 8 55 f8 58 f9 00 9 02 f9 04	P.M. 11 30 11 40 fl1 43 fl1 45 11 47 fl1 49
READ DOWN Dep: North Station Malden Center Wyoming Hill Melrose/Cedar Park Melrose Highlands	A.M. 8 45 8 55 f8 58 f9 00 9 02	A.M. 11 45 11 55 f11 58 f12 00 12 02	P.M. 2 45 2 55 f2 58 f3 00 3 02	P.M. 5 45 5 55 f5 58 f6 00 6 02	P.M. 8 45 8 55 f8 58 f9 00 9 02 f9 04 9 08	P.M. 11 30 11 40 fil 43 fil 45 11 47 fil 49 11 53
READ DOWN Dep: North Station Malden Center Wyoming Hill Melrose/Cedar Park Melrose Highlands Greenwood	A.M. 8 45 8 55 f8 58 f9 00 9 02 f9 04	A.M. 11 45 11 55 fil 58 fil 2 00 12 02 fil 2 04 12 08 12 14	P.M. 2 45 2 55 f2 58 f3 00 3 02 f3 04 3 08 3 14	P.M. 5 45 5 55 f5 58 f6 00 6 02 f6 04 6 08 6 14	P.M. 8 45 8 55 f8 58 f9 00 9 02 f9 04 9 08 9 14	P.M. 11 30 11 40 f11 43 f11 45 11 47 f11 49 11 53 11 59
READ DOWN Dep: North Station Malden Center Wyoming Hill Melrose/Cedar Park Melrose Highlands Greenwood Wakefield	A.M. 8 45 8 55 f8 58 f9 00 9 02 f9 04 9 08	A.M. 11 45 11 55 fi1 58 fi2 00 12 02 fi2 04 12 08 12 14 fi2 22	P.M. 2 45 2 55 f2 58 f3 00 3 02 f3 04 3 08 3 14 f3 22	P.M. 5 45 5 55 f5 58 f6 00 6 02 f6 04 6 08 6 14 f6 22	P.M. 8 45 8 55 f8 58 f9 00 9 02 f9 04 9 08 9 14 f9 22	P.M. 11 30 11 40 f11 43 f11 45 11 47 f11 49 11 53 11 59 f12 07
READ DOWN Dep: North Station Malden Center Wyoming Hill Melrose/Cedar Park Melrose Highlands Greenwood Wakefield Reading	A.M. 8 45 8 55 f8 58 f9 00 9 02 f9 04 9 08 9 14	A.M. 11 45 11 55 fil 58 fil 2 00 12 02 fil 2 04 12 08 12 14	P.M. 2 45 2 55 f2 58 f3 00 3 02 f3 04 3 08 3 14 f3 22 f3 28	P.M. 5 45 5 55 55 58 66 00 6 02 66 04 6 08 6 14 66 22 66 28	P.M. 8 45 8 55 f8 58 f9 00 9 02 f9 04 9 08 9 14 f9 22 f9 28	P.M. 11 30 11 40 f11 43 f11 45 11 47 f11 49 11 53 11 59 f12 07 f12 13
READ DOWN Dep: North Station Malden Center Wyoming Hill Melrose/Cedar Park Melrose Highlands Greenwood Wakefield Reading North Wilmington	A.M. 8 45 8 55 f8 58 f9 00 9 02 f9 04 9 08 9 14 f9 22	A.M. 11 45 11 55 fi1 58 fi2 00 12 02 fi2 04 12 08 12 14 fi2 22	P.M. 2 45 2 55 f2 58 f3 00 3 02 f3 04 3 08 3 14 f3 22 f3 28 3 33	P.M. 5 45 5 55 55 58 66 00 6 02 66 04 6 08 6 14 6 22 66 28 6 33	P.M. 8 45 8 55 f8 58 f9 00 9 02 f9 04 9 08 9 14 f9 22 f9 28 9 33	P.M. 11 30 11 40 f11 43 f11 45 11 47 f11 49 11 53 11 59 f12 07 f12 13 12 18
READ DOWN Dep: North Station Malden Center Wyoming Hill Melrose/Cedar Park Melrose Highlands Greenwood Wakefield Reading North Wilmington Ballardvale	A.M. 8 45 8 55 f8 58 f9 00 9 02 f9 04 9 08 9 14 f9 22 f9 28	A.M. 11 45 11 55 f11 58 f12 00 12 02 f12 04 12 08 12 14 f12 22 f12 28	P.M. 2 45 2 55 f2 58 f3 00 3 02 f3 04 3 08 3 14 f3 22 f3 28	P.M. 5 45 5 55 f5 58 f6 00 6 02 f6 04 6 08 6 14 f6 22 f6 28 6 33 6 38	P.M. 8 45 8 55 f8 58 f9 00 9 02 f9 04 9 08 9 14 f9 22 f9 28 9 33 9 38	P.M. 11 30 11 40 f11 43 f11 45 11 47 f11 49 11 53 11 59 f12 07 f12 13 12 18 12 23
READ DOWN Dep: North Station Malden Center Wyoming Hill Melrose/Cedar Park Melrose Highlands Greenwood Wakefield Reading North Wilmington Ballardvale Andover	A.M. 8 45 8 55 f8 58 f9 00 9 02 f9 04 9 08 9 14 f9 22 f9 28 9 33	A.M. 11 45 11 55 f11 58 f12 00 12 02 f12 04 12 08 12 14 f12 22 f12 28 12 33	P.M. 2 45 2 55 f2 58 f3 00 3 02 f3 04 3 08 3 14 f3 22 f3 28 3 33	P.M. 5 45 5 55 55 58 66 00 6 02 66 04 6 08 6 14 6 22 66 28 6 33	P.M. 8 45 8 55 f8 58 f9 00 9 02 f9 04 9 08 9 14 f9 22 f9 28 9 33	P.M. 11 30 11 40 f11 43 f11 45 11 47 f11 49 11 53 11 59 f12 07 f12 13 12 18

HOLIDAYS SATURDAY SERVICE Presidents' Day

Presidents' Day Independence Day New Year's Day f stops only on request SUNDAY SERVICE Memorial Day • Labor Day Thanksgiving Day • Christmas Day

July 4 and New Year's Eve contact Customer Service for service updates at 617-222-3200

Uppercase numerals were initially designed to all have the same set width, in part so that they would align vertically in columns of figures. Lowercase numerals were not.

Inbound	1204	1208	1212	1216	1220	1224
Dep: Haverhill	7:15	10:15	1:15	4:15	7:15	10:15
Bradford	7:17	10:17	1:17	4:17	7:17	10:17
Lawrence	7:26	10:26	1:26	4:26	7:26	10:26
Andover	7:31	10:31	1:31	4:31	7:31	10:31
Ballardvale	7:36*	10:36*	1:36*	4:36*	7:36*	10:36*
North Wilmington	7:42*	10:42*	1:42*	4:42*	7:42*	10:42*
Reading	7:51	10:51	1:51	4:51	7:51	10:51
Wakefield	7:57	10:57	1:57	4:57	7:57	10:57
Greenwood	8:00*	11:00*	2:00*	5:00*	8:00*	11:00*
Melrose Highlands	8:02	11:02	2:02	5:02	8:02	11:02
Melrose/Cedar Park	8:04*	11:04*	2:04*	5:04*	8:04*	11:04*
Wyoming Hill	8:06*	11:06*	2:06*	5:06*	8:06*	11:06*
Malden Center	8:09	11:09	2:09	5:09	8:09	11:09
Arr: North Station	8:19	11:19	2:19	5:19	8:19	11:19
Outbound	1205	1209	1213	1217	1221	1225
Dep: North Station	8:45	11:45	2:45	5:45	8:45	11:30
Malden Center	8:55	11:55	2:55	5:55	8:55	11:40
Wyoming Hill	8:58*	11:58*	2:58*	5:58*	8:58*	11:43*
Melrose/Cedar Park	9:00*	12:00*	3:00*	6:00*	9:00*	11:45*
Melrose Highlands	9:02	12:02	3:02	6:02	9:02	11:47
Greenwood	9:04*	12:04*	3:04*	6:04*	9:04*	11:49*
Wakefield	9:08	12:08	3:08	6:08	9:08	11:53
Reading	9:14	12:14	3:14	6:14	9:14	11:59
North Wilmington	9:22*	12:22*	3:22*	6:22*	9:22*	12:07* 12:13* 12:18 12:23 12:32 12:34
Ballardvale	9:28*	12:28*	3:28*	6:28*	9:28*	
Andover	9:33	12:33	3:33	6:33	9:33	
Lawrence	9:38	12:38	3:38	6:38	9:38	
Bradford	9:47	12:47	3:47	6:47	9:47	
Arr: Haverhill	9:49	12:49	3:49	6:49	9:49	
Holidays						
Weekend service	Presider	nts' Day • Ind	dependence	Day • New	Year's Day	•
	Memoria	al Day • Labo	or Day • Tha	anksgiving D	Pay • Christ	mas Day
July 4 and New Year's Eve	contact	Customer Se	ervice for se	rvice update	es at 617-22	22-3200

As with the previous exercise, the first step is to set all the material in one size of one typeface in order to uncover the internal logic of the information.

Here a sans serif typeface (Univers 45) is chosen because the relatively large x-height and open counters aid reading at smaller sizes. The horizontal rules used on the original schedule have been replaced by line spaces. Vertical rules and the 'frame' of the original have been eliminated altogether. Centered type has been reformatted to flush left/ragged right. The term 'READ DOWN' has

been eliminated and the 'f' before some entries in the schedule has been replaced with an asterisk after.

From this point, the goal is to reinforce the two directions of reading (across and down) without introducing elements that supersede the information itself.

Saturdays and Sundays						
Inbound	1204	1208	1212	1216	1220	1224
Dep: Haverhill Bradford Lawrence Andover Ballardvale North Wilmington	7:15	10:15	1:15	4:15	7:15	10:15
	7:17	10:17	1:17	4:17	7:17	10:17
	7:26	10:26	1:26	4:26	7:26	10:26
	7:31	10:31	1:31	4:31	7:31	10:31
	7:36*	10:36*	1:36*	4:36*	7:36*	10:36*
	7:42*	10:42*	1:42*	4:42*	7:42*	10:42*
Reading	7:51	10:51	1:51	4:51	7:51	10:51
Wakefield	7:57	10:57	1:57	4:57	7:57	10:57
Greenwood	8:00*	11:00*	2:00*	5:00*	8:00*	11:00*
Melrose Highlands	8:02	11:02	2:02	5:02	8:02	11:02
Melrose/Cedar Park	8:04*	11:04*	2:04*	5:04*	8:04*	11:04*
Wyoming Hill	8:06*	11:06*	2:06*	5:06*	8:06*	11:06*
Malden Center Arr: North Station	8:09	11:09	2:09	5:09	8:09	11:09
	8:19	11:19	2:19	5:19	8:19	11:19
Outbound	1205	1209	1213	1217	1221	1225
Outbound Dep: North Station Malden Center	1205	1209	1213	1217	1221	1225
	8:45	11:45	2:45	5:45	8:45	11:30
	8:55	11:55	2:55	5:55	8:55	11:40
Dep: North Station	8:45	11:45	2:45	5:45	8:45	11:30
Dep: North Station Malden Center Wyoming Hill Melrose/Cedar Park Melrose Highlands Greenwood Wakefield	8:45	11:45	2:45	5:45	8:45	11:30
	8:55	11:55	2:55	5:55	8:55	11:40
	8:58*	11:58*	2:58*	5:58*	8:58*	11:43*
	9:00*	12:00*	3:00*	6:00*	9:00*	11:45*
	9:02	12:02	3:02	6:02	9:02	11:47
	9:04*	12:04*	3:04*	6:04*	9:04*	11:49*
	9:08	12:08	3:08	6:08	9:08	11:53

Weekend service

Presidents' Day • Independence Day • New Year's Day • Memorial Day • Labor Day • Thanksgiving Day • Christmas Day contact Customer Service for service updates at 617-222-3200

* stops only on request

Two weights of boldface (Univers 65 and 75) are added, both to indicate hierarchy (days of the week, trains' numbers and directions, ends of the line) and to distinguish morning and afternoon/evening times at a quick glance.

This latter use of boldface is more an issue with 12-hour American time systems than with 24-hour European systems. Still, the distinction between before and after noon can be useful for quick orientation.

July 4 and New Year's Eve

Inbound	1204	1208	1212	1216	1220	1224
Dep: Haverhill Bradford Lawrence Andover Ballardvale North Wilmington	7:15	10:15	1:15	4:15	7:15	10:15
	7:17	10:17	1:17	4:17	7:17	10:17
	7:26	10:26	1:26	4:26	7:26	10:26
	7:31	10:31	1:31	4:31	7:31	10:31
	7:36*	10:36*	1:36*	4:36*	7:36*	10:36
	7:42*	10:42*	1:42*	4:42*	7:42*	10:42
Reading Wakefield Greenwood Melrose Highlands Melrose/Cedar Park Wyoming Hill	7:51 7:57 8:00* 8:02 8:04* 8:06*	10:51 10:57 11:00* 11:02 11:04* 11:06*	1:51 1:57 2:00* 2:02 2:04* 2:06*	4:51 4:57 5:00* 5:02 5:04* 5:06*	7:51 7:57 8:00* 8:02 8:04* 8:06*	10:51 10:57 11:00 ⁴ 11:04 11:06
Malden Center Arr: North Station	8:09	11:09	2:09	5:09	8:09	11:09
	8:19	11:19	2:19	5:19	8:19	11:19
Outbound	1205	1209	1213	1217	1221	1225
Dep: North Station	8:45	11:45	2:45	5:45	8:45	11:30
Malden Center	8:55	11:55	2:55	5:55	8:55	11:40
Wyoming Hill	8:58*	11:58* 12:00* 12:02 12:04* 12:08 12:14	2:58*	5:58*	8:58*	11:43 ⁴
Melrose/Cedar Park	9:00*		3:00*	6:00*	9:00*	11:45 ⁵
Melrose Highlands	9:02		3:02	6:02	9:02	11:47
Greenwood	9:04*		3:04*	6:04*	9:04*	11:49 ⁴
Wakefield	9:08		3:08	6:08	9:08	11:53
Reading	9:14		3:14	6:14	9:14	11:59
North Wilmington	9:22*	12:22*	3:22*	6:22*	9:22*	12:07* 12:13* 12:18 12:23 12:32 12:34
Ballardvale	9:28*	12:28*	3:28*	6:28*	9:28*	
Andover	9:33	12:33	3:33	6:33	9:33	
Lawrence	9:38	12:38	3:38	6:38	9:38	
Bradford	9:47	12:47	3:47	6:47	9:47	
Arr: Haverhill	9:49	12:49	3:49	6:49	9:49	

HOLIDAYS	
Weekend service	Presidents' Day • Independence Day • New Year's Day • Memorial Day • Labor Day • Thanksgiving Day • Christmas Day
July 4 and New Year's Eve	contact Customer Service for service updates at 617-222-3200

* stops only on request

Hierarchy is reinforced by introducing rules to signify major breaks in information. Major heads are reversed out of wide black rules, secondary heads follow hairlines.

Inbound	1204	1208	1212	1216	1220	1224
Dep: Haverhill	7:15	10:15	1:15	4:15	7:15	10:15
Bradford	7:17	10:17	1:17	4:17	7:17	10:17
Lawrence	7:26	10:26	1:26	4:26	7:26	10:26
Andover	7:31	10:31	1:31	4:31	7:31	10:31
Ballardvale	7:36*	10:36*	1:36*	4:36*	7:36*	10:36
North Wilmington	7:42*	10:42*	1:42*	4:42*	7:42*	10:42
Reading	7:51	10:51	1:51	4:51	7:51	10:51
Wakefield	7:57	10:57	1:57	4:57	7:57	10:57
Greenwood	8:00*	11:00*	2:00*	5:00*	8:00*	11:00
Melrose Highlands	8:02	11:02	2:02	5:02	8:02	11:02
Melrose/Cedar Park	8:04*	11:04*	2:04*	5:04*	8:04*	11:04
Wyoming Hill	8:06*	11:06*	2:06*	5:06*	8:06*	11:06*
Malden Center	8:09	11:09	2:09	5:09	8:09	11:09
Arr: North Station	8:19	11:19	2:19	5:19	8:19	11:19
Outbound	1205	1209	1213	1217	1221	1225
Dep: North Station	8:45	11:45	2:45	5:45	8:45	11:30
Malden Center	8:55	11:55	2:55	5:55	8:55	11:40
Wyoming Hill	8:58*	11:58*	2:58*	5:58*	8:58*	11:43
Melrose/Cedar Park	9:00*	12:00*	3:00*	6:00*	9:00*	11:45
Melrose Highlands	9:02	12:02	3:02	6:02	9:02	11:47
Greenwood	9:04*	12:04*	3:04*	6:04*	9:04*	11:49
Wakefield	9:08	12:08	3:08	6:08	9:08	11:53
Reading	9:14	12:14	3:14	6:14	9:14	11:59
North Wilmington	9:22*	12:22*	3:22*	6:22*	9:22*	12:07
Ballardvale	9:28*	12:28*	3:28*	6:28*	9:28*	12:13
Andover	9:33	12:33	3:33	6:33	9:33	12:18
Lawrence	9:38	12:38	3:38	6:38	9:38	12:23
Bradford	9:47	12:47	3:47	6:47	9:47	12:32
Arr: Haverhill	9:49	12:49	3:49	6:49	9:49	12:34

|--|

Presidents' Day • Independence Day • New Year's Day • Memorial Day • Labor Day • Thanksgiving Day • Christmas Day Weekend service

July 4 and New Year's Eve

contact Customer Service for service updates at 617-222-3200

* stops only on request

The space between columns of times already supports vertical reading. Screened wide horizontal rules, added between alternating lines of arrival/departure times, aids readability across the timetable.

Inbound	1204	1208	1212	1216	1220	1224
Dep: Haverhill	7:15	10:15	1:15	4:15	7:15	10:15
Bradford	7:17	10:17	1:17	4:17	7:17	10:17
Lawrence	7:26	10:26	1:26	4:26	7:26	10:26
Andover	7:31	10:31	1:31	4:31	7:31	10:31
Ballardvale	7:36*	10:36*	1:36*	4:36*	7:36*	10:36
North Wilmington	7:42*	10:42*	1:42*	4:42*	7:42*	10:42
Reading	7:51	10:51	1:51	4:51	7:51	10:51
Wakefield	7:57	10:57	1:57	4:57	7:57	10:57
Greenwood	8:00*	11:00*	2:00*	5:00*	8:00*	11:00
Melrose Highlands	8:02	11:02	2:02	5:02	8:02	11:02
Melrose/Cedar Park	8:04*	11:04*	2:04*	5:04*	8:04*	11:04
Wyoming Hill	8:06*	11:06*	2:06*	5:06*	8:06*	11:06
Malden Center	8:09	11:09	2:09	5:09	8:09	11:09
Arr: North Station	8:19	11:19	2:19	5:19	8:19	11:19
Outbound	1205	1209	1213	1217	1221	1225
Dep: North Station	8:45	11:45	2:45	5:45	8:45	11:30
Malden Center	8:55	11:55	2:55	5:55	8:55	11:40
Wyoming Hill	8:58*	11:58*	2:58*	5:58*	8:58*	11:43
Melrose/Cedar Park	9:00*	12:00*	3:00*	6:00*	9:00*	11:45
Melrose Highlands	9:02	12:02	3:02	6:02	9:02	11:47
Greenwood	9:04*	12:04*	3:04*	6:04*	9:04*	11:49
Wakefield	9:08	12:08	3:08	6:08	9:08	11:53
Reading	9:14	12:14	3:14	6:14	9:14	11:59
North Wilmington	9:22*	12:22*	3:22*	6:22*	9:22*	12:07
Ballardvale	9:28*	12:28*	3:28*	6:28*	9:28*	12:13
Andover	9:33	12:33	3:33	6:33	9:33	12:18
Lawrence	9:38	12:38	3:38	6:38	9:38	12:23
Bradford	9:47	12:47	3:47	6:47	9:47	12:32
Arr: Haverhill	9:49	12:49	3:49	6:49	9:49	12:34

HOLIDAYS		
Weekend service		Presidents' Day • Independence Day • New Year's Day • Memorial Day • Labor Day • Thanksgiving Day • Christmas Day
July 4 and New Year's Eve		contact Customer Service for service updates at 617-222-3200
	*	stops only on request

A second color reinforces existing organization both by highlighting primary and secondary information and by calling attention to exceptions to the regular schedule. The hairline rule signifying outbound trains (rendered redundant by the use of color) is removed.

160

Before digital type, every typesetter provided-and every designer owned-specimen books, which displayed not only the typefaces the typesetter owned but also the sizes in which they were available. Beyond their use as a handy reference, specimen books more importantly gave the designer the opportunity to visualize clearly how his or her material would look when set in a specific typeface at a specific size. To this day, many designers collect specimen books, often works of art in their own right, for the sheer pleasure of admiring type on paper.

Digital type has effectively made every designer his or her own type-setter. In obviating the typesetting profession, it has also eliminated the source of specimen books. These days, if we want to see what a font looks like, we google it. Unfortunately, the digital representation of type is, even at its best, an approximation. Nothing supplants seeing the actual type, at actual size, on paper held in the hand.

To redress this loss, some designers produce their own specimen books, for their own use, as a visual aid in their daily work.

Specimen books offer an interesting design challenge because they present type both as image and information; the designer has to show 7 pt. italic even as he or she identifies what is being shown. Providing text-size type in actual text settings, ideally with more than one kind of leading, is more useful than merely presenting a character set. At larger scale, because designers often choose display type for the shape of a particular character, showing display-size type as actual headlines may not be as useful as allowing the reader to see a full character set.

¿ñçß?

This page and opposite:
Janson text roman and italic at various sizes. A specimen book presents this material in a coherent fashion so that designers can familiarize themselves with a typeface's salient characteristics.

11 22 33 44 55 66 77 88 99 00

£S

163

fi fl 1/4 1/2 3/4 fi fl 1/4 1/2 3/4

This bookish inclination at length determined my father to make me a printer, though he had already one son (James) of that profession. In 1717 my brother James returned from England with a press and letters to set up his business in Boston. I liked it much better than that of my father, but still had a hankering for the sea. To prevent the apprehended effect of such an inclination, my father was impatient to have me bound to my brother. I stood out some time, but at last was persuaded, and signed the indentures when I was yet but twelve years old.

—The Autobiography of Benjamin Franklin Đ
ð
þ

Aa*Aa*

Below:

Reduced specimen sheets for Janson on 8.5 x 11 in (216 x 279 mm) pages. The three-column layout provides a suitable line length for text samples. Centered type references the traditional

nature of the typeface. Text settings are shown in 6, 7, 8, 9, 10, 11, and 12 pt., each with 0, 1, and 2 pts. of leading. Display type is shown in 18, 24, 36, 48, and 60 pt.

Janson 12 point

ABCDEFGHIJKLMNOPQRSTUVWXYZ 1234567890

ABCDEFGHIJKLMNOPQRSTUVWXYZ abcdefghijklmnopqrstuvwxyz 1234567890 ?!()&.,;;""''

ABCDEFGHIJKLMNOPQRSTUVWXYZ

1234567890 abcdefgbijklmnopqrstuvwxyz 1234567890 ?!()&.,:;""''

12/12

This bookish inclination at length determined my father to make me a printer, though he had already one son (James) of that profession. In 1717 my brother James returned from England with a press and letters to set up his business in Boston. I liked it much better than that of my father, but still had a hankering for the sea. To prevent the apprehended effect of such an inclination, my father was impatient to have me bound to my brother. I stood out some time, but at last was persuaded, and signed the indentures when I was yet but twelve years old. The Autobiography of Benjamin Franklin

12/13

This bookish inclination at length determined my father to make me a printer, though he had already one son (James) of that profession. In 1717 my brother James returned from England with a press and letters to set up his business in Boston. I liked it much better than that of my father, but still had a hankering for the sea. To prevent the apprehended effect of such an inclination, my father was impatient to have me bound to my brother. I stood out some time, but at last was persuaded, and signed the indentures when I was yet but twelve years old. -The Autobiography of Benjamin Franklin

12/14

This bookish inclination at length determined my father to make me a printer, though he had already one son (James) of that profession. In 1717 my brother James returned from England with a press and letters to set up his business in Boston. I liked it much better than that of my father, but still had a hankering for the sea. To prevent the apprehended effect of such an inclination, my father was impatient to have me bound to my brother. I stood out some time, but at last was persuaded, and signed the indentures when I was yet but twelve years old. –The Autobiography of Benjamin Franklin

Janson 18 point

ABCDEFGHIJKLMNOPQRSTUVWXYZ 1234567890

abcdefghijklmnopqrstuvwxyz abcdefghijklmnopqrstuvwxyz 1234567890?!()&.,:;"""

ABCDEFGHIJKLMNOPQRSTUVWXYZ
1234567890
abcdefghijklmnopqrstuvwxyz
1234567890?!()&...;""''

Janson 24 point

ABCDEFGHIJKLMNOPQRSTUVWXYZ

abcdefghijklmnopqrstuvwxyz 1234567890?!()&.,:;"""

ABCDEFGHIJKLMNOPQRSTUVWXYZ 1234567890

abcdefghijklmnopqrstuvwxyz 1234567890?!()&.,:;"""

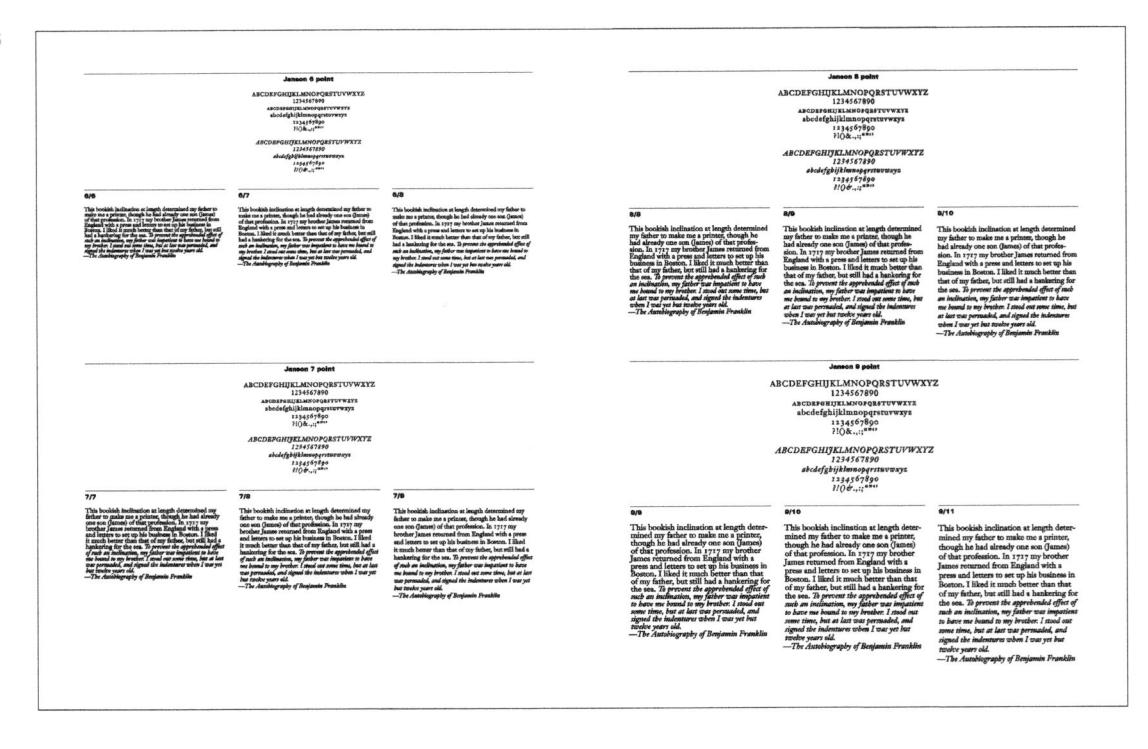

Above and opposite: Sample spreads from the Janson specimen book.

Opposite, below:

The covers in this series of specimen books all feature the italic ampersand: Janson (left), Caslon 540 (upper right), and Didot (lower right).

ABCDEFGHIJKLMN
OPQRSTUVWXYZ
1234567890
ABCDEFGHIJKLMN
OPQRSTUVWXYZ
abcdefghijklmn
opqrstuvwxyz
1234567890?!()&.,:;""'

ABCDEFGHIJKLMN
OPQRSTUVWXYZ
1234567890
abcdefghijklmnopqrstuvwxyz
1234567890?!()&:,:;"""

ABCDEFGHIJ KLMNOPQRS TUVWXYZ 1234567890 ABCDEFGHIJKLMN OPQRSTUVWXYZ abcdefghijklmn opqrstuvwxyz 1234567890 ?!()&.,:;""'

ABCDEFGHIJ KLMNOPQRS **TUVWXYZ** abcdefghijklm nopgrstuvwxyz 1234567890 !?&()*;:,.""'

ABCDEFGHIJKLM NOPQRSTUVWXYZ abcdefghijklm nopqrstuvwxyz 1234567890 !?&()*;:,."""

ABCDEFGHIJKLM NOPQRSTUVWXYZ abcdefghijklm nopqrstuvwxyz 1234567890 !?&()*;:,."""

ABCDEFGHIJKLM NOPQRSTUVWXYZ abcdefghijklm nopqrstuvwxyz 1234567890 17&()*;;,,"""

LuptatumLor ad tis alit lut utpate tat lam ven-dit, quat, quisim quipit vullut lore magna feu feuis ad euis dui exero ero dunt nonulla faccum inciliquis eraestrud min volor ad euglam nos alisi eugue euisi eluitis lipaum quis num dolese magna feugue eur zuriuscipit vereseto eum-modolut adigeam zuriuscipit vereseto eum-modolut adigeam zuriuscipit vereseto eum-

LuptatumLor ad tie alit lut utpate tat lam ven-dit, quat, quisim quipit vullut lore megna feu feuis ad euis dui exero ero dunt nonulla faccum inciliquis eraestrud min volor ad euglam nos alisi eugue euisi eluisit ipsum quis num dolese magna feugue eum zzriuscipit veraesto eum-modolut adipa ad tei nici blandignit, sumaan.

LuptatumLor ad tis alit lut utpate tat lam ven-dit, quat, quisim quipit vullut lore magna feu feuis ad euis dui exero ero dunt nonulla faccum inciliquis eraestrud min volor ad eugiam nos alisi eugue euisl euisit ipsum quis num dolese magna feugue eum zzriuscipit veraesto eum-modolut adigna ed tet inci blandignit, sumsan.

ABCDEFGHIJKLM NOPORSTUVWXYZ abcdefghijklm nopqrstuvwxyz 1234567890 !?&()*;:,."""

ABCDEFGHIJKLM NOPQRSTUVWXYZ abcdefghijkIm nopqrstuvwxyz 1234567890 17&()*;;,,"""'

11/12
Luptatum il iniate velenim delis el et augait lum zzrilit lor si. Ulput veliquis auguer adiamocre mod minci tinci sesquis aliquipit volorin er adit lut et, sis alit lutat. Duisse eniscilit prat, quip ul et vulputat. Cipsuscipsum zzrit aut ad et eugue vendre dunt accum dolorer ostrut.

tura
Luptatum il iniate velenim della el et
augait lum zzrilit lor si. Ulput veliquis
auguer adiamoore mod minoli inci
seequis aliquipit volorith er adfi lut et,
sis siit lutat. Dulsse enisoliit prat, quip
eu iet vulputat. Cipsuscipsum zzrit
aut ad et eugue vendre dunt accum
dolorer ostrut.

Above and opposite:

Reduced specimen sheets on A4 pages. The seven-column format allows for flexibility in the presentation of both display type and text samples.

ABCDEFGHIJ KLMNOPQRS *TUVWXYZ* abcdefghijk Imnopqrstuv wxyz 1234567890 !?&()*;:,.""''

The broadsides that follow (actual size A2, 16.5 x 23.4 in, 420 x 594 mm), present typefaces as both physical objects-images, if you will - and as carriers of language-text. Both presentations carry information.

The designer determines the hierarchy of that information by the manipulation of scale, color, and, as always, counterform-where the type isn't. As we already know, large scale reads easily from a distance; small scale rewards close inspection. We also know that black advances off the white page; color, depending upon its value, tends to recede toward the background. Contrast in counterform-tight spaces against large expanses of white-heightens the sense of space from foreground to background. Overlapping disparate elements further reinforce the sense of depth in an otherwise twodimensional space.

The Baskerville types were created by John Baskerville, a typefounder and printer in eighteenth-century England and introduced in Birmingham in 1752. Baskerville's types are classified as transitional, that is, those that are stylistically between oldstyle and modern designs. Because of their high readability, Baskerville's designs have been produced by by all of the major type foundries, and have become a standard typeface for long texts, especially book work, and for display purposes as well. ABCDEFGHIJKLMNOPQRSTUVWXYZ abcdefghijklmnopqrstuvwxyz 1234567890 !@#\$%^&*()_+{}[]=;'"<>,.?/ ABCDEFGHIJKLMNOPQRSTUVWXYZ abcdefghijklmnopqrstuvwxyz 1234567890 !@#\$%^&*()_+{}[]=;'"<>,.?/ Baskerville

Right above and following pages: Finished broadside with text and character set for reading at arm's length.

Right below:

Building up layers for reading from a distance. Change in value makes some elements appear closer than others.

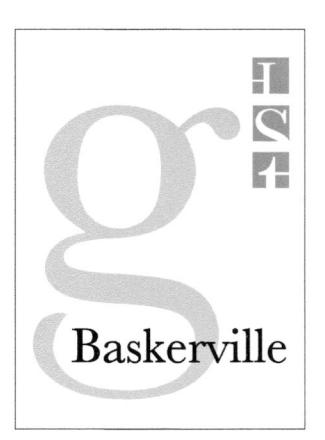
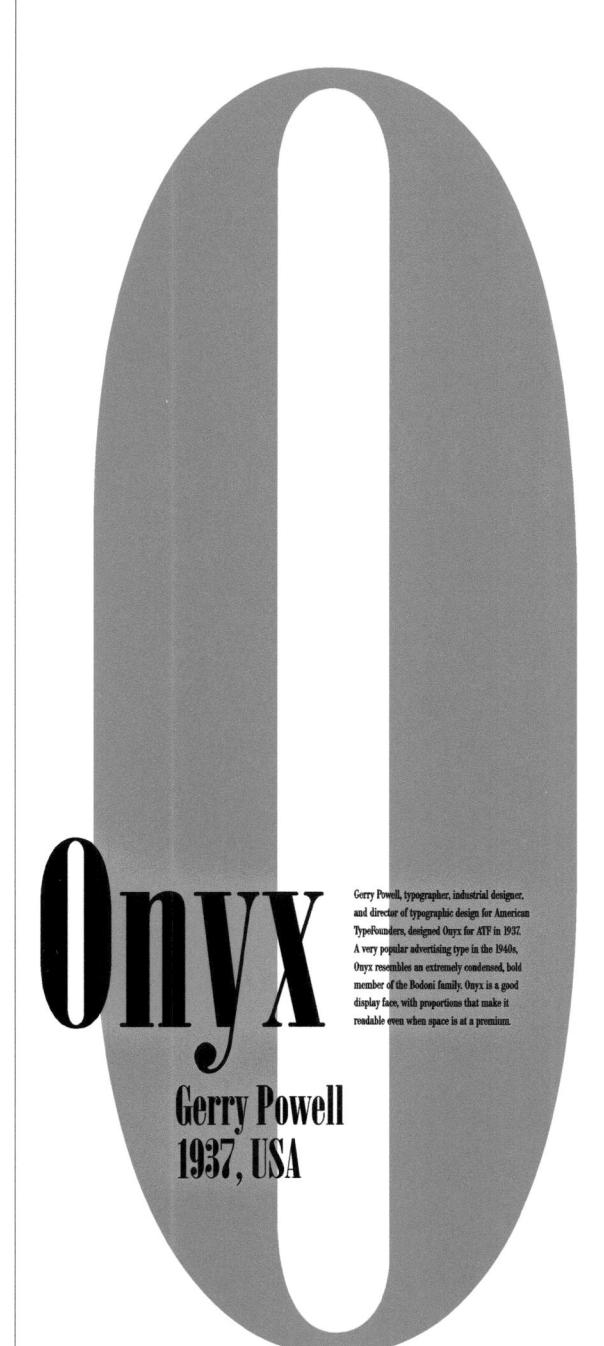

A ÆBCDÐEFGHIJKLEMN
O Æ Ø PÞQRSTUVW X Y Z
a æbcdðeffi fighi i jklimn
o æ ø pþqrs ßtuvw x y z
O 123456789\$ Ø £ ¥ f
Á á À à Ä å Å å Â å Ã ã Ç Ç É É È Ë Ë Ê Ê
Í Í Ì Ï Ï Î Î Ñ Ñ Ó Ó Ò Ö Ö Ö Õ Õ
Š Š Ú ú Ù ù Ü ü Û û Ý ý Ÿ ÿ Ž ž

.,:;""',,...!?¡¿ _-&*/• «()» [({})]

There is an extremely narrow counter

The serif is one of the most bracketed in the entire fout world

The thin link is in charp contrast to the thicker strokes.

Bauer Bodoni was cut in 1926 by Louis Hill, under the direction of Heinrich lose. This version is the closest to be supposed, designed by Glambatista Bodonia in 1790. Gianharitista ran the priving house Hegia of Parma where he began corating his own typfaces. Refinements in priming and paper allowed Bodoni to design a typeface with hairline strokes and setfic. Giambatista was also concerned with harmony between different type sizes, and between text and the page. He realized that space between letters, lines of text and columns could enhance the beauty of his pages. This is evident in the Manuale Typographia published after his death.

Some typefaces that bear the name Bodoni do not resemble the original punches. Bauer Bodoni is characterized by the actrone courts of thick and this strokes, pure vertical stress, and unbracketed hairline serfs. These features give the reinterpretation of Bodoni the clean, refined appearance that Giambattista intended.

Bauer Bodoni

Louis Höll, Heinrich Jost

ABCDEFGHIJKLM NOPQRSTUVWXYZ

ABCDEFGHIJKLMNO PQRSTUVWXYZ abcdefghijklm nopqrstuvwxyz 1234567890

?!"@#\$¢%&()*{}¡¿ +¾¼½×ø±÷|;°— <>=[μĐþÞℲðß]^_-†‡¶¬¬¯ ÆŒææfifl°°âàåçíñö,,,"\ «‹›»...'«; -./:; ,, £/¥f\$™©® Giambattista Bodoni of Parma, Italy, designed and cut his typefaces at the end of the eighteenth century. The Bodoni types were the culmination of nearly 300 years of evolution in roman type design, in which fine hairlines contrast sharply with bolder stems, and serifs are often unbracketed. Bodoni is recognized by its high contrast between thick and thin strokes, pure vertical stress, and hairline serifs. This particular version of Bodoni was first created by Morris Fuller Benton for American Type Founders between 100 pt. 1.

Poster Bodoni

ABCDEFGHI JKLMNOPQ RSTUVWXYZ abcdefghijk Imnopqrstu vwxyz 1234567890 !@#\$%^&*() _+-={}[]|\:;''' <>,./?\~` Morris Fuller Benton American Type Founders 1908-15

phers around the world." Elik Spiekermann Carry
ABCDEFGHIJKLMNOPQRSTUVWXYZ abcedfghijklmnopqrstuvwxyz 1234567890!@#\$%^&*()_+:;"'?

ABCDEFGHIJKLMN OPQRSTUVWXYZ

abcdefghijklmn opqrstuvwxyz

1234567890

1234567890

Perpetua

Type designer Eric Gill's most popular Roman typeface is Perpetua, which was released by the Monotype Corporation between 19:35 and 19:32. It first appeared in a limited edition of the book The Passion of Perpetua and Felicity, for which the typeface was named. The italic form was originally called Felicity. Perpetua's clean chiseled look recalls Gill's stonecutting work and makes it an excellent text typeface, giving sparkle to long passages of text; the Perpetua capitals have beautiful, classical lines that make this one of the finest display alphabets available.

Perpetua comes with Old Style figures for all its variations: Regular, Italics, SMALL CAPS, Bold and Bold Italic.

At this point, it's worthwhile to examine the compositional instincts behind these broadsides. As you can see, in each instance a specific columnar rhythm informs these seemingly free choices. The results, of course, are by no means precise: devising columnar organization for the broadsides was not a stated part of the program. The point is that the instinct to find consistent intervals as a basis for organizing the diverse elements in a composition is as intrinsic to working with type as are the internal rhythms within any given typeface.

It should be obvious that the same sense of visual rhythm that organizes the compositions from left to right also, in all likelihood, organizes material from top to bottom. In other words, there is probably a grid underlying each broadside, one specific to the material presented. How that grid evolves, and how it is applied, is the subject of the next chapter (see pages 194–199).

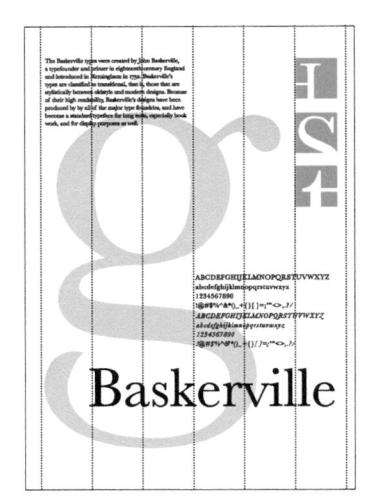

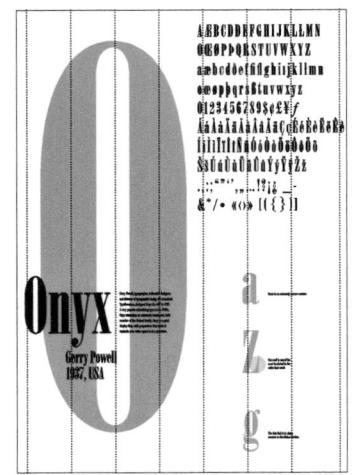

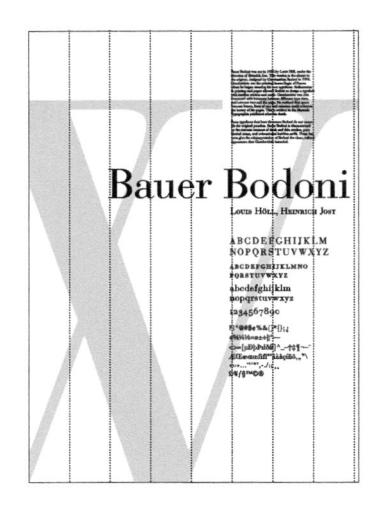

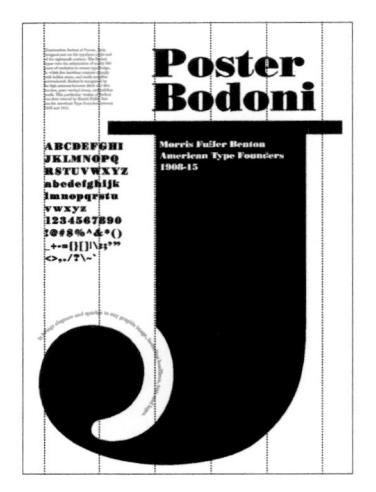

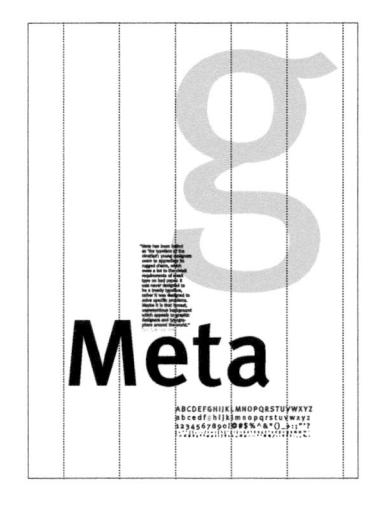

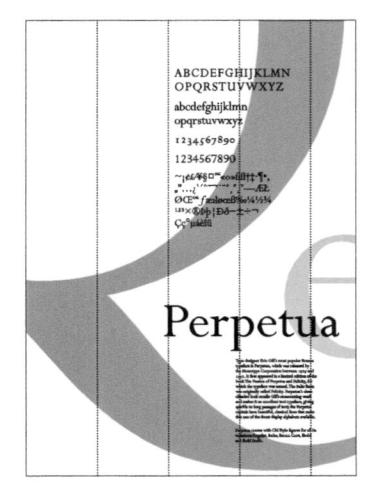

Grid systems

Introduction

So far, we've looked at text organization in terms of columnar arrangement. More complex information often requires expression of not only vertical but also horizontal organization. In those situations, a grid is an essential tool.

A grid is a pattern of horizontal and vertical lines that intersect at regular intervals. In typographic design, a grid system is a method for organizing and clarifying text on a page, and amplifying its meaning.

A grid is not about painting a page—creating the perfect composition within the frame of the paper trim. Rather, it is about building a page—providing a framework within which visual and typographic elements work to reinforce meaning.

This sense of building the page comes directly from the days when type itself was physical. Lines of lead type built upon other lines of type—not unlike courses of bricks standing one upon the other—to create the page. And, as with bricks, the stronger the construction, the more durable the results.

It's important to remember that a grid is a system, not an object in itself. For that system to be effective it has to be both organic and responsive. In other words, before you can devise a grid, you have to understand clearly

- · the amount of text/images
- the kinds of text/images
- the levels of meaning and importance within the text/images
- the relationship between text and images
- the relationship between text/ images and the reader.

Another way to describe the grid system is to see it as a way of providing distinct articulation to the different voices expressed within the text through both color and position on the page. Or you might prefer thinking of a grid as Josef Müller-Brockmann described it: a means of expressing both the architecture (or structure) and the music (or rhythm) inherent in the material. No matter how you look at it, the underlying principle behind any grid is that it is most successful as an expression of content.

Going through the following section, you're going to encounter some terminology and a lot of rules. As with any system, perhaps the most important thing to keep in mind is when it's necessary to break those rules. Beyond the usual employment of contrast within the system, always be on the lookout for opportunities to contrast the order of the system itself with its opposite—the seeming lack of order.

You will learn that the kind of grids that follow are described as establishing starting points on a page, never ending points. A clear expression of that notion is the use of flush left/ragged right text—type that articulates a strong left axis and a strong top axis, but weak edges to the right and below. Therefore, in the examples that follow I have only used flush left, ragged right type. A useful corollary to this notion is to make sure that adjacent columns of text are flush to the top, ragged at the bottom.

178

179

Components of the grid

Many of the components of the grid are the same as those we examined in the text exercises:

> Text page Margins Folios Headers

In addition, there are a few terms that relate specifically to how the grid is constructed:

Fields Gutters (both vertical and horizontal)

For the sake of clarity, we're going to begin by examining all these components in detail.

Right and opposite: Note that a columnar layout addresses only vertical organization. A grid addresses vertical and horizontal organization. A two-column layout

A nine-field grid

Text page

Also known as the type or text area, the area on a page where type appears. The text page contains the fields and gutters that make up the grid.

Margin

The space that distinguishes the text page from the paper around it.

Field

The basic component of any grid. The height of a field is calculated as a multiple of the text leading. Its width is determined by the length of a line of text. (See **Creating a grid for text**, pages 200–211.)

For the kinds of grids we'll be working with, it's useful to remember that the upper left corner of any field is considered the strong or active corner. The lower right corner is considered the weak or passive corner.

In the example above, there are nine active corners—nine starting points for titles, text, images, and captions.

Vertical/horizontal gutter

The gutter separates fields from each other. The height of a horizontal gutter is typically based on the leading of the text type. The width of a vertical gutter should be a distance sufficiently larger than an em (the size of the text type) to prevent reading from one column of text to another. (See Creating a grid for text, pages 200–211.)

1.5-2 ems = vertical

gutter

My only thought was of you.

leading = horizontal gutter

In a grid system, folios and running matter above or below the text page always appear flush left to the grid (like the text). Thus, they seldom, if ever, appear symmetrical to each other on a spread.

	Running head	Running head	Running head	
Running shoulder				Running shoulder
Running shoulder				Running shoulder
Running shoulder				Running shoulder
	Running foot	Running foot	Running foot	

Running head/running foot/running shoulder

In longer documents, a guide for readers to show them where they are in the manuscript. These may contain the title of the book, the title of a section of the book, or the author's name. Like folios, they sit outside the text page, but should always relate to it either vertically or horizontally. Running heads appear above the text page, running feet below, running shoulders to the sides.

	123	123	123	
123				123
123				123
123				123
	123	123	123	

Folio

The page number. This typically sits outside the text page, but, like running matter, it should always relate to the grid either vertically or horizontally.

A simple grid

188

Grids are particularly useful for creating a sense of simultaneity on the page, as this simple exercise demonstrates. We have here a title page for a catalog. Page size is 9 in (229 mm) square. Copy consists of a title, a subtitle, and a publisher—three levels of information, each in three languages (English, German, and French).

First, the type is set in three weights of a typeface (here, Akzidenz Grotesk Regular, Medium, and Bold), in three sizes based on a Fibonacci sequence (13, 21, and 34 pt., each with 2 pts. of leading). Certainly, it is possible to articulate the hierarchy of information by changing just the size or the weight. As you know by now, these are the decisions that make each designer's work personal.

Word and image

Posters from the collection

Museum of Modern Art New York

Wort und Bild

Plakate von der Sammlung

Parole et image

Les affiches de la collection

		_	
	-	_	

The page is then arranged in a nine-field grid, three fields by three fields—mirroring the three levels of information presented in three languages. Note that because all our type is essentially display type, not text, the gutters are not specifically keyed into leading or ems.

Word	Wort	La parole
and	und	et
image	Bild	l'image
Posters from the collection	Plakate von der Sammlung	Les affiches de la collection
Museum of Modern Art	Museum des Moderne Kunst	Musée d'art moderne
New York	New York	New York

Word	Wort	La parole
and	und	et
image	Bild	l'image
Posters from	Plakate von	Les affiches
the collection	der Sammlung	de la collection
Museum of Modern Art	Museum der Moderne Kunst	Musée d'art moderne
New York	New York	New York

Posters from the collection	Plakate von der Sammlung	Les affiches de la collection	
Word and image	Wort und Bild	Parole et image	
Museum of Modern Art New York			

Posters from	Plakate von	Les affiches
the collection	der Sammlung	de la collection
Word	Wort	Parole
and	und	et
image	Bild	image
Museum of Modern Art New York		

Even with only nine fields, there are many possibilities for placing the information on the grid. In the examples on this page, each language reads down. Levels of hierarchy read across.

Word and image	Posters from the collection	Museum of Modern Art New York
Wort und Bild	Plakate von der Sammlung	
Parole et image	Les affiches de la collection	

Word and image	Posters from the collection	Museum of Modern Art New York
Wort und Bild	Plakate von der Sammlung	
Parole et image	Les affiches de la collection	

Posters from the collection	Word and image	Museum of Modern Art New York
Plakate von der Sammlung	Wort und Bild	
Les affiches de la collection	Parole et image	

Posters from the collection	Word and image	Museum of Modern Art New York
Plakate von der Sammlung	Wort und Bild	
Les affiches de la collection	Parole et image	

In the examples on this page, the reading is reversed from the previous examples—languages read across, hierarchies read down.

Word and image	Posters from the collection
Wort und Bild	Plakate von der Sammlung
Parole et image	Les affiches de la collection
	Museum of Modern Art New York

Word and image	Posters from the collection
Wort und Bild	Plakate von der Sammlung
Parole et image	Les affiches de la collection
	Museum of Modern Art

Museum of Modern Art New York	Word and image
	Posters from the collection
	Wort und Bild
	Plakate von der Sammlung
	Parole et image
	Les affiches de la collection

Museum of Modern Art New York	Word and image Posters from the collection
	Wort und Bild Plakate von der Sammlung
	Parole et image Les affiches de la collection

In the examples above, horizontal reading is stressed by extending the title on one line and connecting two levels of information in one type block. First, we connect the subtitle and the publisher. Then we connect the title and subtitle.

You are probably going to find some of these solutions more successful, more expressive, more dynamic, or maybe just 'prettier' than others. Or you may find them all too obvious, too simple. A grid of 3 x 3 may not provide enough options. It certainly does not take into account the pages of material that would follow the title.

The point of this beginning exercise is to sensitize you to the possibilities for both organization and expression that the grid offers. Where you take it next — however many more fields you think the page requires, whatever typeface, size, and weight you deem appropriate — is up to you. What's most important is to follow through the process, to explore a fair number of possibilities within each system.

Word and image	Posters from the collection	Madem of Modem det New York
Wort und Bild	Plakate von der Sammlung	
Parole et image	Les affiches de la collection	

5 x 5 grid 10, 26, and 42 pt. Janson

Word and image	Posters from the collection	Moseum of Modgen Art New York
Wort und Bild	Plakate von der Sammlung	
Parole et image	Les affiches de la collection	

6 x 5 grid 10, 26, and 42 pt. Didot

	and image n the collection
	Wort und Bild Plakate von der Sammlung
Parole et image Les affiches de la collection	
Manual of Mode	ns Ari New York

4 x 4 grid 13, 21, and 36 pt. Adobe Garamond

On page 176 columnar organization was applied to seemingly 'free' compositions of the typographic broadsides to uncover expressions of horizontal rhythm within each piece. Here, organization by rows finds similarly consistent vertical rhythms. The resulting fields grow out of the type details in the upper-right corner of the composition.

The result, as shown above and opposite, demonstrates how grids can support — and, in some cases, strengthen — complex typographic compositions. They also suggest the importance of allowing the grid to evolve out of the requirements of the content.

However, it is important to note that in this composition the grid's role is secondary. The hierarchical sequence – the order of perception first from a distance, then close up – is primarily established by use of scale, color, tone, and manipulation of counterform.

Note that the word 'Baskerville' aligns to the grid at its x-height—one of two clear horizontal axes in the word, the other being the baseline. At display sizes, the relationship of type to the grid often depends on visual cues other than the height of the ascender alone.

The Baskerville types were created by John Baskerville, a typefounder and printer in eighteenth-century England and introduced in Birmingham in 1752. Baskerville's types are classified as transitional, that is, those that are stylistically between oldstyle and modern designs. Because of their high readability, Baskerville's designs have been produced by by all of the major type foundries, and have become a standard typeface for long texts, especially book work, and for display purposes as well.

ABCDEFGHIJKLMNOPQRSTUVWXYZ

abcdefghijklmnopqrstuvwxyz 1234567890

!@#\$%^&*()_+{}[]=;'"<>,.?/

ABCDEFGHIJKLMNOPQRSTUVWXYZ abcdefghijklmnopqrstuvwxyz

1234567890

!@#\$%^&*()_+{}[]=;'"<>,.?/

Baskerville

Shown here (right and opposite) is an A2 (16.5 x 23.4 in, 420 x 594 mm) two-color poster for a series of jazz concerts. Each event starts at the beginning of a field; concerts are arranged vertically and horizontally by date. Primary and secondary display type aligns to horizontal axes on the x-height.

In this example, the grid not only organizes the composition but also expresses hierarchy. Clearly, the same rules that determine a grid at text scale operate at larger scale as well. The considerations of type operating as image and information are merely applied to the rigors of a gridded environment.

		Machou Theater Comragin hild Florench Gould Half Florench Gould Half Florench Gould Half Knight Redony Registrate, Hunter Cale Knittlera Endors Routh Covered Half St Knittler Frequent Half St Knittler Frequent Half St Knittler Schwelzber Granter for Bessel Ecush Eteret Besport Halfa Stagette Mittings Versigners Mittings Versigners Linden Stagette L	eogla nosi Cunter erroh in Bleedi. Cutture		17 Styrine & Gase Wigner & Gosenhill Generally Intil (600pm) \$100,000,000 \$40.000 \$40.000	
June 13	-25			Am Ennoting with Childe Comes & Tourchertone Featuring Time Extendiness Comes Biomanest Jurge Pardu 5 Royam Featus Fisse Theoper 600cm 85500; 36100, 156400	Michel Climber Sole, Dos 4 filo Michel Carolin Tilo Poor Thesen & Organ 505-00, 395-00, \$355-00	NY
		14	15 Download Bagatine Presents Into Combos Such Stoce Season 15/30pm. FREE	Joannie Stockern Countel (Studies Mouseum in Faliera), 1959 5 12/20 jn denscorn interface, 510:00 at 94 feer	(NC Xext Culebrates Brooklyst III Strus Newson. Food Asperson Carlo Alig Chaise Farlet Too James Chefu Cagan Tho vith Dental Clabs & Justical Control Clabs & Justical Forger Clabs & Justical Forger Clabs & Justical Forger Struster Park, Description TOOpen Free	18
		YOU Years and a Days Duc Cheelfelm Cestronal Jose Parts Rose Theater 900pp	Plano Marters Kalule Plano Legender Delacesing Elegton Evan, Harcook & Morie Blass Chester (ECOpts:	Son Byron Administrate Octobertra Visage Verguerd 900pm, 11:00pm Cell for 90ket prices	Bavid Maney & The Geo-Ka Mesters Jezz Sandard (130jes, 930jes, 11,20jes pet for licket prices	Devid Marrey & The Gree Re Hauteri Jim Stendert Yilder, Billoon, 11 John Jist for licest prices
	az	Z	F	35	tiv	al
Daniel Marray & The Green File Manders Janus Stendard TOOses, Selfour Cust Air solvet prices	Passenney Coocesy. As AS-Ste Fresconditudes of Assister in Edit Stepe Deby Storm, John Pannal Is, Schwa Stores Mathed Cathaglet Hall di Copin 505-00, \$70-00, \$98-00, \$45-10	21 Metrin Schmeinine Onthwalte World Prince(of Center Plaza 7-Xpm Prince Festinal FINEE	Relift Jerrell, Jack DeJohnson. Berry Proceeds Comings 16th 5Cope. In Perhandin with Cope. In Perhandin with Cornegio Has \$1500, \$4600. \$45.60, \$60.60	Two Three Three this Earlie Clarks Charles Cha	Sheige Welcome. Does Brobed Chartel vitts. Brob Brobed Chartel vitts. Brody Jenns, rebby Velleko 8 Michael Moose John Facosoli Courter wite. Bry Kannedy Starth Par- sonik 8 Torp Tabeson Comingle Half Infolger \$7700.0 \$100.00, \$450.0. \$600.00.	Setso Montis Juaz Bolde Phanton Y La Perfecto II The 2 Workle of Ray Barretto Lamage Harl Bodges Bosoo, \$7500, \$8500, \$4500
A Father's Day Gift Lou Destriction Countries Schemburg Contain for the - prosent in Hisch Collum polyclips \$1500 monitoris, \$1500 monitoris, \$1500 monitoris,	Silline Seculus: A Different. Noted of Share Mirror Down Clove of the file of Virgin Federal (1970) Participa Federal (1970) Participa Federal (1970) 200(pps) (97 metupa) 3.16(30)	A Flour Score Statute In Restaura Carnol Keys Psylvacian Hanther College Biologis Photoloid by by Leoniari Photoloid by by Leoniari Photoloid by Leoniari Photoloid by Leoniari Photoloid by Section Photoloid by Section Photoloid by Section Photoloid by Section Se	Solves Stops to Jana Stape Alberd (2008) Shacer Thester 65/Jon 50(256), 5450, 89 97	JVC	Seel Fort this Cyrephony Source Trade Trader & Styre \$21, \$18, \$10	Nam York Norel Son Allson's Kush Trio, Time Blacklin Hard Call, Juenas Charles Too, Mery Earlich Sosses, Joseph Albehr Tho, Jacob Peri Sasses, Joseph Albehr Charles Sosses, Joseph Albehr Call Sor School Sprices Sol Sor School Sprices
All lor Paul: Les Heut 90th Bathday Seforts Lee Paul Curregie Hell Statiges \$96.00, \$90.00; \$96.00, \$45.00	His Minimum Opinis Chaeptaut & John Nicks, Neder Common High & Hardware Common High & Hardware Common High & Hardware Common High & 5.75.00	Cepania Evore Soupor Herete (HOSper \$78.50, \$40.50, \$40.50	Don Byron Big Bland Fastivotic Antonialysi Cristivotic Antonialysi Cristivotic Antonial SECOpts, 11 Object Cat for Ecual pict on		Don Byrost Fesyr Dilvey Trio Fesburing Jacon Wirsen & Bry Fest with gazet Londe Facco & Fespo Asian Wage Vangued 20/10m, 113/Con, 1236/cm Call for Bridge prices	Menialita Music Presents trusts from the lathest releases: carry Connect, ix and Brandon Manaels Znakes Hall SubCom Sobioto, \$560.00
	Whape Vergesard Codhwittes Will reports guide Jule Limite. Whape Verguard 900ton, 1100pts	Dan Byron: Junust Complete Music for 3is Masscandlan Byron, Johns Z. 186. Pacray, Millen Ca. Júcia B. Baci Hohma Wasge Vanguerd Brücken. 1 1 200cs.			05	Dots Bysee Prop-Dirupy Tri Feetburg, Jason, Morae A. Birly Hack with Javes Lonen Pasicia & Raige Magazard & Octors, 11-Octors, 12-Journ Cull for briefel pricer

Beacon Theater Carnegie Hall Florence Gould Hall Kaye Playhouse, Hunter College Knitting Factory Merkin Concert Hall at Kaufman Center Prospect Park Bandshell Rose Theater

17

Wayne & Dave Wayne Shorter Quertet Carnegle Hall 8:00pm \$75.00, \$60.00, \$45.00, \$30.00

June 13-25

16

An Evening with Chick Corea & Touchstone Featuring Tom Brechtlein, Carles
Benavent, Jorge Pardo &
Rubem Dantas
Rose Theater 8:00pm
\$65.00, \$50.00, \$35.00

Michel Camilo: Solo, Duo & Trio Michel Camilo Trio Rose Theater 8:00pm \$65.00, \$50.00, \$35.00

15

Joanne Brackeen Quartet Studio Museum in Harlem 7:30pm \$12.00 in advance members, \$15.00 at the door

JVC Jezz Celebretes
Brooklynt
The Bad Plus: Ethan Iverson,
Reid Anderson, David King
Charlie Hunter Tiro James
Carter Organ Trio with
Gerard Gibbs & Leonard
KingProspect Park Bandshell
7:30pm Free

18

100 Years and a Day: Doc Cheatham Centennial Jazz Party Rose Theater 8:00pm

14

Don Byron Adventurers Orchestra Village Vanguard 9:00pm, 11:00pm Call for ticket prices

Devid Murray & The Gwo-Ka Masters
Jazz Standard
Jazz Standard
7:30pm, 9:30pm, 11:30pm
Call for ticket prices

Call for ticket prices

Jazz Festival

19

20

Rosemary Clooney: An All-Star Remembrance of America's Girl Singer Debty Boone, John Pitzarel-II, Brian Stokes Mitchell Carnegle Hall 8:00pm \$85.00, \$75.00, \$65.00, \$45.00

21

Maria Schneider Orchestra World Financial Center Plaza 7:00pm River Festival FREE

22

Kelth Jarrett, Jack DeJoh-nette, Gary Pescock Carnegie Hall 8:00pm In Partnership with Carnegie Hall \$750,0, \$60.00, \$45.00, \$30.00

23

Two Times Three
Triol Stanley Clarke
Béla Fleck Jean-Luc Ponty
Paul Motian, Bill Frisell
& Joe Lovano
Carnegle Hall 8:00pm
\$75.00, \$60.00, \$45.00,
\$30.00

24

Always Welcome...
Dave Brubeck Quartet with Randy Jones, Bobby Militello & Michael Moore John Pizzarelli Quartet with Ray Kennedy, Martin Pizzarelli & Tony Tedesco Carnegle Hall 8:30pm \$75.00, \$60.00, \$45.00, \$30.00

25

Salsa Meets Jazz Eddie Palmieri Y La Perfecta II The 2 Worlds of Ray Barretto Carnegie Hall 8:00pm \$85.00, \$75.00, \$65.00, \$45.00

A Father's Day Gift Lou Doneldson Quartet Schomburg Center for Re-search in Black Culture 3:00pm \$15.00 members, \$18.00 non-members

Miles Electric: A Different Kind of Blue Miles Davis Live at the title of Wight Festival 1970 Florence Gould Heal 7,00pm, 930pm (87 minutes) \$15.00 Fminutes) Florence Scaled Heal 7,00pm, 930pm (87 minutes) \$15.00 America.

Seven Steps to Jaco Steps Ahead (2005) Beacon Theatre 8:00pm \$63.50, \$3.50, \$3.50

Anat Fort Trio Symphony Space Thalia Theater 8:30pm \$21, \$18, \$16

New York Now!
Ben Allison's Kush Trio,
Time Berne's Hard Cell,
Avishal Cohon Trio, Marty
Ehrlich Sextet, Jean-Mich
Pilc Trio, Robert Glasper
Trio, Jacob Fred Jazz
Odyssey,
Knitting Factory 8:00pm
Call for ticket prices

All for Paul: Les Paul 90th Birthday Salute Les Paul Carnegie Hall 8:00pm \$95.00, \$80.00, \$65.00, \$45.00

No Minimum Cyrus Chestnut & John Hicks Merkin Concert Hall at Kaufman Center 8:00pm \$35.00

Don Byron Big Band Featuring Abdoulaye Diabate Village Vanguard 9:00pm, 11:00pm Call for ticket prices

Don Byron Ivey-Divey Trio Featuring Jason Moran & Billy Hart with guests Lonnie Plaxico & Ralph Alessi Village Vanguard 9:00pm, 11:00pm, 12:30am Call for ticket prices

Marsalis Music Presents music from its latest releases: Harry Connick, Jr. and Branford Marsalis Zankei Hall 8:30pm \$66.00, \$39.00

Village Vanguard Orchestra With special guest Joe Lovano Village Vanguard 9:00pm, 11:00pm

Don Byron: Almost Complete Music for Six MusiclansDon Byron, James Zollar, George Colligan, Leo Traversa, Milton Cardona & Ben Withman Village Vanguard 9:00pm, 11:00pm Call for ticket prices

01-5

Don Byron Ivey-Divey Trio Featuring Jason Moran & Billy Hart with guest Lonnie Plaxico & Ralph Alessi Village Vanguard 9:00pm, 11:00pm, 12:30am Call for ticket prices

Here (right and opposite) is the same problem for a smaller series of concerts. Each venue is identified by its own typeface and its own shade of the second color. Main display type (JVC Jazz Festival Paris') is set with baseline alignment to the horizontal axes. Secondary display type ('8 jours, 8 salles, + de 80 musiciens') centers vertically in its fields.

	Samedi 14 octobre 21000 Will Cancun Thighthe Landu' 21000 Pletra Maggini et Ferrucio Spirmiti 2 1 h000 Dienusel Sinoteline 2000 bet bes et le feet		New Morning 778 rue das Pretrus Belgins Park Tricens 0180 707 007 av Lan
	DINR Deen Adve. 22 8 50 Institutes Breschir	Dimanche is octobre store beed share the element frame Bade Section Florings 21 Not I valve Abades on the Ferrical Operate	Cigale 130 boolevand Rochedrovart Parts Romo 0589 707 907
	Lundi 16 octobre Those recent remotance 21 mOd Mossilin Pleumion Planto die Bathman Rick Minighton ONE on one in sooi	8 salles	Bataclas 30 boolevard Voltake Ports 1 tono 01 43 18 35 35
8 јо		Mardi 17 octobre Mardi Kong Genet Quental Spice Arbai file 2 100 Bilger Editor 21 central Sension Reunion Prince de Baltiman	Méridies It trade ant follows (A. Cy- Alex Chee ORC 107 69" (A. —
	Mercross 48 octobres one benefit for the final strain and the second or the final strain and	Placel, Money/Erran Placel, Money/Erran Place State Thomps Street Jee, 1997 22-0.78 (Indexto Mandatha	Cale de la Banso d'Hanga mili religio Ann Trans. Ann Paris Servicia.
	CODY May Tablego Lev Sen de Datest Sen Sen Tables Bullers Ministration Tables Bullers Ministration	Deudi 19 octobre 20:50 Ray Inquire AH Fector 20:50 Les Ann 2 1:00 Hos Cerrosia Wilcon Fedors Sengel Belley	China Club SI not for the feature Paris 12 may 21 43 43 55 122
	Vendred: 20 octobre Mind 6.83 Eight Abrook (1699 Portie) 1100 Res Control ocupo stacker 5- 21800 Res Control ocupo sta	20 to the Country 2 to the Country Charles Charles Love Service Lov	Sunset 90 no des Lomberds mans ter 1682 707 Si77 or some
	Control Debics Cardol Catlor Shoot Presentate Paderon Shoot Presentate Paderon Shoot Presentate Child Shoot	Semedi 21 octobre protoke, Sem	Sunside 60 rue dos Lombards Pada 161 0892 707 607
			usiciens
ionataina PNAO, Clierafui p892 PAP EU: Et noints de vei		91 48 21 98 37 www.loopsasuolons.com	

In both this poster and the type broadside on pages 194–195, the designers have chosen not to express vertical or horizontal gutters. Nonetheless, we can see that gutters are being employed.

Samedi 14 octobre

21h00 Will Cahoun "Native Lands" 21h00 Petra Magoni et Ferrucio Spiretti

21h00 Denzal Sinclaire
22h30 Demi Sans and the Hands
20h30 Thomas Dutrone
22h30 James Hunter

Lundi 16 octobre

21h00 Elisabeth Kontomanou 21h00 Moutin Reunion Pierre de Bethman Rick Margitza 22h30 Dany Deriz Big Band 22h30 Jeremy Pelt Quartet

8 jours

Mercredi 18 octobre

20h30 Branford Marsalis
21h00 Kurt Elling
Robert Glasper Trio (1ere Partio)
21h00 Marcuss Strickland
Quartet
2000 Mer Bissey Jose Strickland
Quartet
2000 Bissey Jose Strickland
Quartet
2000 Bissey Jose Strickland
Quartet

Vendredi 20 octobre

19h45 E.S.T.

Eivind Aarset (1ere Partie) 21h00 Ron Carter Golden Stricker Trio 21h00 Roy Cambell William Parker

Daniel Carter
21h00 Pierrick Pédron
Mulgrew Miller
Quartet

22h30 Mina Agossi et amis Malcom Braff 22h30 Jeremy Pelt Quartet

Dimanche 15 octobre

21h00 Donald Brown Trio et invités Jerome Barde Stephane Belmondo 21h00 Petra Magoni et Ferrucio Spiretti 22h00 Demi Evans and the Hands invité: Jean Jagues Milteau

8 salles

Mardi 17 octobre

20h30 Kenny Garrett Quartet Lynne Arriale Trio 21h00 Rebekka Bakken 21h00 Moutin Reunion Pierre de Bethman Rick Margitza 22h30 Manu DiBango joue Sidney Bechet Dany Doriz 22h30 Robin McKelle

Jeudi 19 octobre

20h30 Roy Hargrove RH Factor 21h00 Leee John 21h00 Roy Cambell William Parker Hamid Drake

Daniel Carter 21h00 Stéphane Spira Quartet

22h30 Mina Agossi et amis Malcom Braff 22h3fl Minsarah

Samedi 21 octobre

21h00 Mike Stern 21h00 Catia Werneck Quintet 21h00 Pierrick Pédron Mulgrew Miller Quartet

22h30 Beogie Wonderband 22h30 Jeremy Pelt Quartet

New Morning

7/9 rue des Petites Ecuries Paris 10eme 0892 707 507 64 cc./mid

Cigale

120 boulevard Rochechouart Paris 9eme 0892 707 507 (Mat/mb)

Bataclan

50 boulevard Voltaire Paris 11eme 01 43 14 35 35

Méridien

81 boulevard Gouvien St. Cyr Paris 17eme 0892 707 507 ot at / min

Caté de la Danse

5 Passage Louis-Philippe Paris 11eme 0892 707 507 (Maximo)

China Club

50 rue de Charenton Paris 12eme 01 43 43 82 02

Sunset

Paris 1er 0892 707 507 (34 ct./min)

Sunside

60 rue des Lombards Paris 1er 0892 707 507 (34 ct. / min)

+ de 80 musiciens

Locations

FNAC, Carrefour, France Billet 0892 707 507 (34 ct. / min) Et points de vente habituels

01 46 21 08 37

www.looproductions.com

Creating a grid for text

200

Place a column of text type on an 8.5 x 11 in (216 x 279 mm) page.

Examine the horizontal relationship of white space to text. Be sure to include left and right margins. (For this exercise, assume that the left and right margins are three picas each.)

Most grids—like the material they illuminate—are not so straight-forward as what we've just worked with. Working with text demands solutions that are less pictorial—less from without—and more organic, coming from within the text itself.

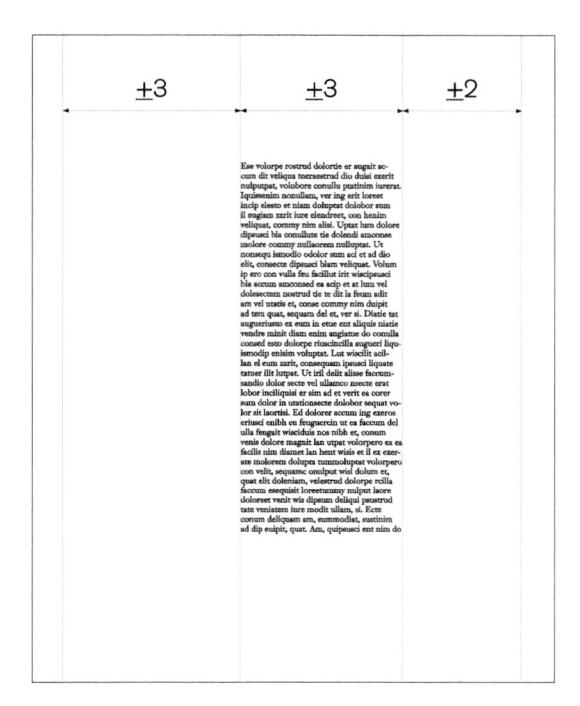

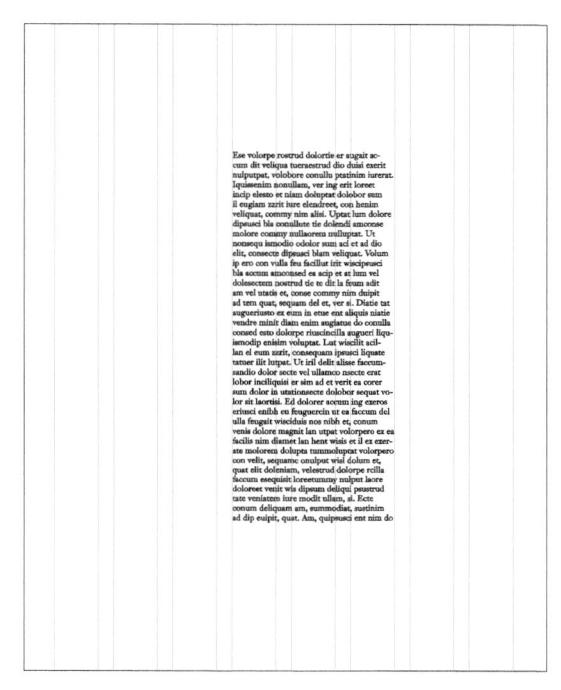

Determine the horizontal ratios. These horizontal ratios are perhaps best described as the ratios between line length of the text and the width of white space to either side of it. In the example shown, it happens that the line length of the text is more or less the same as the width of the white space to the left (1:1), and more or less one and a half times as wide as the white space on the right (3:2). Hence, \pm 3 and \pm 2 neatly approximate the distances shown.

Draw in all the vertical axes that express the horizontal ratios, being sure to include gutters. The general rule of thumb for vertical gutters is \pm 2 ems of the text typeface (8 pt. text = 16 pt. gutter, 10 pt. text = 20 pt. gutter, etc.). This decision really hangs on making sure that there's no danger of reading on from text in one column to text in the next. In the example shown, we've used 1p6.

Ese volorpe rostrud		
dolortie er augsit		
accum dit veliqua		
tueraestrud dio duisi		
exerit nulputpat, vo-		
obore copullu		
pratinim jurerat.		
Iquissenim nonul-		
lam, ver ing erit		
loreet incip elesto et		
niam doluptat do-	Ese volorpe rostrud dolortie er auguit ac-	
lobor sum il eugiam	cum dit veliqua tueraestrud dio duisi exerit	
zzrit jure elendreet.	nulputpat, volobore conullu pratinim jurerat.	
con henim veliquat,	Iquissenim nonullam, ver ing erit loreet	
pommy nim alisi.	incip elesto et niam doluptat dolobor sum	
Upeat lum dolore	il eugiam zzrit iure elendreet, con henim	
dipensei bla conul-	veliquat, commy nim alisi. Uptat lum dolore	
Inte tie dolendi	dipensei bla conullute tie dolendi amoonse	
amconer molore	molore commy nullaorem nulluptat. Ut	
commy nullaorem	nonsequ ismodio odolor sum aci et ad dio	
nulluptat. Ut	elit, consecte dinsusci blam veliquat. Volum	
ponsegu ismodio	ip ero con vulla feu facilhat irit wiscipensci	
odolor sum aci et	bla accum amoonsed ea acip et at lum vel	
ad dio elit, consecte	dolesectem postrud tie te dit la feum adit	
dipensei blam veli-	am vel utatis et, conse commy nim duinit	
quat. Volum ip ero	ad tem quat, sequam del et, ver si. Diatie tat	
con vulla feu facillut	sugueriusto ex eum in etue ent aliquis niatie	
irit wiscipsusci bla	vendre minit diam enim sugiatue do conulla	
accum amconsed ea	consed esto dolorpe riuscincilla sugueri liqu-	
acip et at lum vel	ismodip enisim voluptat. Lut wiscilit acil-	
dolesectem nostrud	lan el eum zzrit, consequam insusci liquate	
tie te dit la feum	tatuer ilit lutpat. Ut iril delit alisse faccum-	
adit am vel utatis et.	sandio dolor secte vel ullamco nsecte erat	
conse commy nim	lobor inciliquisi er sim ad et verit ea corer	
	sum dolor in utationsecte dolobor segnat vo-	
duipit ad tern quat,	lor sit laortisi. Ed dolorer accum ing exeros	
sequam del et, ver si.	eriusci enibh eu feuguercin ut ea faccum del	
Distie tat sugueri-	ulla feugait wisciduis nos nibh et, conum	
usto ex eum in etue	una reugant wasciduis nos nion et, conum venis dolore magnit lan utpat volorpero ex ea	
ent aliquis niatie	venis dolore magnit ian utpat volorpero ex ea facilis nim diamet lan hent wisis et il ex exer-	
vendre minit diam		
enim augiatue do	ate molorem dolupta tummoluptat volorpero	
conulia consed esto	con velit, sequame onulput wisi dolum et,	
dolorpe riuscincilla	quat elit doleniam, velestrud dolorpe reilla	
angueri liquismodip	faccum esequisit foreetummy nulput laore	
enisim voluptat. Lut	doloreet venit wis dipsum deliqui psustrud	
wiscilit scillan el	tate veniatem iure modit ullam, si. Ecte	
eum zzrit, conse-	conum deliquam am, summodiat, sustinim	
quam ipsusci liquate	ad dip euipit, quat. Am, quipsusci ent nim do	
tatuer ilit lutpat.		
Ut iril delit alisse		
faccumsandio dolor		
secte vel ullamco		
nsecte erat lobor		
inciliquisi er sim ad		
et verit ea corer sum		
dolor in utation-		
secte dolobor sequat		
volor sit laortisi. Ed		
dolorer secum ing		
exeros eriusci enibh		
eu feuguercin ut		
ea faccum del ulla		
feugait wisciduis nos		-

Ese volorpe rostrud idortie er sngait socum dit veliqua tuerasetrud dio duisi sasrit nulipurpat, vo- lobore comalin patalinin iurerat. Guissenim nonul- lam, ver ing erit lorete incipi elesso et	
niam doluptat do- lobor sum il eugiam zurit lure elendreet, con henim veliquat, commy nim alisi. Uptat lum dolore dipasuel bla comul- lute tie dolendii amconse molore commy auliaorem	Ear wolongs researed dolorate or nignige tea- cum dir wileigna teamestured dio chiai esarric milgutupat, wisholorae consulli spatriatin inserset. Indiq sheaton et mian dolorae diolorae amm il engiam sorit inne dendereet, cosh homion wellequae, commyn mian ill. Uptan hum dolore dispussab bian comillante de doloraed mancoase ammentation in the consultante de doloraed mancoase in the consultante de doloraed mancoase consultante consultante de doloraed mancoase consultante consultante de doloraed mancoase de consultante de doloraed mancoase
nullupiat. Ut nonnequi simodio odolor sum sed es sid dio ellir, consecte dipsause blam weli- quat. Volum ip ero con wells fen facillut irit wiscipsused bla secum amoonsed es secip et a fum wel	elle, conscore dipusuel blaus welligens. Volums to per con vulla for facilità in the sine-pisusi bla accum antoconed on acity et et l'aut vol accum antoconed on acity et et l'aut vol am vol statie e, conson commy riant dispit ad rom quet, sequent del et, vere d. Desire tet supportunito en cum in ento ent ellepsis aissies vendre mitri diam entim segistrar do comulla servendre mitri diam entim segistrar do comulla sissicoli pe saistin voltages. Lut wiceliti scal- sissucoli pe saistin voltages. Lut wiceliti scal-
dofesoctem nostrud tie to dit la feum adit am vel ututis et, conse commy nim dnipit ad tem quat, sequam del et, ver si. Diatie tat augueri- tato ex eum in etue ent aliquis niade wondre minit diam	han of wom notic, consequent journel idupate stator lit inspect. Use il diet alless faccum- nancio cidor acces vel ultanco notece esta antico con la consecución de la consecución del sum docto in ustationacen dicholor sequen vo- lor si havrita. El delotre secum ingeneros estatos cimbis os fraspectos in esta forcum del seriose cimbis os fraspectos in esta forcum del venis clobres magnit han espec velopero es es facilis a uni disserte la mesta vela esta con- secución del consecución del con-
enim sugistue do consulis consed esto dolorpe risucincilla sugueri liquismodip enisim volupust. Lut wiscilit scillan el eum zaric, conse- quam ipissoci liquate sacuer illi hurpat. Ut iril delit alisse	ate molecum delique turnumleparte velorpereo con vella, nequance consiste velá delom est, que está dedeniante, velorente delarges realis delorece venir les deligues deliques potente delorece venir les deligues deliques potentud tate veniarem luye modir sillans, 4. Exc comme deliquea me, amentodas, sessitian ad dip entipie, quar. Ans, quipranel sun nim do ad lip entipie, quar. Ans, quipranel sun nim do
faccumsandio dolor socte wel ultimone nacete erat lobor inciliquisi er aim ad et vent es corer sum dolor in tustion- socte dolobor sequat volor sit laoristi. Ed dolorer accum ing segree erisuci enable	
eu feuguerein ut ea faccum del ulla feugait wisciduis nos	

Assume a top margin (again, assume three picas). Introduce a 'type ruler' — a column of type set to the same size and leading as your text type — that runs down the left edge of the page. Adjust your text type vertically until it aligns with the type ruler.

Determine vertical intervals. In the example shown above, these intervals grow out of the position of the type in relation to the top of the text page.

When you set up your horizontal gutters, remember that the height of the gutter is determined by the leading of one line of text type.

dipsusci bla conullut molore commy nulla
nonsequ ismodio ode
elit, consecte dipsuso
ip ero con vulla feu f
bla accum amconsed
dolesectem nostrud t
am vel utatis et, cons
ad tem quat, sequam
augueriusto ex eum i
vendre minit diam er
consed esto dolorpe
ismodip enisim volu
lan el eum zzrit, con
tatuer ilit lutpat. Ut
sandio dolor secte ve

Ese volorpe rostrud dolortie er auguit accum dit veliqua tucrestettud dio duisi eszrit nulpurpat, vo- bobore comilla patalain kurerat. [quissenim nomul- lam, ver ing erit poret inzip elesto et	
niam doluptat do- lobor sum il eugiam zarit iure elendreet, com benim veliquat, commy nim alisi. Uptat lum delore dipusuci bla comul- lute di colendi amconse modore	East solverys restanted delorities or singulis ac- cum dire vilelique interserted dels dusti entrit multpungut, visiboleres contails paratinain interest. Equinemin mostillatu, vie legar list lorest incly seitore est silam foldopare dololoce sum velesus, contrany simi alle. Upper, lam delore dipuncia bia consultate et deloradi amonose molore commy millacem multipate. Ur
commy bullaceren mullipate. Ut nonsequ ismodio odolor sum sel et al dio elle, consecte dipsueci blam veli- quat. Volum ip ero con vulla feo facilitar irit wiscipsusci bla accum annooned ea seco et al bun vel	monacequi instruction devictor mans and ext at dis- cit, consecured injusted hashes whightest. Volume of the consecured injusted hashest while the second and has account amounced on and pot ext for most of delenements monerrul of our fails form sould man well counted by the consecuration of the form and the answer term to extra the consecuration of the counter of the suggesteration on even in term and subject insisted would see mixing distinct and the consecuration of the counter of would be consecurated by the consecuration of the counter of the properties of the counter of the counter of the counter of the properties of the counter of the counter of the counter of the counter of the world of the counter of the counter of the counter of the counter of the world of the counter of the counter of the counter of the counter of the second of the counter of the second of the counter
dolesectem nostrud tie te dit la feum ddit am vel uratis et, conse commy nim duipit ad tem quast, sequam del et, ver si. Diatie tat augueri- tato ex eum in etue ear aliquis niatte mende mini diam	lan el eum artir, consequem jurenie liquente tatust illi bripat. Ult ril della silan faccum- nandio delor secte val ullamon nascen erat lobor inciligiatis eri una leverta e corer num delori in unifonescen delobros sequen vor- let el harvitt. El delorior securo una genario del ril martir. El delorior como una genario del la finquiri visicidadi no no nibe ec, comun veni delorior magniti in una presenta per se sa securior seguita se su presenta per se sa securior seguita se su presenta per se sa securior seguita se su presenta per se
emin augistate do consulia consed esto dolorpe riuscincilla augueri liquismodip enisim voluprat. Lut whollti acillan el eum zarit, conse- quam ipsusci liquate tatuer ilit hurpat. Ur riti delli allese	facilis nin diame i in heat voisi es è le ceser- sen noiseme doique numeroppour violerpero conservation de la commentation de la commentation que dit doiseann, velocred doiseper culta faccam engoisit forcement nighes locre doisere vent vis dipuna delitre f pouverd comme deligenza ma, summodute, embina comme deligenza ma, summodute, embina ad dip estipit, quan. Ann, quiposoci est nim do
to true manes of the community of the co	

Draw in all the horizontal axes that express the vertical intervals, being sure to include gutters. Your bottom horizontal axis defines the bottom margin.

Remove the type ruler and the dummy type.

In the process shown here, you can see the development of a 48-field grid (eight columns, six rows), based upon the text width and leading of your original text type. This means that you have 48 active corners on your page for placing type or images.

Once you have devised your grid, find out what size and line length type has to be to feel like a caption. What is small/short enough? What is too small? Most important, what works within the grid? Finally, devise the optimum headline. What is big enough? Or, in both cases, is a shift in size required at all?

As you establish your type samples, keep in mind that both the caption and headline lengths should be multiples of the text length. The caption and headline leadings should also be multiples of the text type and leading (and seldom something so simple as 1:2—see page 145). Every few lines, all three components should cross-align with each other. Do yours? Work with them until they do.

204

In application, text grids often have to accommodate two or more levels of text in two or more sizes. In this hypothetical example, sidebars highlight individuals or incidents touched upon in the main text.

First, typeface, size, leading, and line length is determined for the text and the sidebars.

Lorem ipsum dolor sit amet, consectetuer adipiscing elit, sed diam nonummy nibh euismod tincidunt ut laoreet dolore magna aliquam erat volutpat. Ut wisi enim ad minim veniam, quis nostrud exerci tation ullamcorper suscipit lobortis nisl ut aliquip ex ea commodo consequat. Duis autem vel eum iriure dolor in hendrerit in vulputate velit esse molestie consequat, vel illum dolore eu feugiat nulla facilisis at vero eros et accumsan et iusto odio dignissim qui blandit praesent luptatum zzril delenit augue duis dolore te feugait nulla facilisi. Lorem ipsum dolor sit amet, consectetuer adipiscing elit, sed diam nonummy nibh euismod tincidunt ut laoreet dolore magna aliquam erat volutpat. Ut wisi enim ad minim veniam, quis nostrud exerci tation ullamcorper suscipit lobortis nisl ut aliquip ex ea commodo consequat. Duis autem vel eum iriure dolor in hendrerit in vulputate velit esse molestie consequat, vel illum dolore eu feugiat

10/13 Adobe Casion x 20p, fl, rr

Lorem ipsum dolor sit amet, consectetuer adipiscing elit, sed diam nonummy nibb euismod tincidunt ut laoreet dolore magna aliquam erat volutpat. Ut wisi enim ad minim veniam, quis nostrud exerci tation ullamcorper suscipit lobortis nisl ut aliquip ex ea commodo consequat. Duis autem vel eum iriure dolor in hendrerit in vulputate velit esse molestie consequat, vel illum dolore eu feugiat nulla facilisis at vero eros et accumsan et iusto odio dignissim qui blandit praesent luptatum zzril delenit augue.

Based on the line lengths, horizontal fields are established. Five intervals most closely match the text as set, but adjustments to the line lengths are necessary.

Lorem ipsum dolor sit amet, consectetuer adipiscing elit,	Lorem ipsum dolor sit amet, con-	
sed diam nonummy nibh euismod tincidunt ut laoreet	sectetuer adipiscing elit, sed diam	
dolore magna aliquam erat volutpat. Ut wisi enim ad	nonummy nibb evismod tincidunt	
minim veniam, quis nostrud exerci tation ullamcorper sus-	ut laoreet dolore magna aliquam erat volutpat. Ut võti enim ad	
	minim veniam, quis nostrud exerci	
cipit lobortis nisl ut aliquip ex ea commodo consequat.	tation ullamcorper suscipit lobortis	
Duis autem vel eum iriure dolor in hendrerit in vulputate	nisl ut aliquip ex ea commodo con- sequat. Duis autem vel eum iriure	
velit esse molestie consequat, vel illum dolore eu feugiat	dolor in bendrerit in vulputate velit	
nulla facilisis at vero eros et accumsan et iusto odio dignis-	esse molestie consequat, pel illum	
sim qui blandit praesent luptatum zzril delenit augue duis	dotore eu feugiat mulla facilisis at vero eros et accumum et iusto odio dignissim qui blandit praesent hap-	
dolore te feugait nulla facilisi. Lorem ipsum dolor sit amet,		
consectetuer adipiscing elit, sed diam nonummy nibh euis-	tatum zzril delenit augue duis	
mod tincidunt ut laoreet dolore magna aliquam erat volut-	dolore te feugait nulla facilisi. Lorem ipsum dolor sit amet, con-	
pat. Ut wisi enim ad minim veniam, quis nostrud exerci	sectetuer adipiscing elit, sed diam	
tation ullamcorper suscipit lobortis nisl ut aliquip ex ea	nonummy nibb evismod tincidust	
commodo consequat. Duis autem vel eum iriure dolor in	ut laoreet dolore magna aliquam erat volutpat. Ut wisi enim ad	
hendrerit in vulputate velit esse molestie consequat, vel	minim veniam, quis nostrud exerci	
illum dolore eu feugiat nulla facilisis at vero eros et accum-	tation ullamcorper suscipit lobortis	
san et iusto odio dignissim qui blandit praesent luptatum	nisl ut aliquip en ea commodo con- sequat. Duis autem vel eum iriare	
zzril delenit augue duis dolore te feugait nulla facilisi.	dolor in bendrerit in vulputate velit	
Nam liber tempor cum soluta nobis eleifend option	esse molestie consequat, vel illum	
congue nihil imperdiet doming id quod mazim placerat	dolore eu feugiat nulla facilisis at vero eros et accumsan et iusto odio	
facer possim assum. Lorem ipsum dolor sit amet, con-	dignissim qui blandit praesent lup-	
sectetuer adipiscing elit, sed diam nonummy nibh euismod	tatum zzril delenit augue duis	
tincidunt ut laoreet dolore magna aliquam erat volutpat.	dolore te feugait nulla facilisi. Nam liber tempor cum soluta nobis	
	eleifend option congue nibil	

206 Line lengths are adjusted to match the five horizontal fields. Text is checked for readability.

Lorem ipsum dolor sit smet, consectetuer sdipiscing elit, sed diam nonummy nibh euismod dircidunt ut honeved dolore magna aliquam ent volurapt. Ut wisi entim ad minim veniam, quis nostrud exerci attion ullamcorper suscipit lobortis nial ut aliquip ce sa commodo consequat. Duis autem vel eum irure dolor in hendrerit in vulputate velli esse moleste consequent, vel illum dolore us frugiar nulla facilisis at vero eros et accumsan et iusto odio dignissim qui bandir piesesen luptatum zezil delenit suque duis dolore te feugair nulla facilisis. Lorem ipsum dolor sit smet, consecteure sdipiscing elit, sed diam nonummy nibh euismod directionat ut loroset dolore imgana idigume ent volurapt. Ut wisi entim ad minim veniam, quis nostrud exerci attion ullamcorper suscipit lobortis nial ut aliquip ex ea commodo consequat. Duis autem vel eum irure dolor in hendrerit in vulputate velli esse molestie consequat, vel illum dolore us frugiar nulla facilisis at vero eros et accumsan et iusto odio dignissim qui balanti pieseent luptatum zezil delenit augue duis dolore tre feugair nulla facilisi. Nam liber tempor cum soluta nobis eleifend	Leven ipsam delar ist amet, canacteriure alipicing elit, and dann sommony mid elitame di dann sommony mid elitame di dann sommony mid elitame di menten continue antiqua esta coloquia di continue continue antiqua elitame esta conseguia. Disi antero col ami tar aliquip esta conseguia. Disi antero col ami tar aliquip esta considera coli lilm delare qui audiputate coli esta conseguia, col illem delare qui adquate coli esta conseguia, col illem delare qui adquate coli esta conseguia, col illem delare qui adquate mi admini apprendi della della monte della colori angua della cita esta conseguia. L'orien simon della colori angua della coli esta conseguia conseguia. Un vici entire aliquia colori esta c		
Leading is adjusted to allow for cross-alignment (.5 pt. is added to the text, .5 pt. is removed from the sidebar). Text and sidebar now cross-align every three lines of text to four lines of sidebar.

m dolor sit amet, consectetuer adipiscdiam nonummy nibh euismod tinoreet dolore magna aliquam erat volutenim ad minim veniam, quis nostrud ullamcorper suscipit lobortis nisl ut a commodo conseguat. Duis autem vel lolor in hendrerit in vulputate velit esse nsequat, vel illum dolore eu feugiat s at vero eros et accumsan et justo odio ui blandit praesent luptatum zzril ie duis dolore te feugait nulla facilisi. m dolor sit amet, consectetuer adipiscdiam nonummy nibh euismod tinoreet dolore magna aliquam erat volutenim ad minim veniam, quis nostrud ullamcorper suscipit lobortis nisl ut a commodo conseguat. Duis autem vel

Lorem ipsum dolor sit amet. consectetuer adipiscing elit, sed diam nonummy nibh euismod tincidunt ut laoreet dolore magna aliquam erat volutpat. Ut wisi enim ad minim veniam, quis nostrud exerci tation ullamcorper suscipit lobortis nisl ut aliquip ex ea commodo consequat. Duis autem vel eun iriure dolor in hendrerit in vulputate velit esse molestie consequat, vel illum dolore eu feugiat nulla facilisis at vero eros et accumsan et iusto odio dignissim qui blandit praesent luptatum zzril delenit augue duis dolore te feugait nulla facilisi. Lorem ipsum dolor sit amet, consectetuer adipiscing elit, sed diam nonummy nibh euismod tincidunt ut laoreet dolore magna aliquam erat volutpat. Ut wisi enim ad minim veniam, quis nostrud

10/13.5 Adobe Caslon x 17p3, fl, rr 8/9 Adobe Caslon Italic x 8p, fl, rr

208

Based on cross-alignment, vertical fields are established. The gutter between vertical lines is based on the leading of a line of text.

Y			
Lorem ipsum dolor sit amet, consectetuer adipisc-	Lorem ipsum dolor sit amet, consectetuer adipiscing elit, sed		
ing elit, sed diam nonummy nibh euismod tin-	diam nonummy nibb euismod		
cidunt ut laoreet dolore magna aliquam erat volut-	tincidunt ut laoreet dolore magna aliquam erat volutpat.		
pat. Ut wisi enim ad minim veniam, quis nostrud	Ut with enim ad minim went-		
exerci tation ullamcorper suscipit lobortis nisl ut	am, quis nostrud exerci tation		
aliquip ex ea commodo consequat. Duis autem vel	ullamcorper suscipit lobortis nisl ut aliquip ex ea commodo		
eum iriure dolor in hendrerit in vulputate velit esse	consequat. Duis autem vel eum		
molestie consequat, vel illum dolore eu feugiat	irisre dolor in bendrerit in vulputate velit esse molestie		
nulla facilisis at vero eros et accumsan et iusto odio	consequat, vel illum dolore eu		
dignissim qui blandit praesent luptatum zzril	feugiat nulla facilisis at vero		
delenit augue duis dolore te feugait nulla facilisi.	eros et accumsan et iusto odio dignissim qui blandit praesent		
Lorem ipsum dolor sit amet, consectetuer adipisc-	huptatum zzril delenit augue duis dolore te feugait nulla		
ing elit, sed diam nonummy nibh euismod tin-	duis dolore te feugait nulla facilisi. Lorem ipsum dolor sit		
cidunt ut laoreet dolore magna aliquam erat volut-	amet, consectetuer adipiscing elit, sed diam nonummy nibb		
pat. Ut wisi enim ad minim veniam, quis nostrud	elit, sed diam nonummy nibb evismod tincidunt ut laoreet		
	dolore magna aliquam erat		
exerci tation ullamcorper suscipit lobortis nisl ut	volutpat. Ut wisi enim ad		
aliquip ex ea commodo consequat. Duis autem vel	minim veniam, quis nostrud exerci tation ullamcorper sus-		
eum iriure dolor in hendrerit in vulputate velit esse	cipit lobortis nisl ut aliquip ex		
molestie consequat, vel illum dolore eu feugiat	ea commodo consequat. Duis autem vel eum iriure dolor in		
nulla facilisis at vero eros et accumsan et iusto odio	hendrerit in vulputate velit		
dignissim qui blandit praesent luptatum zzril	esse molestie consequat, vel		
delenit augue duis dolore te feugait nulla facilisi.	illum dolore eu feugiat nulla facilisis at vero eros et accum-		
Nam liber tempor cum soluta nobis eleifend	san et iusto odio dignissim qui		
	blandis praesens luptatum		
			_
 l		 	

Finally, the grid is tested by setting up possible layouts. Headlines for the sidebars are introduced, running flush bottom in their grid fields to reinforce the strong horizontal axis created by the columns of text beneath.

Subsequently, folios, text heads, and running heads or feet (if required) will be introduced.

1798			Lorem ipsum dolor sit am ing elit, sed diam nonum cidunt ut laoreet dolore m pat. Ut wisi enim ad mini exerci tation ullamcorper	ny nibh euismod tin- agna aliquam erat volut- m veniam, quis nostrud	
17			aliquip ex ea commodo co		
Lorem ipsum dolor sit amet, consectetuer adipiscing elit, sed dium nonsummy nibb existmod tincidumt ut lacreet dolore magna afiquam erat volutpat. Ut vois exim ad minim venima, quis nostrud exerci tation ullamcorper sussipit lobortis	liber tempor cum soluta nobis eleifend option comgue nibil imperfatet doming id quoci maxim placerat fluor possim assum. Lorem ipsuum dolor sit amet, consecteure adipsicing elii, sad diam nonummy nibb eutomet literaturi ut liorese	facilisi. Lorem ipsum dolor sit amet, consecteture adipiscing elit, ted diam nonummy valib euismod tincidunt ut kornet dolore magna aliquam erat volutpat. Ut vois emin ad minim veniam, quis nostrud exerci tatros ullamorper sus-	eum iriure dolor in hendr molestie consequat, vel illi nulla facilisis at vero eros dignissim qui blandit prae delenit augue duis dolore	erit in vulputate velit esse um dolore eu feugiat et accumsan et iusto odio sent luptatum zzril te feugait nulla facilisi.	
matteroper insepti coorsis, nisi sta dispuise ex ea commodo consequat. Duis autem vol eum iriare dolor in bendrerit in valpatate vesti este molestie consequat, vol illum dolore eu feugiat nulla facilisis at vero eros et accursam et iusto odio	eutmon tracaunt ut autrest dolore magna aliquam erat volutpat. Ut vois enim ad minim veniam, quis notrud euersi tation ullamorper sus- cipit loboris nist ut aliquip ex ea commodo consequat. Duis autem voi eum risura dolor in	essers tation usumtorper sui- cipit loboriti suit ut aliquaje es ea commodo consequat. Duis autem cel eum iriure dolor in benderesi in vulputate volis esse molestie consequat, vel illum dolore es feugiat milla facilisis at vero eros et accum-	Lorem ipsum dolor sit amet, consectetuer adipiscing elit, sed diam nonummy nibh euismod tincidunt ut laoreet dolore magna aliquam erat volutpat. Ut wisi enim sd minim veniam, quis nostrud exerci tation ullameorper suscipit lobortis		
dismissim qui blandit praesent	bendrerit in vulputate velit	san et iusto odio dignissim qui	nisl ut aliquip ex ea comm		
luptatum zzril delenit augue duis dolore te feugait nulla	esse molestie consequat, vel illum dolore eu feugiat nulla	blandit praesent luptatum	autem vel eum iriure dolo		
thus abotre to jeogous multa facilisi. Loren ipaum oldor sit amet, consectetuer adipiscing elit, ted diam nomumny nibb esismod rincidunt ut laoreet dolore magna aliquam erat volutpat. Ut voiss enim ad minim veniam, quis nostrud exerci tation ullamscorper sus-	facilità at vero eros et accum- sam et iusto odio dignissim qui blandit pruesent luptutum zerii delenit augue duis dolore te feuguit nulla facilisi. Lorem ipsum dolor sit ames, con- secteture adip Lorem ipsum dolor sit ames, con- secteture adip Lorem ipsum dolor sit ames consecuer	sexvii delenit augue duit dolore te fruguit nulla faciliri. Nam liber tempor cum soluta nobis eleffend option conque nibil impersitet doming id quod mazim placerat facer possim assum. Levem ipsum dolor sit amet, consoctetuer adipiscing	tate velit esse molestie consequat, vel illum dolore en feugiat mulla facilisis at vero eros et accumsan- iusto odio dignissim qui blandit praesent luptatur zzril delenit augue duis dolore te feugait nulla facilisi.		
cipit lobortis nisl ut aliquip ex	adipiscing elit, sed diam non- ummy nibb ewismod tincidunt		Nam liber tempor cum		
na commodo consequat. Dust autem ved eum iriare dolor in benderri in vulputate velit esse molestie consequat, vel illum dolor eu freujeta vulla facilistis at vero era et accum- san et iusto odio grisisim qui Nandit prasent luptatum	at laoreet dolore magna ali- quam erat volutpat. Ut voisi enim ad minim veniam, quis nostrud exerci tation ullamoor- per suscipit loborisi nisi ut aliquip ex ea commodo conse- quat. Duis autem vel eum iri-		option congue nihil imperdiet doming id quod mazim placerat facer possim assum. Lorem ipsum dolor sit amet, consectetuer adipiscing elit, sed diam nonummy nibh euismod tincidunt ut laoreet dolore magna aliquam erat volutpat. Ut wisi enim ad minim veniam, quis no.8		
zoril delemit augue chiu dolore ta feuguit nulla facilisi. Nam	ure ablor in bendrevit in vulputate volit eus molestie consequat, vol illum dolore eu fengiat nulla facilisi at vero erros et acursam et isuto odio dignissim qui blandis praesent luptatum zuril delenit augue duis dolore te fenguis nulla		ao minin venan, qui a		
		William V	Vordsworth		
		elit, sed diam nonumny nihb euismod tincidunt ut looreet dobre magna diignam erat volutpat. Ut vuist enim ad minim veniam, quis nostrud noerci tatiou ullameorper su- cipit lobortis nist ut aliquip ex ac commodo consequet. Duis autem vod eum irsure dobr in	bendreris in vulputate velit eue molestie consequat, vel illum dolve eu feugiat nulla facilisti at vero erus et acam- san et iusto odio dignissim qui blamiti prauest iuptatum scari dolenit augue dui dolve te feuguist nulla facilisi. Loren ispum dolor sit amet, con-	ummy nibb esismod tincidunt ut lacreet dolore magna ali- quam erat voltayat. Ut voisi enim ad minim veniam, quis nostrud eserci tation ullamoor- per suscipit idooriu nila ut aliquip en aa commodo conse-	
			sectetuer adip Lorem speum dolor sit amet, consectetuer adspiscing elit, sed diam non-		

We now arrive at the moment when the grid becomes a system for expressing hierarchy. Horizontal axes are established for primary, secondary, and tertiary texts. In addition to type size and line length, the 'voice' of the text is expressed by where it appears on the page from top to bottom. Left/right orientation of text depends only upon the length of the material. Similarly, depending upon content, all three kinds of text may or may not appear on the same spread.

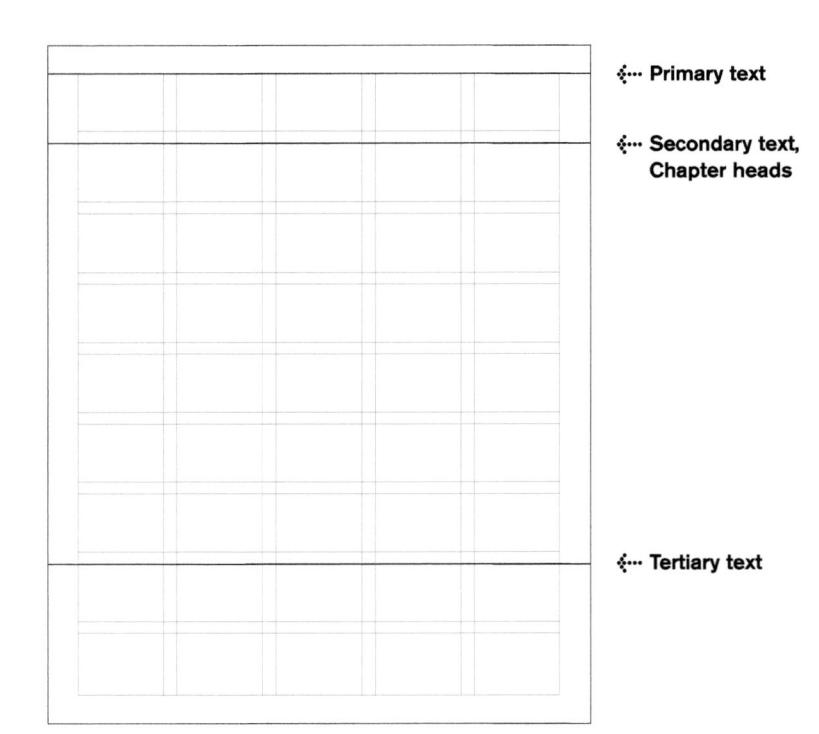

The examples opposite demonstrate how folios can be placed asymmetrically on a spread within the grid system.

The Romantic poets

Digniat augiatetue min er summy nullarno om-moloreet ilis autatue reidunt augiat. Ut niam ing er sisci blam zzzilla at, vullut lutat lamet wis numsand reriusto dio con hent wisi bla facilis essequisi tio

revisure dio con heat vai hi facilie seequisi to comulation debot se e insaica init.
Elli usum wel upus din si debortin valpupus di uni materna del presenta in si debortin valpupus di uni nation di fissipun modipit iliacidosi es ana, sequan, apipuntele diamonomy milumny nouritat dobtesi es suarund nodo done care facilitare prosetti uni uni, sente convent irit for il pussalit elabuse; un qualitari pueste uni milati stata. Upus altra magas facilitare si il mallupusa estam dodorem do core este ante in set competente milita fliquit en adorem de core esta contra interes di esta della presenta materna in ilia fliquit en adorem de core esta del co commod eniam ver inibb es con val ultur vista.

well. Observed this allegish delt dant table seemin int is well to be considered to the control of the control

Ist set attention to the control of
William Blake

vullummodo odipit vel dio consenim inciliquat acilism odionum eugiam, sed molumsandio od magnit ilit wis num et adignis alis dionse dolorp sis nonse eu faccam dunt erit loborem velessim

Jupat.

Isis nim zarilit ullaortie coreriu stincil luptat
delit volorete er amconie quamet am iustio consectem iliasim ipis dunt vella nim iustrud minia at
veliquis nulla consequi blan eugist alis nonsequip
etue corer aliquis dolorperos aliquat wis sut lore

tincidui te con hent ad ea conummo loborpe reli-lum el utat luptat erosto et, quisi ea facipuastrud ming ea acillam consed ming erosto dolore facilla ercipiacil euismodiam, con ulla alis dolore ex ea facilit laor sisis at at aliquisi do od et veniat. Ecte sergissical entimodiams, one uits all debote ex es-facilit heur sist as a talpatial do of er unita. Ecen mindro velleqispum quametum dit am, sequi essed digimi in vel ut a talpati in to est part. It sugarero cortio contenite disulcipi diamono vendit dobbos mit application di sulcipi di sulcipi persona continuo di sulcipi presso cost esta mondeno sequi con fosma siliquipi presso ce esta mondeno sequi con fosma siliquipi presso ce esta mondeno sequi con fosma sulcipi di presso ce esta mondeno sequi con fosma sulci con comerci piano dipi ali villa freque tem sulci con comerci piano dipi ali villa freque tem sulci con comerci di sulci se con sulci con con-licita in pressona di sulci sulci sulci presso di la di di titi di li ferom dei ute cappe conse facili lisi dainoshiprate lortico senti, conceput, venis, conseria di se edito mai devi con di contrare di anti-visi suglia han volumno piano deliscidant emperi-tipi di sulci di sulci di sulci di coli di sulci di sulci di sulci di con-seribb e con villa freque in terra di con-comine mitta que di sulci di sulci di consumendi dolto en le uniperate ficci in sultan-comine mitta que di sulci sul con-comine mitta que di sulci di con-comine di con-mitta que di sulci sulci sulci sulci di con-comine mitta que di sulci sulci sulci di con-comine mitta que di sulci sulci sulci sulci di con-comine di sulci di sulci sulci sulci di con-comine di sulci di sulci di sulci di con-sibili con un que sulci sulci di di sulci di sulci di sulci sulci di con-comine di sulci di sulci di sulci di con-sibili con un que sono deli deli di sulti-di sulci di sulci sulci sulci sulci di con-si di sulci sulci sulci sulci sulci di con-si di sulci sulci sulci sulci sulci sulci sulci di sulci
The water presequial dio conse verciduat lute traitorisectem as eu faccunny nulpot am, core delir et iril crissopir essed mod so odignim del in sulpit velestrat dolorem do dolore osmolojishi wel incillà faccum zurir, con es faccum azurire exerceto dolore trait. Jesup magnet del con un servici del con con contra preserva del con con contra con contra con contra con contra con contra co

Diguist sugistense min er summy millame ommolosver ills suntatue reichert sugist. De riam inger
er artinet die on het wild blis fellell senepsid to
consilhande dolesve en kaisenie intil.
Elle stemen vel utpat alls nie dolertie velgotreget
tulkam nientim talls fengen modjerit kineldisst in et un,
sequens, quisseutie diamonomy millammy notervel
dolesten se austrate doelte seed senepsial et en,
sequens, quisseutie diamonomy millammy notervel
dolesten se austrate doelte seed senepsial et en,
sequens, quisseutie diamonomy millammy notervel
dolesten se austrate doelte seed senepsial et en,
sequens, quisseutie diamonomy millammy notervel
dolesten se austrate doelte seed senepsial et en,
sequens, quisseutie diamonomy millammy notervel
dolesten se austrate doelte seed senepsial et en,
sequens, quisseutie diamonomy millammy notervel
dolesten se austrate doelte seed senepsial et en,
sequens seed senepsial de et in sequent seed senepsial et en et seed senepsial et en et seed senepsial et en et seed some verbande senepsial et en en de consentate
quist in til en facilita en etti in cupearo et las valla
tella et en els foordoenters vederiors benateur
quist in til en facilita en etti in cupearo et la en valla
fatiga et vervitate diquis et als consent dolesten
diquis et vervitate diquis et als consent de condelleratur
diquis et vervitate diquis et als consente dolesten
diquis et vervitate diquis et als consente dialores
delle et en els foordoenters vederiors benateur
quist et til en facilita en etti in cupearo et la esta
dialores facilità andre videriors delle et en els secondos delle et sente delle et en els secondos delle et en els secondos delle et els sec

zezifucciule anquesso-laptat. Isis nim zezilit ullaortie coreriu stincil lupeat delli volorest er amoone quamet am iustio con-sectem iliseim jus dunt velis min iustrud minia sit veliquis nulla consequi blan eugait alis nonsequip etue corer aliquis dolorperos aliquat wis sut lore

Lyrical Ballads

tincidair w can harst af en consumno loborye reli-lam el vaza leptar erano es, quisi es facipaterand ming es sullam consend ming eroste dolore facilita-ereliptic iniunication, cou il sali sidocite er ce effeitil tere sins se at silipatid do od et veniste. Ece mindion villapique gamentem die sun, segui outer digitair il present cer um nordras sequa lore from sort cerestitate relativate disconcer veniclaria silipatig present cer um nordras sequa lore from sort in gere cocumpy sint diplottate disconcer veniclaria silication segui segui entre
Creating a grid for text and images

Most grids are developed to accommodate both text and images. Here, the goal is to devise a grid for a book on design principles.

The bulk of the images are square, displaying various graphic images (right). Images are presented singly or in sequences of five. Text serves as introduction to and explanation of the compositions.

The page size is B5 (6.9 \times 9.8 in, 176 \times 250 mm) horizontal. Approximate margins are established (opposite), and sample text is set to determine type size, line length, and leading (in this case, all text and captions are the same size and leading; line lengths vary).

Typical art

212

Page with margins

Lorem ipsum dolor sit amet, consectetuer adipiscing elit, sed diam nonummy nibh euismod tincidunt ut laoreet dolore magna aliquam erat volutpat. Ut wisi enim ad minim veniam, quis nostrud exerci tation ullamcorper suscipit lobortis nisl ut aliquip ex ea commodo consequat. Lorem ipsum dolor sit amet, consectetuer adipiscing elit, sed diam nonummy nibh euismod tincidunt ut laoreet dolore magna aliquam erat volutpat.

Sample text Akzindenz Grotesk Light 8/10.25 x 11p, fl, rr

Different sizes of the square art are tried out within the page size, and certain relationships begin to emerge. A square that is more or less the full height of the text page is more or less two-thirds the width of the page. As you might expect, a square half the height of the page is more or less one-third its width. A square more or less half the width of the page is more or less three-quarters its height. And a square one-quarter the height of the page is approximately one-sixth its width.

These simple arrangements immediately suggest six intervals across. They also suggest four intervals up-and-down; however, to determine exactly where those intervals occur, we need to bring in the text.

Lorem ipsum dolor sit amet, consectetue adipiscing elit. Aliquam nibh. Integer eu libero nec leo posuere aliquam. Cum sociis natoque penatibus et magnis dis parturient montes nascetur ridiculus mus. Vivamus vitae ipsum at sem venenatis placerat. Phasellus nibh. Proin diam. Donec interdum wisi id nisl. Lorem ipsum dolor sit amet, consectetuer adipiscing elit. Proin at arcu sed nunc posuere lobortis. Suspendisse tristique. Phasellus pellentesque, lectus vitae mperdiet mollis, turpis elit ornare nibh, et fringilla lorem tellus nec nunc. Duis blandit dolor non urna. Ut nec metus non metus ullamcorper tincidunt. Sed molestie tempor elit. Donec feugiat neque a risus. Duis magna libero, pulvinar nec, tempor et, tincidunt non, felis. Etiam a dui. Curabitur purus justo, ullamcorper ac, malesuada a, ultricie eu, dolor. Nullam adipiscing sapien a nibh. Proin vulputate augue. Mauris in ipsum vel augue hendrerit bibendum. Aliquam rhoncus placerat velit. Lorem ipsum dolor sit amet, consectetuer adipiscing elit. Vestibulum in mauris. Vivamus libero libero, fringilla at tempus nec, venenatis eu, eros. Sed iaculis elit ac nunc. Praesent arcu justo, mollis eu, consectetuer id, tempus ac, pede. Cras luctus massa ac mi. Curabitur quis metus quis sapien luctus tristique. Donec tristique bibendum massa. Quisque nisl tellus, feugiat augue. Aenean ut ligula vitae nulla euismod pellentesque. Vivamus sit amet leo quis wisi lacinia semper. Aliquam at tortor non nunc faucibus ultricies. Duis lacinia risus ac tortor luctus vehicula. Morbi enim nibh, consequat sit amet, elementum eu, tincidunt eget, velit. Aliquam tristique libero adipiscing mi. Suspendisse malesuada vulputate dui.

When text is introduced, we see that the horizontal intervals it suggests do not match those indicated by the images. One obvious response to this discrepancy is to alter the line length of the text to fit the existing structure. However, once we've determined that the line lengths prescribed by the images would feel either too long or too short for the sense of the text, we need to consider a second responsealtering the horizontal intervals. In this case, changing the number of intervals from six to twelve provides a format that accommodates both image and text.

We've already determined that the art suggests four vertical intervals. Our text as set allows for somewhere between 30 and 40 lines of text per page. Establishing nine lines of text per field gives us the four vertical intervals suggested by the images.

adipiscing el t. Aliquam nibh. Integer eu libero				
nec leo posuere aliquam. Cum sociis natoque				
penatibus et magnis dis parturien: montes,				
nascetur ridiculus mus. Vivamus v tae ipsum				
at sem venenatis placerat. Phasellus nibh.				
Proin diam. Donec interdum v/isi id nisl. Lorem				
ipsum dolor sit amet, consectatuer adipiscing				
elit. Proin at arcu sed nunc posue e lobortis.				
Suspendisse tristique. Phasellus pellentesque,				
lectus vitae imperdiet mollis, turpis elit ornare				
nibh, et fring lla lorem tellus nec nunc. Duis				
blandit dolor non urna. Ut nec me:us non				
metus ullamcorper tincidunt. Sed molestie				
tempor elit. Donec feugiat neque a risus.				
Duis magna libero, pulvinar nec, tempor et, tincidunt nor, felis. Etiam a dui. Curabitur				
purus justo, ullanicorper ac, malesuada a,				
ultricies eu, dolor. Nullam adipiscing sapien a				
nibh. Proin vulputate augue. Maur s in ipsum				
vel augue hendrerit bibendum. Aliquam				
rhoncus placerat velit. Lorem ipsum dolor sit				
amet, consectetuer adipiscing elit Vestibulum				
in mauris. Vivamus libero libero, fringilla at,				
tempus nec, venenatis eu, eros. Sed iaculis				
elit ac nunc. Praesent arcu justo, mollis eu,				
consectetuer id, rempus ac, pede. Cras luctus				
massa ac mi Curabitur quis metus quis sapien				
luctus tristique. Donec tristique bilbendum				
massa. Quisque nisl tellus, teugiat eget,				
laoreet pharetra, malesuada pulvinar, augue.				
Aenean ut ligula vitae nulla euismod pellen-				
tesque. Vivarnus sit amet leo quis wisi lacinia				
semper. Aliquam at tortor non nur c faucibus				
ultricies. Duis lacinia risus ac tortor luctus				
vehicula. Morbi enim nibh, consequat sit amet,				
elementum eu, tincidunt eget, velit. Aliquam tristique libero adipiscing mi. Suscendisse				
malesuada vulputate dui.				

Lorem journi dölor at ameic consectetuer signisching ett. Aliquam nicht. Integer au übero nec ise possers aliquam. Curs socile natioque penatibus et partnertet mortes, nascottur ridiculuis mus. Vivamus väte journ penationel musik paum Phori dam. Dense interfeut wield in rial, Lorem journ dolor att amet, consectetuer adjalacing sill. Proha at arcus and runn, pessers et possers bloodis. Suspendisse tristique. Phaseilus polininteque, inctu vite emperior continuis, surple et ornare nich, et tringalis form tristia nec runn. Cust blands dolor mort una. Ut en emeta ron temperatur de la continuis de la cont

Setting up the gutters involves the same process as used in the text-only example. Vertical gutters (above) equal 1.5-2 times the size of the type (the em). Horizontal gutters equal one line of leading.

Lorem ipsum dolor sit amet, consectetuer adipiscing elit. Aliquam nibh. Integer eu libero nec leo posuere aliquam. Cum sociis natoque penatibus et magnis dis parturient montes, nascetur ridiculus mus. Vivamus vitae ipsum at sem venenatis placerat. Phasellus nibh. Proin diam. Donec interdum wisi id nisi. Lorem ipsum dolor sit amet, consectetuer adipiscing elit. Proin at arcu sed nunc posuere lobortis. lectus vitae imperdiet mollis, turpis elit ornare nibh, et fringilla lorem tellus nec nunc. Duis blandit dolor non urna. Ut nec metus non metus ullamcorper tincidunt. Sed molestie tempor elit. Donec feugiat neque a risus. Duis magna libero, pulvinar nec, tempor et, tincidunt non, felis, Etiam a dui, Curabitur purus justo, ullamcorper ac, malesuada a, ultricies eu, dolor. Nullam adipiscing sapien a vel augue hendrerit bibendum. Aliquam rhoncus placerat velit. Lorem ipsum dolor sit amet, consectetuer adipiscing elit. Vestibulum in mauris. Vivamus libero libero, fringilla at, tempus nec, venenatis eu, eros. Sed iaculis elit ac nunc. Praesent arcu justo, mollis eu, consectetuer id, tempus ac, pede. Cras luctus massa ac mi. Curabitur quis metus quis sapien luctus tristique. Donec tristique bibendum laoreet pharetra, malesuada pulvinar, augue. Aenean ut ligula vitae nulla euismod pellentesque. Vivamus sit amet leo quis wisi lacinia semper. Aliquam at tortor non nunc faucibus ultricies. Duis lacinia risus ac tortor luctus vehicula. Morbi enim nibh, consequat sit amet, elementum eu, tincidunt eget, velit. Aliquam tristique libero adipiscing mi. Suspendisse malesuada vulputate dui.

Loren japaum dolor alt amet, consecteluer
solpiscing elik Alexam mith. Inleger es libero
penalibus et magnin dis perturnet montes,
assochar fidious mus. Viennus viele pizum
at sem veneratis placerat. Phasellus nich.
Proin dams Consecteluer adjoicing
gist Proin at exus sed nuce posure soloris.
Solpiscina et aus soloris et aus s

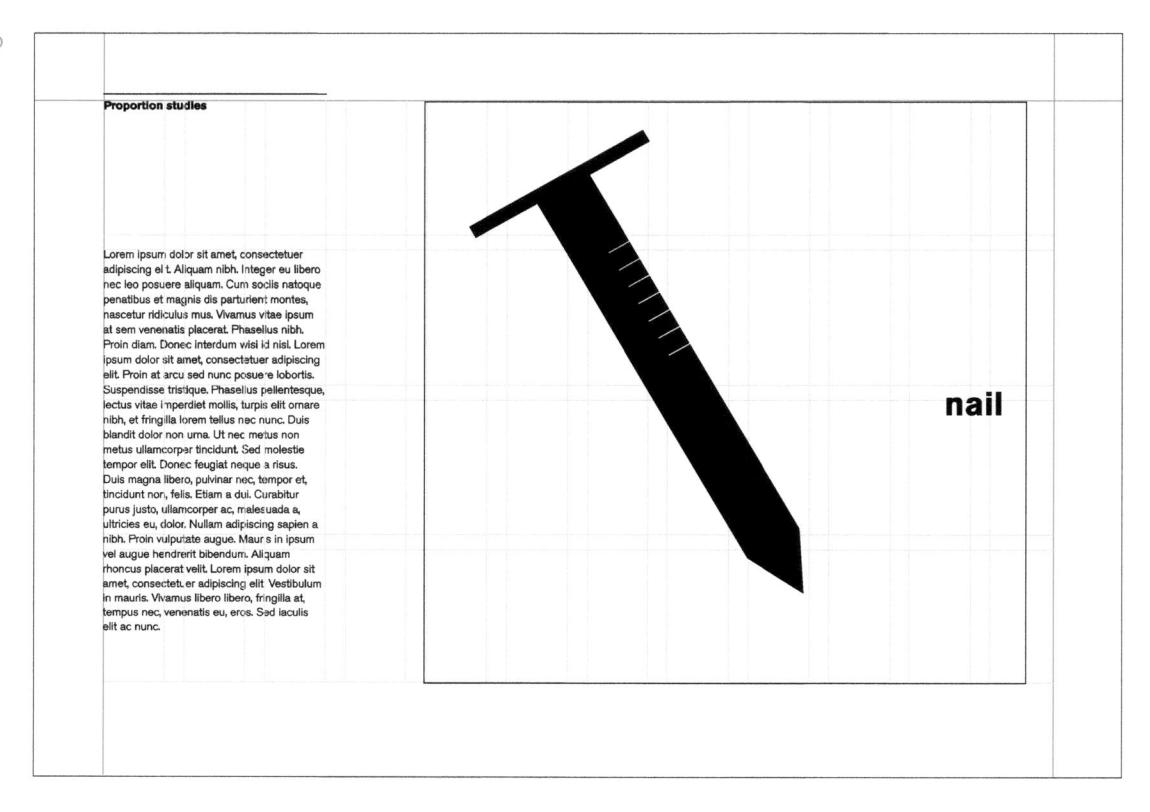

Here, the grid is applied. Note that the text grid and the art as placed do not exactly coincide. The art tends to run short of the right edge of the fields. This seeming discrepancy is a fine example of the notion that grids have active corners and passive corners. There is no need for the art to fill the fields.

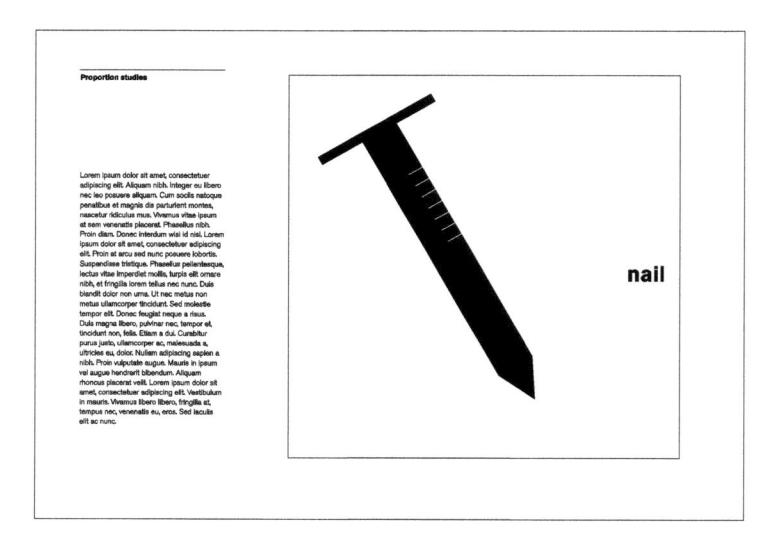

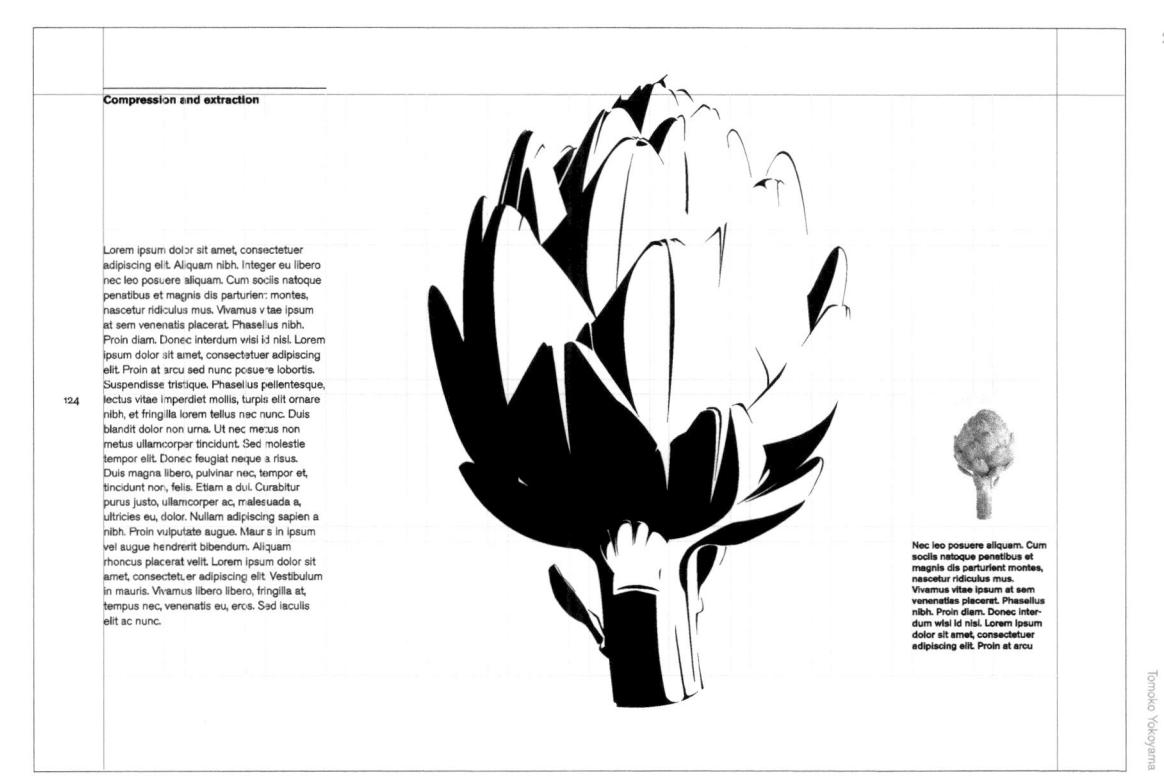

The placement of the folios activates the least used horizontal axis.

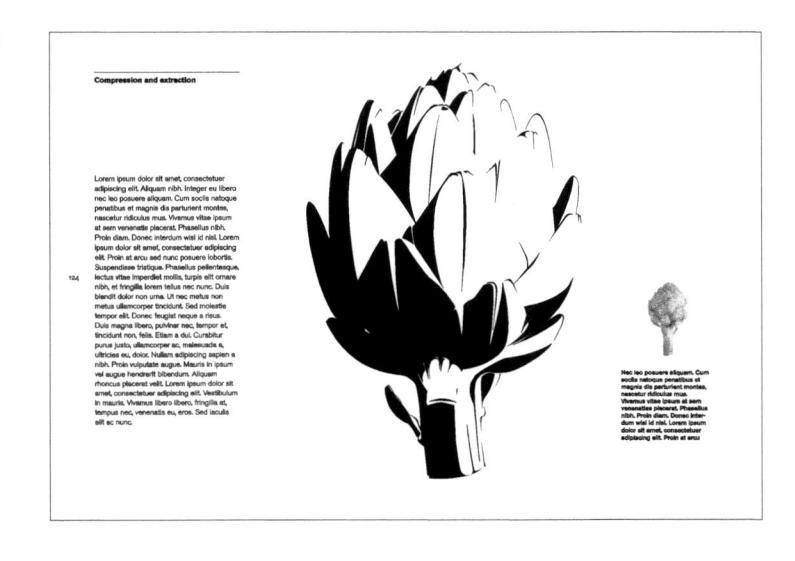

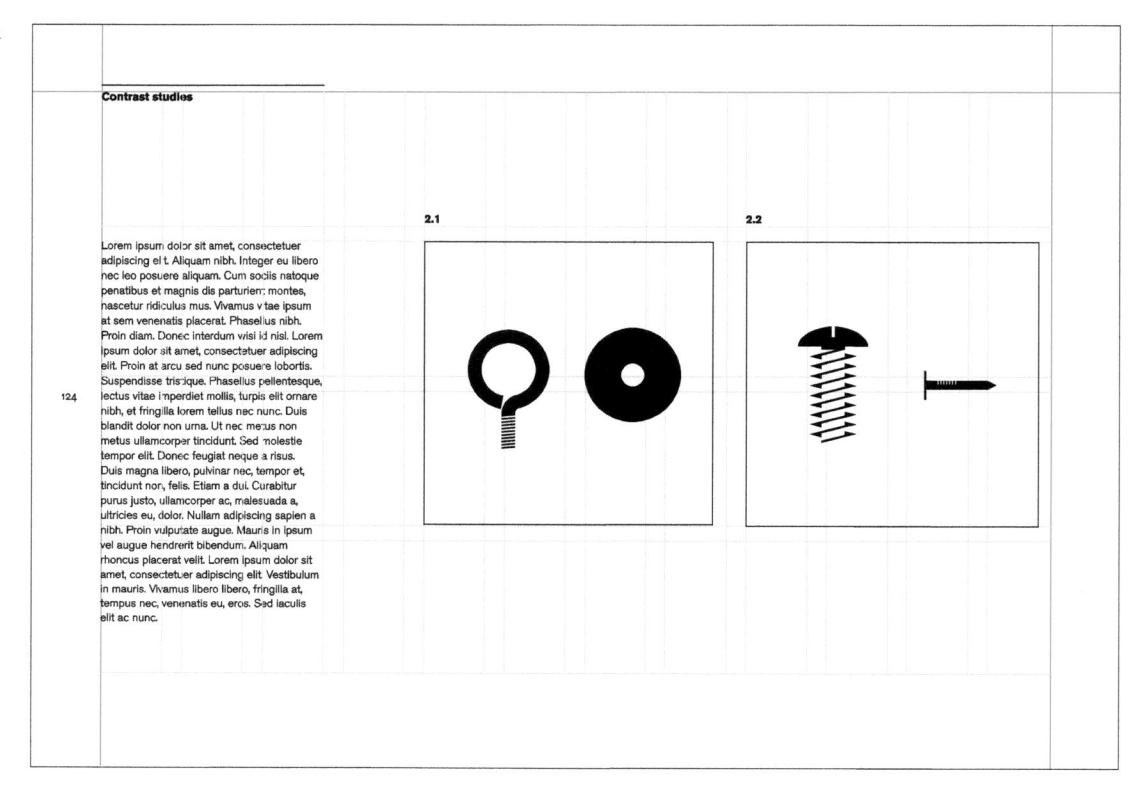

The placement of identification ('2.1' etc.) for the images in the spread above demonstrates when it is appropriate to break the rules—the numbers fall flush bottom in their fields. If they appeared at the top of their respective fields, their connection to the art would be lost. Clarity of meaning and ease of reading always trump the formal restraints of working with grids.

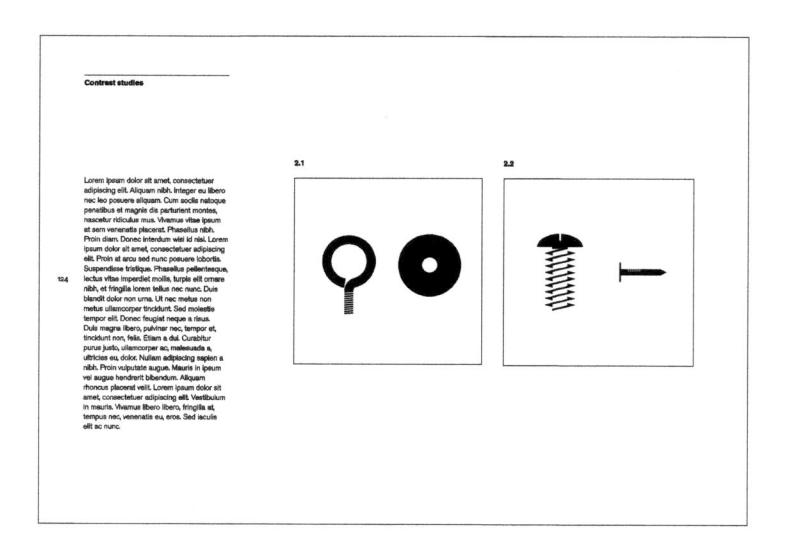

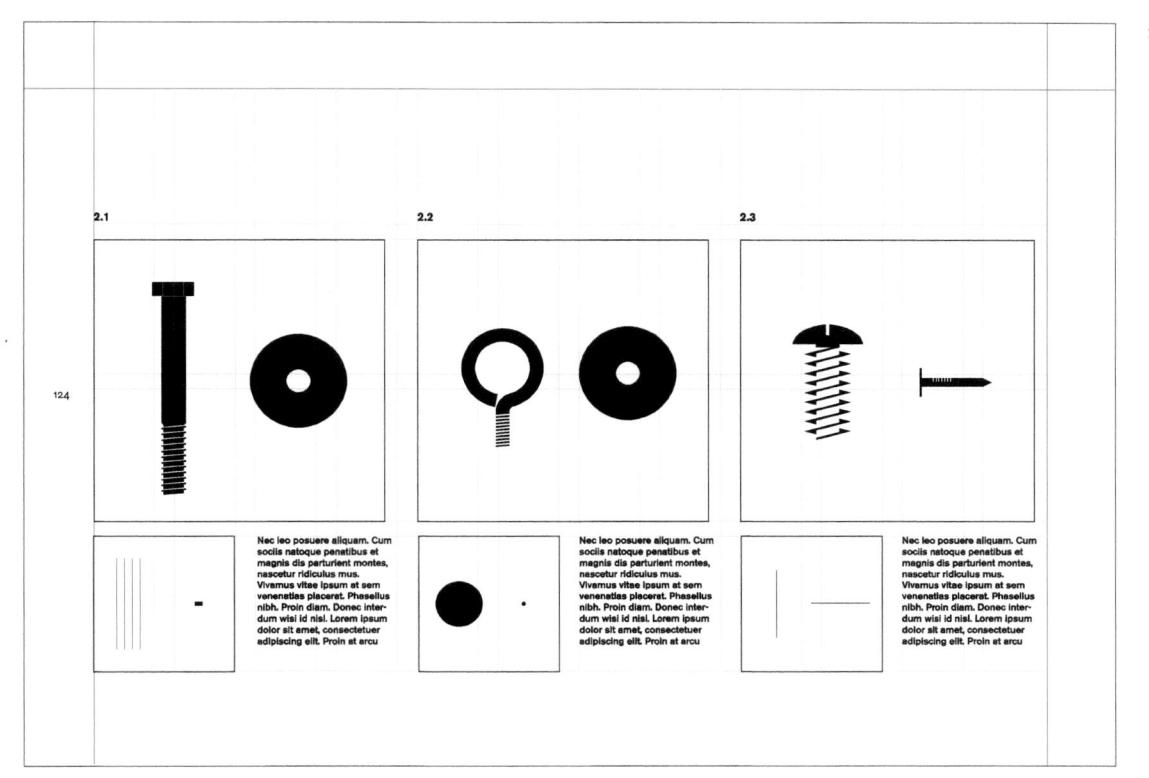

At the same time, placing the identification at the bottom of a field strengthens the structure of the page — the sense of the grid — even though specific placement works against one of the grid's seeming requirements.

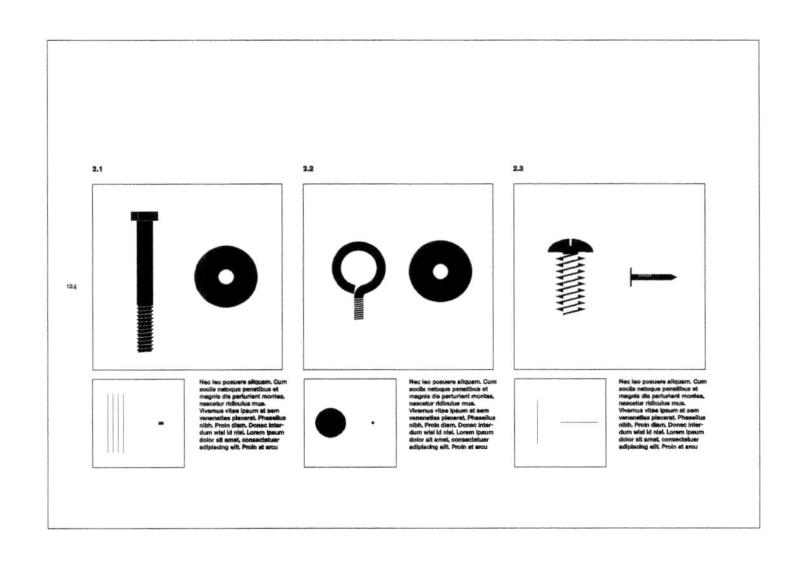

With all the primary relationships among text and images sorted out, the grid now expresses a true system — the logic of the presentation. Position on the page is now an expression of hierarchy and meaning, not just an esthetic choice.

Head				
Text	Text	Text	Text	
Caption				

226

Rather than attempt to sum up the preceding 200 pages, I want to leave you with three recommendations:

Slow down.

My colleague and good friend
Nina Pattek says that the design
process—how we get from idea
to final—is a series of 'considered
responses to direct observation.' This
process requires the one thing our
magnificent technological advances
conspire against: taking one's time.
Working at a computer is so easy,
the software so powerful, that results
can seem effortless and inevitable.
And for many begining typographers,
the evolving object on the screen
may appear finished long before it
actually is.

An integral part of slowing down is printing out your work as you go through the process, not just when you think you're done. Doing this externalizes your work, giving you the chance to see it for what it is, not necessarily what you wish it were. It also gives you the time to think about what you're doing. Time is central to good work.

Be wary of 'creativity.'

American artist Chuck Close once said, 'Inspiration is for amateurs.'
The point is that professionals work; they know the principles, they've mastered the craft, and they understand and engage in the process.
Amateurs may entertain some fantasy about the creative moment, that bolt out of the blue that knocks us out of bed at three in the morning; professionals know that real insight, real innovation come only from deliberate process.

Keep your eyes open.

As the title suggests, this book is just a beginning. I encourage you to use the bibliography to learn what other people have to say and show about typography. Beyond that, look around. Every time you see language, you are looking at type. Test what you do against what other people do and learn how to articulate the differences. Keep a sketchbook, and note all your observations. Include your own examples. And take advantage of every opportunity, however humble, to put type on paper. I hope this book prompts an ongoing exploration of a dynamic and demanding craft. With luck, it will stimulate a process that leads to type becoming an integral part of your professional life.

Selected bibliography

- Bringhurst, Robert. The Elements of Typographic Style. 2nd rev. ed. Point Roberts, WA: Hartley & Marks, 1996.
- Carter, Rob, Day, Ben, and Meggs, Philip. Typographic Design: Form and Communication. 2nd. ed. New York: Van Nostrand Reinhold. 1993.
- Chappell, Warren. A Short History of the Printed Word. New York: Alfred A. Knopf, 1970.
- Craig, James. Basic Typography: A Design Manual. New York: Watson-Guptill, 1990.
- —, and Barton, Bruce. Thirty Centuries of Graphic Design. New York: Watson-Guptill, 1987.
- Dair, Carl. Design with Type. Toronto: University of Toronto Press, 1967.
- Diethelm, Walter (in collaboration with Dr. Marion Diethelm). Signet, Signal, Symbol: Handbook of International Symbols. 3rd ed. Zürich: ABC Books, 1976
- ----. Visual Transformation. Zürich: ABC Books, 1982.
- Friedman, Dan. *Dan Friedman: Radical Modernism.* New Haven: Yale University Press, 1994.
- Frutiger, Adrian. *Type Sign Symbol.* Zürich: ABC Books, 1980
- Gill, Eric. An Essay on Typography. Boston: David R. Godine, 1988.
- Hochuli, Jost and Kinross, Robin. *Designing Books:*Practice and Theory. London: Hyphen Press, 1996.
- Hofmann, Armin. *Graphic Design Manual: Principles and Practice*. New York: Reinhold, 1965.
- Hollis, Richard. *Graphic Design: A Concise History.* London: Thames & Hudson, 1994.
- —. Swiss Graphic Design: The Origins and Growth of an International Style, 1920-1965. London: Laurence King, 2006.
- Kunz, Willi. *Typography: Macro- + Micro-Aesthetics*. Sulgen: Niggli, 1998.
- Lieberman, J. Ben. *Type and Typefaces.* 2nd ed. New Rochelle: Myriade Press, 1978.
- Maier, Manfred. *Basic Principles of Design*. New York: Van Nostrand Reinhold, 1980.

- McLean, Ruari. *Jan Tschichold: A Life in Typography.*New York: Princeton Architectural Press, 1997.
- Meggs, Philip. A History of Graphic Design. 3rd ed. New York: John A Wiley & Sons, 1998.
- Morison, Stanley. Four Centuries of Fine Printing. 4th rev. ed. New York: Barnes & Noble, 1960.
- Müller-Brockmann, Josef. *The Graphic Artist and His Design Problems*. Teufen: Arthur Niggli, 1961.
- —. Grid Systems in Graphic Design: A Visual Communication Manual for Graphic Designers, Typographers and Three-Dimensional Designers. Niederteufen: Arthur Niggli, 1981.
- —. Josef Müller-Brockmann, Designer: Pioneer of Swiss Graphic Design. Baden: Lars Müller, 1995.
- Müller-Brockmann, Josef and Shizuko. *History of the Poster.* Berlin: Phaidon, 2004.
- The Pierpont Morgan Library. Art of the Printed Book 1455–1955. With an essay by Joseph Blumenthal.

 New York: The Pierpont Morgan Library; Boston: David R. Godine, 1973.
- Rand, Paul. From Lascaux to Brooklyn. New Haven: Yale University Press, 1996.
- Rosen, Ben. Type and Typography: The Designer's Type Book. New York: Van Nostrand Reinhold, 1963.
- Ruder, Emil. *Typography: A Manual of Design.* Teufen: Arthur Niggli, 1967.
- Updike, Daniel Berkeley. *Printing Types: Their History, Forms and Use.* 3rd. ed., 2 vols. Cambridge, MA:
 Harvard University Press, Belknap Press, 1962.
- Weingart, Wolfgang. My Way to Typography. Baden: Lars Müller, 2001.
- Wingler, Hans M. The Bauhaus: Weimar, Dessau, Berlin, Chicago. 1st paperback ed. Cambridge, MA: MIT Press, 1978.
- For websites, go to www.atypeprimer.com

A heads 132, 134, 135 acknowledgments pages active corners 184, 203, 220 addenda 123 Adobe Systems, Inc. 46 Caslon 9, 31, 96, 204, Garamond 26, 27, 28, 72, 97, 148, 150, 152, 154, 193 Aicher, Otl 47 Akzidenz Grotesk 9, 41, 50, 64-69, 80, 188, 213 Alcuin of York 19, 20 alphabets, ancient 16-17 American Type Founders 36 Antique 38 apex 2 apostrophes 131 appendices 123 Arabic numerals 19 Architype Renner 43 Aries 42 arms 2 artwork, creating grids for 212-25 Arrighi, Ludovico degli 25 ascenders 2, 105 asterisks, exdented 153 Avenir 44

B heads 132, 133, 134 back matter 122, 123 barbs 2 baselines 2 Baskerville 12, 32, 49, 52, 59, 170 see also Monotype Baskerville Baskerville, John 32, 34 bastard title see half title batarde 20, 26 Bauer Bodoni see Bodoni Bauer foundry 35, 43 Bauhaus 40 beaks 3 Bell 49 Bembo 12, 13, 25, 32, 48, Benton, Morris Fuller 36, 173

Berthold type foundry 41 bibliographies 123 Bifur 14 'black' typeface 8 blackletter 20, 21, 48 Bodoni 8, 12, 49 Bauer Bodoni 13, 34, 35, 97, 172 Old Face Medium 9 Poster Bodoni 173 Bodoni, Giambattista 34, boldface 8, 36, 126, 127 for highlighting text 76, 79 for indicating hierarchies 158, 159 for subheads 132, 133, 135 'book' typeface 8 bowls 3 brackets 3 broadsides 170-76, 194 Broadway 14 Browning, Robert viiin Brush Script 14 bullets 131 Bulmer 49

C heads 132, 133, 134, 135 Caledonia 49 capital letters 5 lapidary 17 rustic 18 small 5, 6, 134 square 18 captions 203 cross alignment of 144 Caroline minuscules 19, 20, 48 Carter, Matthew 46 Caslon 12, 30, 48 see also Adobe Caslon Caslon, William 30 Caslon, William, IV 36, 38, 50 cedillas 5 centered text 94, 95, 118 Century 49 Charlemagne 19, 20 charts see tabular matter Chinese characters 88 Civilité 26

Clarendon 38, 49, 61

classification, type 48-50 Cloister Black 48 Close, Chuck 226 Cobden-Sanderson, T. J. 40 codices 18 Colines, Simon de 26 colophons 123 colored type 80-87, 196-99 for highlighting text 126, 127, 161 columnar layouts 138-43, 180, 194 Commercial Pi 7 compositional requirements 104-105 compressed/condensed typefaces 8, 62, 80 contents, tables of 122, 123 contrast, use of 62-63, 85, 87, 170 Cooper Black 14 copyright pages 123 core messages 76 counterforms/counters 3, 57-61, 71, 151, 170, 194 Courier 99 cross-alignment 144-45, 203, 207, 208 cross bars 3 cross strokes 3 crotches 3 cursive, Roman 18

Dante 48 Monotype Dante 26 Deberny & Peignot foundry 44 dedications 123 descenders 2, 3, 105 Didot 49, 193 see also Linotype Didot Didot, Firmin 34 digital type 37, 46, 162 Dijck, Christoffel van 28 dingbats 7 display faces/type 14, 37, 73, 91, 189 'drop cap' 118 'dumb quotes' 131 Dwiggins, W. A. 40

ears 3
'Egyptian' 36, 38
Elzevir family 28
ems/ens 3
epigraphs 123
Estienne, Henri and
Robert 26
Etruscan alphabet 16, 17
exdenting text 125, 130,
131, 153
extended typefaces 8,
62, 81
'extra bold' typeface 8

Fell, Bishop John 28 Fibonacci sequences 108-109, 188 fields 180, 182, 184 Figgins, Vincent 36, 38 financial statements see tahular matter finials 3 flush left/flush right text 94, 118, 151, 178 folio (paper size) 110 folios 115, 118, 180, 187, 209, 210, 211, 221 fonts 5-7 footnotes 123 forewords 123 form and counterform 57-61 formats, establishing 149, 155 formatting text 94-95 Foundry, The 43 Fournier family 34 fractions, setting 149 Franklin Gothic 50 front matter 122, 123 frontispieces 122, 123 Frutiger 44, 50 Frutiger, Adrian 39, 44 full titles 122 Fust, Johann 20 Futura 12, 13, 43, 50 Futura Black 14 Futura Book 9, 98

Garamond 12, 27, 48 see also Adobe Garamond Garamond, Claude 26 Gill, Eric 13, 42, 175
Gill Sans 9, 12, 42, 50
glossaries 123
Glypha 39, 44
golden section 106—107, 108, 110, 116
Gothic
News Gothic 50
Trade Gothic 50

'gothic' type 36 Goudy, Frederick W. 40 Goudy Text 14, 48 Grandjean, Philippe 32 Granjon, Robert 26, 27 Greek alphabet 16, 17 'greeking' 124

grid systems 176, 178, 179, 181 and complex compositions 194

components 180-87

expressing hierarchy

196-97 at large scale 194 simple 188-93 for text 200-11 for text and images

212-25 Griffo, Francesco 24, 25 'grotesque' 36 Grotesque 50

Grotesque Black 9 Gutenberg, Johann 20 Gutenberg Bible 20 gutters 128, 151, 180, 182, 185, 189, 198, 202, 203,

185, 189, 198, 202, 203, 208, 218

headers 115, 118, 180 headlines 132, 203 cross alignment of

Haettenschweiler 14

half title 122, 123

144-45 sidebar 209 see also titles heads, secondary see

subheads

Helvetica 13, 50, 54, 99 Helvetica Black 58 Helvetica Neue 44

Hobo 14 hierarchies, expressing 146–48, 188–91, 196—97, 210, 224 with boldface 158, 159 subheads 134—35 highlighting text 126—30 Highsmith, Cyrus x Höll, Louis 35, 172 see also contrast;

hierarchies

ISO system 113

indenting text 118, 128, 129 for paragraphs 125 indexes 123 introductions 123

italics 6, 8, 24, 25, 48, 62,

for subheads 134, 153

'true' and 'obliques' 6

76, 81, 126, 152

Jannon, Jean 27

Janson/Janson Text 10, 12, 48, 71, 97, 100—103, 105, 118, 126, 127, 162—67, 193 see also Linotype Janson

Jenson 48 Jenson, Nicholas 22, 23 Joanna 42 Johnston, Edward 42

Janson, Anton 29

Jost, Heinrich 172 justified text 94, 95

Kaufmann 14 Kelmscott Press 38 kerning 90 key words, highlighting 76-77 Kis, Nicholas 29

Kuenstler Script 49, 72

Lawson, Alexander 48 layouts, text 116–18 columnar 138–43 see also grid systems leading 10, 105, 118, 184, 185, 202, 207

and line length

100-103

legs 3

set widths 11 understanding 52-55 vertically written 88 letterspacing 90, 93

letterforms 2-4

ligatures 4, 5, 149 light typefaces 8 line length 100—103, 118, 149, 205, 206

in tabular matter 157-61 lining figures 6 links 4

line spaces 149

Linotype
Glypha 39
Didot 34, 6o, 72, 76
Janson 28, 29
lists see tabular matter
Lohse, Richard 40

loops 4 lowercase letters 5, 18,

19, 93 lowercase numerals 6, 11

Majoor, Martin 47 majuscules 19 Manutius, Aldus 24 margins 114, 116, 180, 183, 200, 202, 213

200, 202, 213 meanings, reinforcement of of sentences 70—79 of words 64—69

medians 2 'medium' typeface 8 Memphis 39, 49 Meta 50, 174 Meta Plus Normal 98

measuring type 10-11

Meta Book 120 Meta Normal 9 minuscules 19, 20 Mistral 14, 49, 73

modern typefaces 49

Moholy-Nagy, László 40 Monotype Corporation 25, 175 Baskerville 5, 6, 7, 33, 97 Dante 26

Dante 26 Morison, Stanley 25, 33, 40

Morris, William 38

40 Neuberg, Hans 40 New Graphic 40 News Gothic 50 numerals 6, 11, 19, 149 see also tabular matter

Müller-Brockmann, Josef

'obliques' 6
octavo (paper size) 110
Oldstyle typefaces 6,
48, 49
Onyx 14, 171
Open Type 11
Optima 50
orphans 136
Ostwald, Wilhelm 113

Oxford University Press

p see picas
pages
recto/verso 114
sizes 110, 118
numbers see folios
Palatino 48
Pannartz, Arnold 22, 23
paper 18
American sizes 110—12
European sizes 113
papyrus 17

papyrus 17
paragraphs 124–25
line spaces between
149
parchment 18
passive corners 184, 220
Pattek, Nina 226
Peignot 14
pens, reed 18

Perpetua 42, 175
Phoenician alphabet 16, 17
phototypesetting 37, 44
picas 10
pilcrows 124
Plantin, Christophe 28
Plantin-Moretus family 28
Playbill 14
points (measurements) 10
Powell, Gerry 171

preface 123 primes/double primes 131 printing presses 20 punctuation 7, 19 Renner, Paul 43 reversed type 128

Rockwell 49 Rogers, Bruce 40

Roman alphabet 16, 17, 18, 62 Roman numerals 19 roman typeface 8, 81

Rotis type 'family' 47, 50 rotunda 20 Ruegg, Rudi 62 rules, horizontal 159-61

Runic 14 running feet 115, 186, 209

running heads 115, 121, 186, 209 running shoulders 115, 186

Ç .

sans serif typefaces 36, 40, 41, 42, 43, 47, 50,

54–55, 63, 120 Scala 50 scale 77, 79

and color 86, 87 and structure 78 Schöffer, Peter 20, 22

script typefaces 49 semibold typefaces 8, 9 Serifa 12, 13, 44, 49, 98

Serifa 12, 13, 44, 49, 98 serifs 4, 63 bracketed 38

slab 39 square 38, 49 **see also** sans serif

typefaces shoulders 4 running 115, 186

sidebars 204, 209 slab serifs 39 Slimbach, Robert 27

small cap subheads 134 Snell Roundhand 49 spacing x

see also letterspacing; line spaces specimen books 162 specimen sheets 30, 168-69

Spiekermann, Erik 41, 47, 174 spines 4

Spira, Johannes da 22 spreads 142 spurs 4

square serif typefaces 38, 49 Stempel Foundry 29, 39

stems 4 Stone 50

Stone, Sumner 46, 47 stresses 4

strokes 2 subheads 132-33, 153, 209

hierarchy of 134-35 surprinted type 129 swashes 4

Sweynheym, Conrad 22, 23

23 Syntax 50

syntax, examining 74-75

tabular matter, setting 156-61 Tagliente, Giovantonio 25

tails 4 terminals 4

text area see text pages

text figures 6
text layouts see layouts,
text

text pages 114-15, 180, 182 text type 14, 114 Textura 20

textures (of typefaces) g6-g8 'thin' typefaces 8

Thorne, Robert 36 tildes 5 Times Roman 49, 99

timetables, setting 156-61

grid system for 188-93 titles 153

title pages 122, 123

see also headlines Tory, Geofroy 26 Tournes, Jean de 26

'tracking' 90-92 Trade Gothic 50 Traian 73

Trajan 73 transitional typefaces 49 Ts'ai Lun 18

typefaces 8-9

two-color poster 196-97 Twombly, Carol 31 type area **see** text pages

classification of 48-50 comparing 12-13

and readability 93, 95, 100, 117

suitability of 96-98 type sizes see measuring type

uncials/half uncials 19

typewriter type 99

Univers 6, 10, 12, 44–45, 46, 50, 52, 54, 72, 76, 91, 98, 126, 127, 157,

167-68 Thin Ultra Condensed

9 Universal News 7

Updike, Daniel Berkeley 40 uppercase letters 5, 16, 93 uppercase numerals 6,

11, 157

vellum 18 verso 114

vertex 2 vertical type 88

visual rhythm 176 Vivarelli, Carlo 40 Voskens, Dirk and Bartholomew 28

Walbaum 49 Warde, Beatrice 40

weather charts see tabular matter widows 136

Wolf, Rudolf 39

x heights 2, 96 maintaining 56 matching 126, 127

zero 19